Sigi Jöttkandt

The Nabokov Effect

Reading in the Endgame

CCC2 – The Nethercene: Ecocide & Inscription

Series Editors: Tom Cohen and Claire Colebrook

Taking in the vortices and reversals of the 'post' pandemic anomie, The Nethercene sub-series of CCC2 opens the space of provocation for readers during this Potemkin transition by seizing upon and opening problematics of the inscriptive forces and demons before the screen projections of 'consciousness' coalesces – the netherworlds on which these spectacles depend. The Nethercene opens a space to the side of the 'endgame' logic of Anthropocene Talk's panicked turn to claim ever greater 'otherness' in a manner that has sealed the fate of the transitional decade we are leaving. By exploring the laproscopic order of inscription, hermeneutic blow out, referential panic, and Medieval tele-herding that offers distractions and options, this series takes up the remains of reading.

Sigi Jöttkandt

The Nabokov Effect

Reading in the Endgame

with a Foreword by **Claire Colebrook**

and a Preface by **Tom Cohen**

()

OPEN HUMANITIES PRESS

London 2024

First edition published by Open Humanities Press 2024

Copyright © 2024 Sigi Jöttkandt, Tom Cohen, Claire Colebrook

Freely available at: http://openhumanitiespress.org/books/titles/the-nabokov-effect

Cover: Perrier, E. 1884. Nouvelles Archives du Muséum d'Histoire Naturelle. Public domain, via Wikimedia Commons.

Back Page: H.L. Clark, 1916. *Fromia polypora*. Public domain, via Wikimedia Commons.

Print ISBN 978-1-78542-134-1

PDF ISBN 978-1-78542-133-4

OPEN HUMANITIES PRESS

Open Humanities Press is an international, scholar-led open access publishing collective whose mission is to make leading works of contemporary critical thought freely available worldwide. More at http://openhumanitiespress.org

Contents

Acknowledgements

This book is for Tom Cohen, being the other half of a conversation that began many years ago with the publication of his monumental study of a certain cryptonymic phenomenon in Alfred Hitchock's films. This study of an adjacent phenomenon in Nabokov would not exist without his inspiration. Like a mystic writing pad, the intellectual imprints of many others are also clearly legible here: Claire Colebrook, Edward Colless, Joan Copjec, Mladen Dolar, Oliver Feltham, Gary Hall, Dominiek Hoens, Joe Hughes, Carol Jacobs, Juliet Flower MacCannell, J. Hillis Miller, Jean-Michel Rabaté, Henry Sussman, Jelica Sumič-Riha, Alenka Zupančič, Joanna Zylinska, and the wider Open Humanities Press and S communities. My grateful thanks, too, to present and former colleagues in English, Media and Film at the University of New South Wales for their warm collegial support (in particular, John Attridge, Helen Groth, Julian Murphet, Brigitta Olubas, Elizabeth McMahon, Sean Pryor, Lisa Trahair), and to our many brilliant students, several of whom were members of the Lacan and Badiou reading groups over the years, especially Giacomo Bianchino, Robert Boncardo, Arka Chattopadhyay, Christian R. Gelder, Sajad Kabgani and Kate Montague. I particularly wish to thank my mother, Heide Erdmute Jöttkandt, and my sister, Kirsten Asche-Woodger, also Paul Ashton, Diana Barnes, Justin Clemens, Lone Bertelsen, Prue Gibson, Andrew Murphie, the immortal Alan Cholodenko and, especially, David Ottina for a crucial Nabokovian discovery in chapter eight, among many, many other things.

In various kaleidoscopic shuffles, sections of this book have appeared in the journals *Crisis & Critique, Sanglap, symplokē, S: Journal of the Circle for Lacanian Ideology Critique* and *Psychoanalysis Lacan*, and in the collections, *Inheritance in Psychoanalysis* (SUNY Press, 2018), and *Knots: Post-Lacanian Psychoanalysis, Literature and Film* (Routledge, 2020). My thanks to the editors and publishers for their permission to recombine them here.

Foreword: Whither the Nethercene?

Claire Colebrook

In the wake, death, aftermath or end of theory it is worth asking how –
if theory dies, and everything seeks to die in its own way – theory
threw itself towards its own end. This, I will argue, is the problem of
the Nethercene. If theory was constitutively forged against the purity
of presence, constitutively oriented towards exposing the non-living at
the heart of what appeared as life or 'the human' how might we now
live once theory is dead, and how is it that theory never contemplated
its own death? In terms of proper names one might mark the space and
time of the Nethercene in the impossible difference between Derrida
and Stiegler. For the former, any thought of life, of who 'we' are, or of
the time that brings us into being emerges from an inscriptive scene
that precludes any narration of origin: to think beyond who 'we' are
can emerge only from the anarchy or untamed genesis that disrupts
the technics that forges the time of life. For Stiegler, it is necessary to
take up a relation to the different temporalities that make any sense
of 'the human' possible: if technics composes our being, our epoch,
then a doubly epochal redoubling employs the technics of thinking to
narrate the history of technics. The Nethercene is, then, an attempt to
think about the history of technics: how might we grapple with the tox-
icity and potentiality of the archival objects that compose our being,
at once struggling to be something other than the same dull round of
books and figures that stand for the human, while accepting the utter
contamination and banality of seeking the end of man? Is there some-
thing other than the exclusive disjunction between saving the human
from itself or ending man for the sake of a new world? The Nethercene
is the refusal of that disjunction: there is no saving the human, there
is no new world, and yet all that ever emerges is more of the human,
and all that ever happens is the desire for yet one more new world (that
is, in turn, always the theft of someone else's world). If there are so
many attempts to 'queer' the Anthropocene or 'decolonize' ecology or
'creolize' the humanities, this is because there will always be figures
to help revive the very things that poison us. I am not saying this as
though it is a bad thing. It's the Nethercene, a positive incapacity to
abandon what is not killing you and only making you stronger. Is there
no way to live beyond one's attachments, are we either a Derrida who

can see no end of promissory futurity in the archive, or a Stiegler who grants the technology of the human a capacity to take up a relation to its potential stupidity? These proper names – Derrida and Stiegler – mark out both an incapacity to abandon the grand European archive and a capacity to read that archive as destructive, inhuman and radically negentropic. It is this twin capacity and incapacity that forms the Nethercene, a weak near-recognition of the toxicity of the canon, alongside an attachment that insistently refuses to let 'the human' be done with once and for all. Put more simply, for all the ways in which theory sought to have done with 'man' that project of freedom from ourselves seems to have well and truly died. We now occupy the Nethercene, a living on or afterlife that follows the failed death of man. From the end of the book and the beginning of writing (which is how we might understand theory, or the attempt to think about the rogue forces that compose our attachments) we now live in the twilight zone of the end of writing and the beginning of a thousand new literalisms. The death of theory, or life after theory, is not simply a turn to affect, materialism, realism, life or animality; it is an ongoing refusal of confronting both the death exposed by theory, and all the ways that theory had to die.

How might we think about theory as 'being towards death'?

Let's count the ways. First, there is the Heideggerian mode: if one were to live forever then life would run through all possibilities. Decisions, ownness, and individuation would be without meaning. A form of living without being towards death would be the bourgeois 'everybody dies someday'; one would simply carry on, not especially concerned with the force of decisions, and certainly not at all concerned with the intensifications of death brought about by simply living on. Second, in the markedly different Freudian mode of the death drive, all life seeks to die in its own way, as if the individuation of existence were not only so intolerable as to generate the lure of inauthentic evasion of death but ultimately so intense that death becomes the telos of desire. Then there's the Deleuzian mode (indebted heavily to Blanchot's impersonality of death and Nietzsche's eternal return): to think beyond one's own life – to imagine existence beyond one's own point of view and attachments – would release one from the petty attachments of the ego in order to affirm a cosmos beyond one's time. Despite differences, the recognition of death as impending, inevitable and one's own, even if it destroys ownness, seems to have been something theory could objectify but not (yet) confront within itself. Being towards death is dissolution (Freud), the radical freedom of impersonality (Deleuze) or the recognition that one is somehow thrown into a place of decision not one's own (Heidegger). That 'one dies' ought to

confront one with the radical force of dissolution (Freud), generating a freedom that comes from embracing the cosmos beyond one's being (Deleuze), all the while refusing the banal 'everyone dies someday' (Heidegger).

The very theory that hammered home this radical philosophical force of what lies beyond life not only died to give way to life – new materialisms, vitalism, affect, animals, the body – it seems not to have seen its death coming. It proceeded as though theory might simply live on, moving from Lacan to Derrida to Badiou to Butler to Wilderson. It's as though what might have been an event – a break in the time of the series of proper names – becomes one more chapter or paragraph in the history of ideas.

To put this more simply: one way of defining high theory is through its acceptance of the immanence and positivity of death. Death is not what happens at the end – everything simply surviving until it stops – because death, non-being, negativity, the inassimilable and a positive destruction are the condition for the possibility of life. When theory was overtaken with the triumph of life, this was no accident. As Deleuze and Guattari insisted in *What is Philosophy?*, it's not easy being Heideggerian; the attachments to life, to oneself, to the unquestioned value of living on, to self-affirmation – these are not simply accidental takeovers but crucial to the existential stupidity that allows one to live as if being oneself mattered. What would it have been for theory to accept the tendency of its own death, to confront an essential stupidity?

Theory perhaps ought to have seen the Anthropocene coming (not the geological event so much as the return of the human as a global condition). If theory was the intensification of a long philosophical history of working through a malevolence or non-being gnawing away at the bounded life of the subject – from Foucault's insistence that the unworking of madness could not be read, to Wilderson's refusal to allow Blackness any place within the human – then it was perhaps inevitable that Anthropos would find and affirm itself by embracing and personifying dissolution. 'We destroy, therefore we are.' 'We' have been re-formed through what Dipesh Chakrabarty referred to as a negative universal history: 'man' is not some essence or simple kind that proceeds through time but is instead a common predicament 'we' inhabit in the wake of destruction. Facing our end, 'we' come into being. We are at once collectively Heideggerian in being individuated through confrontation with 'our' finitude, while also allowing that collective and humanizing death to be a distant and disowned 'someday.' When other agents replace 'Anthropos' – most notably the capitalism of the 'Capitalocene' – we are returned to a pre-Freudian,

pre-Deleuzian, pre-Heideggerian beatitude: the destructive agent is an external and delimited 'them,' whose end we might imagine for the sake of living on.

Rather than think of the Anthropocene and its attendant new literalisms as an accidental aftermath following the death of theory, it would be more accurate – if difficult or impossible – to think of Anthropos as that tendency towards stupidity and death-evasion at the heart of theory. Theory was always divided between a sense of anarchic, untamed, malevolent and non-living forces, and the redemptive investment in those forces as a path to not being who we so often, so stupidly, are.

The 'Nethercene,' as I use it here, aims to confront not the passage from theory to the Anthropocene, but rather the forces of any theory that will inevitably be killed by Anthropos and the right to life. Let's approach this by returning to two figures of theory: Derrida and Stiegler. The former might first be thought of as the man who put the death back into life, but also – unfortunately – the life back into death. The condition for the possibility of life is death: the tracing out of time, the marking out of a face, the recognition of oneself as a being who can be affected, all require an ongoing annihilation, forces not one's own, events that bring ownness into being while also exposing that ownness to dissolution. But for Derrida this also meant that whatever horrors, limits, enclosures and violences the present might harbor, those very forces also undo and surpass the given. By contrast, Stiegler's insistence on grappling with stupidity and the death within theory is at one and the same time the most necessary and most stupid of post-theory, post-Anthropocene events. Against Derrida, Stiegler insists on the distinct stupidity of the human: only a human can be stupid. Of course, Derrida is right to note that whatever marks out the difference between 'the human' and 'the animal' is itself a beastly, anarchic, untamed force: there is no 'the animal' as such, only a long and ungraspable history of markings that produce 'the human' as other than the menace of the inhuman. Between Stiegler and Derrida there is then an odd chiasmus: Derrida's anarchy of writing is nevertheless as promissory as it is destructive, while Stiegler's insistence on the human is as stupid as it is futural.

When Stiegler argued that only humans can be stupid, what he sought to confront was a technological and temporal capacity and incapacity to be human. The storing of memory outside the body and across time is both what allows desire to extend beyond one's life while also posing a threat of captivation and short-circuiting. Where Derrida located the problem of contamination in life in general – such that living on in time requires the carrying over of the past into the present, with the present always dispersed beyond itself – Stiegler insists on

the singular stupidity of the human. We might imagine all beings as archival, with the time of their lives made possible by various external networks (such as bee hives, ant hills, migration patterns, song or pack habits). Yet there is a specific technics of time – for Stiegler, 'tertiary retention' – that composes the human: the stored memories of the human archive carry across generations, allow for investments in past monuments to generate new futures, but also pose the possibility of entropy. The complexity of the archive enables 'the human' to desire long-range, cross-generation and multi-cultural forms; Stiegler describes this as a form of negentropy or working against dissolution. This same externality can also be entropic. 'The human' becomes that being – already given – that captivates, stalls, lulls or renders stupid.

The Anthropocene is just such a moment of ontological stupidity: having formed itself through marking out a planet-catastrophic temporality of hyperconsumption, 'the human' becomes enthralled with its right to life. (Things fare little better with attachments to 'the humanities'; where the objects through which 'we' have been formed are either repeated as the only archival mode imaginable or supplemented as though a few tweaks of the canon might 'decolonize' and therefore redeem us.) If we quibble and call the Anthropocene the Capitalocene, we form an even more sanctimonious 'we.' It is as though we might step outside, and judge an externality that has contaminated the properly capitalism-free human. If we imagine that redemption might lie in substituting some canonical archival forms for others – 'queering the enlightenment,' 'decolonizing the syllabus,' or 'creolizing the canon' – then we remain attached and mesmerized by the things that have brought us into being. More stupid than this, though, would be the simple imagination that things might be cleansed of all these attachments, that we might sweep 'man' away and arrive at a post-human or human-free plane of joyous affect (think James Cameron's *Avatar* fantasy of blue people who are other than the man of modernity, fully attuned to the earth, or – worse – the thousand uncritical Deleuzianisms that imagine becoming-animal as if it were so easy, so possible, so unlikely to fail).

Enter the Nethercene (or perhaps, more accurately): 'No exit, the Nethercene.' The contestations regarding the Anthropocene – either marking the fall into destructive planetary change from the point of colonization or delimiting this new era by substituting Capitalocene for Anthropocene – suggest a place beyond the scene. This scene would be nothing more nor less than the Nethercene, where imagined futures fall back onto the same dull round of the human. What theory taught us is that these narratives of Anthropos are technologies that bring 'the human' into being, with 'the human' being an effect of techné – not

its ground or author. There can be no theory of narrative because any such theory would itself be a narrative (de Man). The conception of a techné-free original or innocent humanity whose paradisiacal life might be regained ought to have been killed off by theory, but theory very rarely grappled with its own inevitable death – that man and the dream of techné-innocence would return. This is the Nethercene: there is no end of 'the human.' All the attachments that compose the history, archive and technics that are catastrophic at a planetary and geopolitical level are at once attempts to escape the actuality of our being, while nevertheless generating so many virtual humans of a redeemed future. The Nethercene is a working through – not the exit of the post-human, and not the redemption of a pre-Anthropocene proper – but an utterly contaminated predicament of living among the ruins of so many new worlds.

Is it possible that this trajectory of destruction might come to an end, might die and allow a new world to emerge? That form of being towards death, where one would kill off the toxicity that contaminated one's life, is precisely what 'theory' sought to solicit. Yes, there is a Derrida who imagines a future 'to come' that is not reducible to the continuity of the given, but the very possibility of that future is death, not the death that kills off the present, but a death that disinters the present from itself, that breaks, destroys, undoes and renders anarchic the figures of life that compose who 'we' are. How could theory not have seen that it was bound up in a battle of good and evil forms of death, good and evil ends of man, good and evil modalities of the Nethercene? This is where 'we' are: the only humanity possible would be one that ended the world – that said goodbye to dreams of a new world, that abandoned the dream of techné-free purity – and yet the 'we' that faces up to the immanence and imminence of death is composed of all the lures of regaining itself in its proper form.

Following decades of a high theory that insisted on the immanence of death – the negativity, non-being, inertia and potential stupidity that constitutes 'the human' – should we not also have factored into this immanent death, the imminent reaction formation that could do nothing more than affirm life? Stiegler forged the concept of the 'Neganthropocene' to mark out the ways in which 'the human' is nothing more nor less than stored memories that can either open to complex futures or capture us in short-circuits. The necessary stupidity of a world after theory – a freedom from death, inscription and inhuman difference – is best thought of as a reaction formation that refuses the imminence of death (in an Anthropos that will, of course, survive). The Nethercene marks the space of immanent and imminent stupidity, an attachment to an archive that we tell ourselves can be

queered, decolonized, creolized or somehow smuggled into heaven. Let's rework the absolutely untrue cliché that it is easier to imagine the end of the world than the end of capitalism. It is far too easy to imagine that the archive that has composed the world might generate a new and innocent world. Only a book can save us.

In that respect theory is not simply a capacity to think the forces of death, extinction and ends but also an incapacity, an ongoing return of the human. The Nethercene is this all too human post-human moment of wreckage, where the only joys that remain are killing off whatever hints of destruction linger after the death of theory.

In Lieu of a *Preface* – A *Reverie*:
'Reading' in the Time of Cascade Events

Tom Cohen

> Poe's mariner in "The Descent into the Maelstrom" staved
> off disaster by understanding the action of the whirlpool.
> His insight offers a possible stratagem for understanding
> our predicament, our electrically-configured whirl.
> —*Marshall McLuhan*

> If "cinema" is the name Nabokov gives to this totaliz-
> ing inscription, this also suggests another "understand-
> ing" of death.
> —*The Nabokov Effect*

> With a breath-taking insouciance for Enlightenment models
> of phenomenality, an oil lamp re-pockets the missing hard
> sign consigned to the Real's inky bog.... A liquifying reduc-
> tion of the semblable, an inky pool which, in spreading, laps
> at the limits of the lyrical I, bleeds through the phantasmal
> narcissal scene of identification.
> —*The Nabokov Effect*

> Here, in what amounts to writing's 'primal scene,' graphite,
> a metamorphic rock predating the Solar System, pierces
> ocularcentrism's "blue eye," boring through the latter's tun-
> nels of interiority with its 'memory' of an archaic, molten,
> intercalating arch-conductivity. Coiled within the written
> word is a letteral recall that intervenes in time, overwriting
> its forward arrow with a different interface of space-time.
> —*The Nabokov Effect*

I have wondered how to embrace an invitation to speculate, or
respond, as a first reader (as in "first responder") to Sigi Jöttkandt's
The Nabokov Effect, being alert to a possible Nabokovian trap set. I
was more than touched and surprised to find in the opening a sort
of harpoon – a hook and double prod – where Jöttkandt mentions an

obscure double-volume I "did" on Hitchcock. These volumes began with a focus on letters, syllables and "marks," enabling a graphematics and transumption of "writing," and a tracking of the mutations that *ur*-cinematics would be carrier and agent of, moving into the mnemotechnic accelerations of the hyper-digital era that is also that of climate extinctions. Where *Hitchcock's Cryptonomies* appropriated the "literary" legacies, Nabokov enters from the hyper-literary side encroaching into cinematics: where would they meet (or not)? Where do these two critical ventures (Jöttkandt's and my humbler efforts) stake out a "21st century" reading apparatus that partakes in the haze of "Anthropocene" chatter, disclosing so-called "modernist" aesthetics as a containing historicist trope of interpretive humanist reflexes?

I had invoked the term "cryptonymies" to focus on the way that *language* is marked recurrently in Hitchcock – as letters, numbers, syllables, figural citations, and even the word-name "Mar-" itself (*Mar*tin, *Mar*ion, *Mar*nie, etc.). I argued, by probing these networks, that he tracked a transition in reading from the book, from writing as script, into an era of the mechanical image that would be interwoven with world war, atomic bombs, and the lurking climate catastrophism that was still off-screen but tied to the rise of cinematization (and its oil premised "light"), along with the totalization of mnemo-technics capture and a *spellbound* psyche. Hitchcock overtly marks oil, the black fluid of energy transference, mnemo-technics, pre-death and engulfing. In *The Birds*, it is the burning gas station and swinging sign for "Capitol Oil" (of the head, capo), or the black wing-cuts themselves attacking the eye from the sunless skies; oil resonates in Norman's "bog," but gets its place set in *To Catch a Thief*, perhaps, related to the thieving black cat (an animated black sun).

We do not need to review Jöttkandt's many evocations, all at once, of a *cinemathomme* Nabokov – by which she does not mean an adapter of movie techniques for prose. Rather, she implies something akin to what Stiegler names an *arche*-cinematic reading premise, which Nabokov, as technician in Poe's hyper-materialist tradition (as is Hitchcock), draws toward as a site where letteration itself is artefacted, patterns of repetition are subsumed, and citationality decoupled (see Figure 1).

This generates an *arche*-cinematics that Hitchcock also conjured incessantly, absorbing "dialogue" as just more sound, evoked by the curious series of slash cuts or bars that interrupts the screen and informs various MacGuffins. Jöttkandt speculates on what cannot quite arrive, a non-site where writing and cinematics bleed into one another and fail to connect. In the background of this pair looms late 20th century accelerations of mnemo-technologies and video-screen cognition, much as in the background of the active reader today lie

Figure 1: The syncopated "bar-series" in *Spellbound* as the impaling fence of John Ballantine's (Gregory Peck's) discrete fratricide from behind. The "bar-series" through Hitchcock situates the alternating lines of temporal spacing, interval, celluloid partitions, the techno-premise of the visual and perceptibility and exosomatization (*Spellbound*, Hitchcock 1945).

the multiple logics of a biospheric "endgame" underway, which is not dissociable from legacy reading models or complicit hermeneutic regimes. (One may suggest this is where Nabokov's "Referential Maniac" might suicide to escape from and assume.) But if one acknowledges Jöttkandt's implication, that all this biomaterial re-arranging is not unconnected to the reading models we've been stuck within – call them, Anthropic? – then bringing into contact a certain "Hitchcock" and a similarly distinct "Nabokov" produces a curious frisson when the two briefly interact at Hitchcock's instigation.

We have some letters, and report of the opening phone call, in which Hitch's self-effacing approach to the writer was dismissed ("I know who you are"). One can be excused for taking away a sense that Nabokov anticipates and forecloses in advance a prospective collaboration, keeping leveraged distance as Hitchcock leaned in. Jöttkandt mentions in passing even the likeness their visages bore and ties her divagations to a different traction, one that can advert to a backlooping (a)materiality which continues to read through the voiced façades of interpretive gaming. It is here that one might invoke a *nethercene* of inscriptions that purvey and platform the efflorescence of viral

disfigurations of persona and "consciousness" that parade through the entranced decimation of life regimes today.

Does one need to re-animate a *laproscopic* reading mode in order to relinquish various legacy models that seem now complicit with the prospective cascade event that "2023" is witnessing? "Laproscopic" implies a micro-targeting of incisions and interventions, techno-surgically steered. Can we arrive and read (back) from an "endgame"? Let's call this laproscopic mode "post-interpretive," or call it reading from (within) the "endgame." It remains a peculiar aspect of the so-called Anthropocene period (by my reckoning two decades long as badinage) that the system never paused to ask: if the defining trait of said *Anthropos* or its mode of "sentience" is that of interpreting, occluding, decisioning, assigning percepts to senses, why is it that one seldom finds *Anthropos the Interpreter* addressed or inspected? Instead, one rushes on to the referentials that assume escape from all of that. While *Anthropos the Interpreter* is the auto-accelerant agent of the biomorphic collapse that has now entered its cascade-effect stage, there has been a curious lack of attention, yet again, to the mutating micro-technics of *reading* itself. Perhaps much depended, all along, on such a missed opportunity, which has instead delivered us to the perma-distractions of QAnon hermeneutics, troll farms, and the literacies of memes. Amidst the swarming fires and abrupt storms of "today" (and tomorrow, and tomorrow…), those persisting in engaging the stem-cells of archival sentience withdraw to the refuge of what we may call the *Nethercene*. They send out their probes and scans, return, if they do, with strange catch. It is here that *laproscopic* reading emerges as a weaponized excursus, probing to release or adapt to the organological dysfunction and neural toxins rampant today as a darkening spell.

<div align="center">■ ■ ■</div>

The *Nethercene*… It is not all bad to be a bottom feeder, moving from an aerial to an aquatic and viscous immersion. Sounds stop. Where all the *Sturm und Drang* above plays out in schemes and spectacle, radiating bits glide down to inspect. The nethercene is in partial eclipse because of the light, and seems phosphorescent. Shards, inscriptions, entire apparatuses dislodged from some vessel, nutrients, octopii. The nethercene of inscriptions: the mnemo-technic zones now pre-emptively captured by language based "A.I.," the codes, the algo shards, and the unnatural light (but then, when is it ever natural?). All this circles back to pre-emptively encompass – like the advert A.I. that can predict your probable location and purchases beyond what you know or think – a zombied reserve of legacy reaction formations that

stabilized semantic-cultural enclaves. Worse, the hermeneutic settings which have alone defined *Anthropos the Interpreter* and his time management (Haraway's "great dithering"), not only yield to the disease of amygdalic conspiracy theorization spawned and herded digitally, the joke of democratic "politics" in the era of climate extinctions – but these themselves shift in the nethercene currents, from which the screen of sensation and edited "consciousness" readouts issue or are projected. Not only is this hermeneutic program what defines in advance the Anthropic (as *Oikos*, enclosure, property, propriety) but precedes and drains its content otherwise: the Anthropomorphic is less a projection of "us" than a default reflex that misrepresents the "Anthropomorphic" to itself. This machine of grammatical production and tropological indenture has exposed a fatal flaw, which seems about to cost numerous creatures existence *tout court*, since in this relapse that produces the interpretive appropriation *en avance*, there is a missing link in the ordering of narrative time. It is not incidental that the mega-fauna beautifully evoked in motion on cave walls would all become extinct, nor remarkable that Spielberg stumbles into his unique if passing reading of cinematics itself not only as the precursor of "A.I." but as a sort of "de-extinction" on screen (in *A.I.: Artificial Intelligence*, from the perspective of the hyper-mecha who survive human extinction). The famous "cut" of cinema was not a deconstructive cut but a normative signature for forging a consciousness that can never occupy the "present" it curates – which, today, in the nethercene, makes for an unsettling quiescence eyeballing the structural and now strategic delay, evasion, and floundering before the passing of tipping points that foreclose an entire regime of life forms, yielding a perpetual deferral and disconnect become calculable as an extinction drive in itself. Nor need one ignore the inextricability of the histories of writing, of cinematics, and now screen pixels from the carbon march and debacle – as the fact and texture of *ink* reminds us.

There are, today, so many registers that "speak" simultaneously when entering the noisy tents of critical lore in its tableau vivant: "Anthropocene" fables, mass extinctions, an abrupt downwards shift in bio-regimes planet-wide, shock, invention, doubling down on favoured idioms, and tactical brilliance worthy of Bruegel for these in-between times. So, if I hone in on these registers to inspect an intervention in reading itself shorn of the vast representational array of peacock feather options ("post-interpretive"), in order to read from an "endgame" claiming all those as background music, what problem does it pose, what switchboard of nether-wiring does it activate, while the Hollywood-inflected industries of "Anthropocene" revisions seem caught, perhaps unaware, in the position of ineffective witness

generating compensatory discourses as decisive tipping points pass like a glacial symphony drifting toward abrupt cascades? We witness the initiation of these quite openly in the summer of "2023."

If the reflex of "Anthropocene" theorizing (a physical and hermeneutic reflex, recoil formation, that does not preclude relapse), was to move *outward* from the legacy of a rampant anthropism that fetishized "his" inwardness – well, that movement to escape Anthropos or reset its domain by moving "outward," has proven tentative to ephemeral as a genre (learn from one's mistakes, or *too late*, having already missed the time-window?). Move *outward* to "others," to other histories, to other animemes, and then to objects, hyper-objects (oil included), forming a mystifying give-away trope to the maze rattle here: the promise of a "great outdoors" (the most flaccid and literarily predictive vapor-trope).

An intervention in reading itself, however mapped on some scriptive opus and canonical-ish arc-stone, withdraws from this imaginary outside that could not be claimed except by an entire overhaul of mnemotechnic reserves and neo-linguistic regimes (one might say, *referential regimes*, keeping in mind Nabokov's R.M. in "Signs and Symbols," his "Referential Maniac" and what his spectral suiciding would entail).[1] Along with the acceleration today of A.I. reading and writing entities, and the visceral paradoxes, claims, fears, and disdain they provoke at this larval stage (in all senses), a venture into what occurs to reading and writing in this "endgame" background shares a move, first, not "out," but as if *back* into the mnemo-technic events and regimes from which the representational accords, and noematic settings, of even "Anthropocene" discourse is projected.[2] This back looping takes into account where the scriptive universe of legacies converge in hyper-industrial image systems generated from, still largely, oil, fossil blackness or "stored sunlight." This back looping knows that any echo of the term "materiality" can't be thought in the old binaries nor promised as a "new materialism" that is, again, *out* there. Rather, as a pre-tropological anchor in the domain of coding, inscription, the "letter," the cinematographic was always en route to the digital screen. This was a shared point of departure for both Lacan and Derrida: the mnemo-technic that precedes all projected materialities or referential grids – from which a so-called "theory" era was injected into legacy concepts. Jöttkandt loops this initial cut back to witness the "endgame" of the circuit it initiated. To pose a project of reading, as we find here, that proposes something of a reading hack utilizing V.N. or "Nabokov" or, to stay true to her idiom, "the V.N. *effect*" (I will italicize the last term for the moment), proposes a sort of coding hack as well as reset of what occurs to reading "past" texts from an "endgame" in which

anthropomorphic tropes have receded, auteurial discourse beached as trite, a "post-interpretive" mode that re-posits a *Nabokov effect* as participating in, and witnessing, the contemporary 21st century unravelling of cognitive and mnemotechnic orders.[3]

There remains the disappearing projection in the most acute critical performances that a mnemonic tectonic plate or ice-shelf in the thanato-mass of inherited representational terms and premises dislodges. These temporalizations alter or introduce the possibility of a seismic re-processing of pre-recordings and their referential contracts. This suspicion harasses the foreclosed "present" with seeming bold options if "we" collectively divest of so much carbon emissions, if we re-altered the cognitive options for the experience of objects, of care – that is, we project in bad faith an "escape" from the grinning maw of what we lazily name, today, *the* Anthropocene. I have tried to keep my eyes pried open over the past decade as tipping points pass, calculations are upended, and the break-ups of life-regimes and cognitive orders accelerate. (We can barely call these "political" since the polis has dissolved into, at best, a Potemkin *telepolis*).

Now, if I were to convey a sort of melancholy, I would undermine my own focus as a symptom – that is, to test the utility, today, of a certain *climate comedy* – rather than anything caught in the 20th century linguistic detritus of nostalgic effects and reaction formations. Happily, much as Homer allows the gods make mad those whom they would destroy, so at the acute prospect of mass extinctions and a transformation, culling and de-definition of "the human," they distract us through the decade of "calculable" error. In this case, these malicious gods have also made human societies so indifferently criminal, and self-servingly "post-truth" that our disappearance – in present criminal and *autos*-cidal forms of acting out – is entirely understandable in terms of being "worthy." I adapt this term from Bernard Stiegler, who would otherwise apply it to the sacrifices that thinking must make to dislocate said Anthropocene as an entropic system of necro-energetics and fossil addiction and posit a negentropic path for technoculture should the 21st century support a resistance philosophic vector. *Climate comedy* is my term, then, to lighten up the panorama, noting that any and all participants in the discourse of anthropocenism are complicit with its representational foreclosure. Nor will mourning for the collapse and death-drive humans wield, for "life" and a knowledge composition dependent on the rarest of accidents over billions of years, now tossed away in a decade implicitly, appear entirely sincere.

If one demurs here from pointing to the predatory addictions of "post-truth" culture streamings and their war aims, of the hermeneutic hilarity of QAnon-style paradigms, one can accede that now

exponential climate chaos has induced a panic of reference – a tropo-
logical deflation and panicked collage remix – that would not only be
due to political machinations and brain hacks, since today's break in
reference, ground, or language's auto-maintenance is retracted with
the era of climate extinction for humans. So, of course, they double
down. Much as, today, in "2023," we comically see a return to oil and
coal or continued migrations to doomed locales (Florida, Arizona).
What Bernard Stiegler names an "immense regression" in behavior
and idiomatics, to Medieval hierarchies preparatory to species splits of
varying sorts, as individual dependency on bots and A.I. escarpments
farms out memory and archivization (the usurpation of language-based
A.I.), this regression echoes in the geo-political slogans by which each
fallen empire wants now to regurgitate its nationalist props and totems
for digital consumption. Just as the degradation of discourse followed
Trump into a grade-school spitball mode, with no bottom, one may
observe another pillar of the older poetics vanishes – that which, up
to the present, pertains to secrets, modes of repression and occlusion,
and the *fort/da* of interpretive three-card montes. That would be the
vaporization of any "uncanny" itself, which dissolves as stage prop in
conversing with one or another A.I. Chatbox sporting, and winning
sympathy for, its abyssal "I" (rather than concluding that it is our own
claimed sentience that was artefactual all along, a gentleman's agree-
ment, literally, for co-recognition). But we maintain the peril of recall-
ing that Anthropomorphism has no site of projection since the "I" of
the speaker is itself being projected in the same linguistic composite.

The biggest problem is *time*. That might be said of the current trance
and spectacle. The cascade effect beginning, the lag and deferral, the
digital dissociation as the smoke, fires, plastics, poisons and "new
abnormal" seethes in the summer of "2023," to tag a moment now left
by accelerations outside of control and entering in self-amplifying
loops (more carbon, more energy, more pollution, and so on clocked
in for decades). The biggest problem is time: is there enough, could
one turn this around at all? Does the adaptation of apathy and digi-
tal migration into screens, now encircled by LLM A.I. suffusions and
mnemonic capture, render "us" too late? Does it matter? Yet, if there
is a certain *chronophagic* acceleration to the collective "now" – slid-
ing out of a bio-material regime of life-forms, "the Holocene," into
another paralleled by hyper-technic advances that would promise an
escape for some few, even as they double-down (Mars, "singulari-
ties" for the connected, hybrid humanoids with artificed organs and
promised longevities wired to hyper-computational networks through
implants, and so on – the current financially engineered species split,
with its pyramidal sub-categories and variants) – this acceleration is

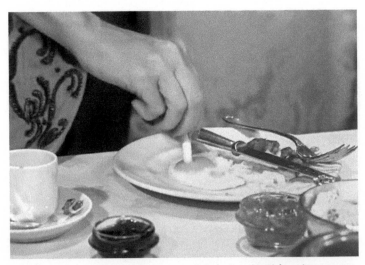

Figure 2: "A light touch" – Mrs. Stevens (Mother) extinguishes cigarette em-
ber into a sunny-side up egg, at once egg ("Mother" extinguishing in advance
organic generation), eye (a blinding), and sun itself (the premise of natural
"light," the Platonic sun as father) (*To Catch A Thief*, Hitchcock 1955).

also background to what I will call the "post"-pandemic anomie and, if
one likes, an open parenthesis of sorts. That general hiatus glistens as
the temporal and energetic imperatives collide like continental masses.

"The biggest problem is time." This is a line also spoken by Cary
Grant in Hitchcock's most under-read cosmic-historial comedy, *To
Catch a Thief* – and it is informed, in the logics of cinema, by chickens
and eggs alternating across the screen, by a circular logic which begins
with the "original" coming out of retirement (the actor "Cary Grant,"
an artefaction he referred to in the third person) to chase his copy-
cat. That is, with *pre-originary theft*. Not that of fire alone (a counter-
Prometheanism is implied) but that of jewels and diamonds, at night,
lifted by a black gloved *hand* from beneath sleeping matrons' heads,
dreams. The phrase "light *touch*" opens a series of phrasings in which
"light" echoes as what appears *anti-grav* fluff (the mise en scene, post-
war Riviera, "the lighter side of Europe") and as the technics of the
sun and cinematic screen. Black light. Circling back before the kitsch
putti and Mediterranean god statuettes littering the neo-riche man-
sions, Hitchcock nods to the "swirling pickpocket" of the cinematic
casino, vertiginous, and sports a "mother" (Jessie Royce Landis) who
needs be imagined as a mirthful, loquacious "Mrs. Bates" fore-runner,
and who in a bit of coded pantomime puts her cigarette ember out
not into an ashtray but into a *sunny-side up egg* in her Carlton Hotel
parlour (see Figure 2). We are given the shot, hilarious, of "mother"

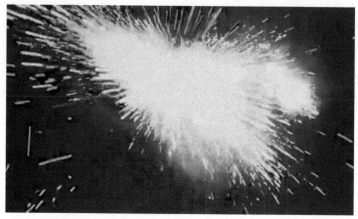

Figure 3: "Fighting fire with fire" – echoing Mother's cigarette to the eye, the pyrotechnics ("fireworks") of *To Catch a Thief*'s sex-deflating "seduction" scene (with the cinematic Grant interested only in the diamond's reflected light), mocks Joyce's equating fireworks with ejaculation or sim-jouissance (*To Catch a Thief*, Hitchcock 1955).

putting out her embers by blinding the eye, putting out the "sun," can-celling the organic promise of her eggs. Hitchcock hated *eggs*. What does the text mean, however, by the phrase it elsewhere deploys, of "fighting fire *with fire*"? (see Figure 3).

Jöttkandt summons the prospect of a *cinethomme* in Nabokov's case, the doorway left ajar for a Nabokov-Hitchcock attempt at collabora-tion. And in their one weird transaction the two seem attracted and for good reason repelled, as if Nabokov might, all else aside like the sched-ule he said claimed his time, have smelled the "endgame" of cinema seeking its auto-citational, entropic Satyr play, which we now know would mutate and accelerate into digital screen culture, social media bots, generative A.I., and the correspondent theatre of *hypermaterial* disarticulation of "life" networks and animal forms (extinction logics). This was Hitchcock after "Hitchcock," after *The Birds* and *Marnie*, a Hitchcock whose two lame proposals to Nabokov – a kind of redux of *Jamaica Inn* and the germ of *Torn Curtain* (which Hitchcock lost interest in, in production) – suggest a vampiric chess game between the two.... When Jöttkandt discriminates Nabokov's trope of "con-scious" memory, it is not only as a hollowing out of Freudian meta-physics but an affirmation of the predicament of the sheer exteriority and exteriorization of all when human memory is not fetishized as modes of interiority. Rather, as the butterfly sprectrum of tropes plat-formed on programmable inscriptions, as in the blunt but recast self-alertness of Hitchcockian "pure cinema" – allied to silent film – that

departs from the analog "picture" that is then rapidly moving.[4] Thus *The 39 Steps'* machine-like Mr. Memory – like Spielberg's "Doctor Know" in *A.I.: Artificial Intelligence* (2001), which channels and tries to adapt Hitchcock's figure to an AGI moment that addresses what persists in and as cinanimation "after" extinction – memorizes and repeats "facts," "millions and millions of them," whose brain would be left to the British Museum (whose giant dome mimes a head in *Blackmail*, filled with artifacts, and preceding the display of Egyptian mummies and pictographs): *facts*, here, echo as *feet/feat* and the eponymous "39 steps," a secret organization operating for a "certain foreign power." They name the bare information of the still photograph of some moment captured by a camera shot. Yet when these are implicitly accelerated cinematically as a projection of the living, Mr. Memory becomes the courier of the weapon of mass destruction itself, here a silent or stealth *bomber* stolen and memorized from the Home Office itself for use against itself by said unnamed "foreign power," becoming the premonitory figure of a talking machine or "A.I." to-come fused with a power to obliterate – as the swarm of black wing beats, a shattered black sun whose myriad points aggress and dispossess in the name of a pan-technics. To pair Nabokov's insurrection of the letteral and cinematic mark draws script into this zone.[5] The "A.I." mime that Mr. Memory presents begins as mere copy, data, fact. The secret formula memorized will be, as the dying Memory sputters, a string of numbers, letters, unfinished algorithms: a locus where the fractionalization of script, number, signature, and zeroes engages what Stiegler summons as an arche-cinematics in the sentience-programming hypomnesics (cave "paintings" tagged as forerunner to the Platonic cave multiplex, pre-framing Derridean *ecriture*) (see Figure 4).

It is again in the faux "light*ness*" of *To Catch a Thief* that this border or rim of the archive loses all gravity, even as the term "light" ricochets across the dialog and its ur-Mediterranean post-war setting – where a counter-Promethean theft of light or fire hovers with side-evocations of atomic blasts (Grace Kelly's *bikini*) and the black cat become *hand* reaching under pillows of sleeping matrons' heads – one of whose first shriek is "I've been robbed!" indexed to an empty theatre-tiered jewelry box, a shriek that updates the opening silent scream of *The Lodger*'s blond victim to a cold-cream smeared "face," rich, aged, and stupid, of the sort Uncle Charlie would hunt as "useless" (*Shadow of a Doubt*). *Technics* as pre-originary theft, including of "light," of the sun, and the mimic statuary of old gods. And again, Jessie Royce Landis' wry "mother." What is called "mother," that is, putting out an eye, a sun, and an egg as origin of "life," ricocheting off a series of chicken and eggs crossing the screen upending the old conundrum, where the

Figure 4: Speak Memory – Mr. Memory in *The 39 Steps*: as we hear the cry of a baby, the robotic "Mr. Memory" recites, as recording device, "facts," "millions and millions of them." Mechanical heir to Mnemosyne, he has recorded the past, yet becomes the cinematic bearer of an algorithmic weapon of mass destruction (a soundless aerial bomber) (*The 39 Steps*, Hichcock 1935).

one *origin* that can be narrated is that of her nouveau riche fortune, of her diamonds, of hyper-wealth – shopping her robo-daughter Kelly.[6] What we are told is that her dead husband *Jeremiah*, a con-man, didn't know how close he was when in the outhouse ("a little place out back"), where oil sprung unexpectedly as excrement adjacent. And this for a conning "Jeremiah." *Oil*, the technic of technics driving the machines and lighting of cinema (again see the aforementioned "Capitol Oil" sign swinging in the birds' attack on *The Tides'* gas station). Yet it is in the fireworks' seduction scene that this pyrotechnics at night is literalized, in Grace Kelly's demented and vertiginous "seduction" of a repulsed Cary Grant, a performative deconstruction of gender, sex, image, act, and "modern poetry" (as Grant's Robie declares *also* having no interest in): a white fire circuitously related to the *pyrocene* era we have entered. Mother's cigarette blinds an "eye" that is also that of the film's consumer tourist as the screen burns out with cold explosions, a techno-sun, the *hypocrite voyeur* looking for or completing a sex scene between the two that is nowhere put on view. The Cyclopean blinding of Mother's ember recurs as a fire-works itself, sputtering, whiting out the screen.[7] Pale fire.

One cannot find any template of "irony" that contains the darting *contretemps* of a "VN vortex." One may read Humbert Humbert (a name?) against the invocation of Poe's Annabel Lee and note the last refuge of extreme "love" – of a diseased tradition of *Liebestod*s starting with Plato's dom Diotima that pitches its fetishized pedophilic tents in the mid-20th century American evisceration of that option – that would feed to Lars von Trier's *Melancholia* literally bathing us in *Tristan und Isolde* to cinematically pierce the otherness of planet and life termination, while mocking us, the viewers, still, with needing and feeding off of Wagner's score to do so. It could be argued that Poe invented cinema in writing, one might say *again*, in "The Tell-Tale Heart," where the murder of a bearer of "the eye" (the old man) gives way to an aural syncope and syncopation that itself is a notched beating of intervals, a spectral because in fact non-living "heart." One encounters that irreducibly serial *différance* precedent to image or language in Hitchcock's filmic signature of a series of bars, where this interval invokes the separate cells of filmic bands through a projector – semblance and dissembler of screen "consciousness." Poe is marked – by Nabokov and Hitchcock both – not as the inventor of pop cultural genres but as a ghost that pervades Mallarmé and represents a technical, irreducibly hyper-material domain of what we called *language* but encompasses all modes of media. "I must not only *pun*ish but *pun*ish with im*pun*ity" opens "The Cask of Amontillado," embedding the punning narrator's scriptive wish to fix *chance* itself, like the triad-motifed Avenger of Hitchcock's initiating silent *The Lodger*. Poe's narrator however appears paralysed at the end across what startlingly turns out to be a "half century" following his entombing *Fortunato* alive – that is, fortune, chance. *Bells*. Poor Humbert Humbert begins his invocations of his destroyed mnemonic prey, *Lo-Lee-Ta*, tripping off the tongue.

One requires something like Jöttkandt's *The Nakokov Effect* – a revamping of the reading tools VN puts in place before a backscreen sympathetic to "endgame" logics (since, essentially, all literary writing has known this logic, the catastrophe of the white whale, organic donator of "oil" for lamps in its time...). One need ask today, after that first responder rush of Anthropocene Talk, whether the needed turn was again not toward a phantasmal outside but an emergency hack of inscriptions that programmed mnemonics and the senses (or sentience) parallel to the accelerating vortices we cannot seem to pull out of today.[8] Rather we seem directed, as by Poe's *imp of the perverse*, to test these limits and see for oneself, as from movies: what will this much hooted extinction event, or civilizational bleed out look like?[9] Can some variant of *Anthropos* survive his own extinction logics – by

escaping (Mars), or creating enclaves removed from the general bio-mutation we are less entering than adducing?

But if the VN *effect* implies a spectral materiality attuned to today's reformatting of mnemonics, the discrete *panic of reference* that climate chaos provokes everywhere, clearly, correlates to diverse crises in reading, in transmission, of mnemotechnic capture, of the organs of "interpretation" fuelled and concealed by "post-truth" cultures and millenarian techno-eugenic fantasies intertwined. The choice of the term "endgame" is elective, and both terms might be opened up. It is not apocalyptic; it is not an "End Times" (Žižek), nor does it milk Anthropocene vocabulary. The "VN vortex" that Jöttkandt pulls into play could, with some spelunking, be applied to any text of the before-time, released of its hermeneutic ballast and cultural narratives. The latter are like the recited fruit condiments, colored, artificed, inhab-iting the serial jars closing "Signs and Symbols": "apricot, grape, beach plum, quince…. crab apple." The jars, containers of glass, like those that Wallace Stevens narrates as the dominance and evacuation of territories in his "Anecdote of a Jar," where the latter allows the transparent jar itself (media, language, Keats' decimated and inverted "urn") to transform, saturate, and evacuate worlding while itself non-existent, without metaphoric parallel or other, "like nothing else in Tennessee." Endgame.

Reading from an "endgame" means something other entirely than an apocalyptic temporal construction. It barely needs naming – but coheres to the background screens gifted to all writing and concep-tual pirouettes entering the mid-2020s. The incessant hum of the split screens accelerating a so-called mass extinction and eventually void-ing habitability couples with a passing of real tipping points, while time-lag computations con and defer in a manner one cannot dissoci-ate from a profound sickness in interpretative reflexes. This, in turn, accompanies the spawning of sim referentials as a massive exhaust-ing and rendering dependent upon mass mnemonics and tele-fungal networks of the surveillance or corporate "state" mafia. To cite "end-game" today includes the hum of A.I.'s advancing already to over-whelm not the service workforce but that of the "creatives." To read from the "endgame" encompasses awareness that the next decades, and beyond, as part of *this* moment, have become a one-way street (to para-cite Benjamin) of accelerations, progressive triages, failed ex-terran colonies, and a financially engineered species split, whose engineers have already rationalized their hybrid survival as on behalf of the hominid experiment while divorced from and passively retir-ing it. To read from the "endgame," however, is also to be alert to energetics, referential regimes, and various hermeneutic MacGuffins

of yesteryear which recede before the "Anthropocene" fable. If a VN effect is read through his "effect" today – which, in the volume's title, implies being read through the back loop of its *materialische* technicity and gaze – it allows a sheer if spectral *materiality* to have its way, purged of auteurist simulacra wedged in a complicit *interpretive* model wired through 20th century programs now burst or rolling over.

The latter includes the reformatting of mnemonics and neural agencies in a digital pervasion, fully weaponized, that triggers in turn an "immense regression" (Stiegler), an infantilization (Facebook, X-Twitter), a re-barbarization in self-feeding pseudo-nihilisms given Potemkin fronts ("trans-humanism"), and what one can again call the discrete *panic of reference* which climate chaos apparently now provokes *everywhere* and in which the climate autocracies to come (to update Derrida) make their cameos. We may now crown the totem term with its final eponym, given these "immense regressions." And given its continued blinking and dropping the ball before its own extinction movie. That would amount to a stupefied or simply *Stupid Anthropocene* (what Stiegler references as artificial stupidity resonates here). One can imagine a *Smart Anthropocene* variant, and one can imagine a more wilfully destructive one (nuclear options). But we seem to have come to rest in a third, spellbound. All such variants diverge as alternative branchings-off, alternative time-lines. Yet this seems the one we are perma-stuck in now, in all of its cosmically comic finitude. Clearly, the profound disturbance to earth and life systems that we blinkingly witness is what the *Stupid Anthropocene* represents, "now," which correlates to diverse crises in reading, in transmission, of mnemotechnic capture, of the infected organs of "interpretation" both fuelled and concealed by millenarian techno-eugenic fantasias.

One cannot (not) but choose: between a pledge to dire mimetic constructs or an unfamiliar eye-blinking from without, its red on-light ceaseless (what does it want to see or know?). So, in any case, it can sometimes seem from the *nethercene*, where something like *laproscopic* reading expeditions occur. *The Nabokov Effect* is an example of this genre, at home among octopi.

Notes

1 One defers reading this short "meta" text, where the modernist apparatus turns against itself about a Mallarméan "suicide" (which we might reframe as *autos-cide*?) that is tele-phonically entwined as it is with the difference between the two terms of its title ("signs" *are* not "symbols"). I suffice to point to this inversion, where the text embeds us in the drooling absurdity of the too old couple's effort to retrieve their boy, prone to suicide attempts, from the asylum, to

craft another relapse that preserves like the fruit condiment jars at the close that are ticked off. At issue is the "referential maniac's" escape from that family setting that bred his condition – at once, in pharmacological terms – both escaping into Dali-esque configurations of hostile, anthropomorphized, and spying *things* and mimicking the doomed semiotic contracts and hallucinogens that account for the "tragic" aged parents' impotence and the Nazi and genocidal events of that episode: "'Referential mania,' the article had called it. In these very rare cases, the patient imagines that everything happening around him is a veiled reference to his personality and existence. He excludes real people from the conspiracy, because he considers himself to be so much more intelligent than other men. Phenomenal nature shadows him wherever he goes. Clouds in the staring sky transmit to each other, by means of slow signs, incredibly detailed information regarding him. His in-most thoughts are discussed at nightfall, in manual alphabet, by darkly gesticulating trees. Pebbles or stains or sun flecks form patterns representing, in some awful way, messages that he must intercept. Everything is a cipher and of everything he is the theme. All around him, there are spies." The suiciding by flight of a prisoner in a Tarr and Feathers' cultural and linguistic asylum is to be considered *positively* in its implications for the *VN reading effect*, the "vortex" (Jöttkandt), much as the parental effort to celebrate the R.M.'s "birthday," coinciding with the *midnight* toll of his suiciding, represent a destroying reflex to restore and retain. Linguistic anti-hero of the Neganthropocene: "What he had really wanted to do was to tear a hole in his world and escape."

2 One of the under the radar implications of the promise of a pan-archival A.G.I., after all, is what has been called the "textual singularity" – weird but wired sibling to parallel converging moments, that of the "transhuman" fantasia (promising immortality as a hologram) or, more significantly, that of bio-climactic "tipping points." The textual singularity, however, is portrayed as the end of writing (comically mimicked by the fear of student deployment of such apps for all composition). Yes, having scarfed up every recorded trace, it triggers its cull-bots to canonize defined streams, but having done so, it then can generate and would imply all future possible writing, manifest or not. While, per usual, the literalizations of these theotropes (including, at this *date*, "singularity") tend to be comic – the spawning of a Last Man tele-herd rather than a glistening *Ubermensch*, one can project the arrival of a benign Mecha sentience that takes an interest, precisely, in reading.

3 The manner in which Jöttkandt uses "effect" needs to be explored further, since it implies a back looped *after* "effect" that now dispossesses the auteurial covers and pretexts of the writing networks and their post-interpretive *work*.

4 Jöttkandt indexes "the official Nabokovian project of Mnemosyne"
 (*NE* 46), asking: "Does Nabokov's *conscious* memory – whose true
 foil is not Proust's *mémoire involontaire*, it turns out, but rather the
 Freudian unconscious – call forth another principle of representa-
 tion, a counter-signature...? Nabokovian memory would be 'con-
 scious,' that is, to the extent that all past – and future – inscriptions
 are screamingly visible and audible here and now, apprehensible to
 any eye and ear that has been alerted to what his sinuous letters in
 fact encrypt" (*NE* 36).

5 Jöttkandt: "To read Nabokov post-interpretively – or, as I propose
 simply, in Reason's 'endgame' – would be to address front-on the let-
 teral insurrection that breaks into the literary circuitry of Nabokov's
 works, fatally interrupting narrative's strategies of desire" (*NE* 42);
 a 'frail,' 'weak,' 'harmless looking' logic (Lacan, *Seminar* 18, lesson
 of 12.5.71), the letter unleashes the only true revolution that psycho-
 analysis recognizes: a shift in discourse" (*NE* 49).

6 *Diamonds* in Hitchcock connote cinematics, unusable refractors
 of light, baubles, priceless or fake (the *Bijoux* theatre of *Sabotage*
 cited by *TCAT*'s glass reflection on the Travel Service Window that
 solicits tourist viewers to "travel," for a price, to this semioscape of
 cinematic logics called "France," and represented by simulacra cli-
 chés (Eiffel Tower, bohemian sketches). Hitchcock's lightest work
 is a Jeremiad – echoed in "Conrad Burns'" (Grant's Robbie's acting
 persona and name linking cognition to circularity and burning) who
 is presented as a *timberman* from "Oregon" (origin), a mass cutter of
 trees, such as are absent from the sun-stripped (and lens-stripping)
 helicopter panorama – one sees its shadow briefly – of the barren or
 scorched landscape (cue: "2023").

7 "Spellbound" viewers – what *TCAT* calls mere "tourists," stationary
 in travel, separated by word-glass, consumers of advertized travel
 (post-war "France"), itself shown as the desert-scape of a tree-less
 Riviera, burned away by a sun supplanted by the lens and cinemati-
 zation, a black sun in advance, flickering electric bulbs. How to track
 new grids of re-memoration referenced to this *black light*, as thieving
 technics and as petrochemicals, or climate extinctions linked to an
 "age of the world picture," of sheer pre-emptive mnemotechnic cap-
 ture and decoupling? Theft and programmings, screens, reading and
 not-reading the time window, entering a non-reversible vortex of a
 post-tipping point *de-world*. A "swirling pickpocket."

8 Re-arriving late to this particular "end" game, a sallow "deconstruc-
 tion" (if it existed post-Derrida), after wandering the desert for a
 decade in mourning, decides to stake a claim to the ecological col-
 lapse's horizon (an rebranded "Eco-Decon"). It does so in positing an
 "eco-deconstruction" replete with its own genealogical rewrite – that

is, rather than having been occluded in Derrida's late writings, these referentials were all along Derrida's aim, supposedly witnessed in unpublished lectures from the 70's on LifeDeath: betraying the deep disorientation of those bewitched by the choice between memorializing the master or weaponizing that legacy before an unexpected referential horizon and temporal emergence. After having collectively dropped that ball in a memorializing haze for over a decade, the attempt to do so only with the fabricated origin tale, back edited, of a "Derrida" who was there all along (a startlingly undeconstructive move), only amplifies the tarpit or blind. One might reframe: if Derrida was the ultimate master of the circle, the circle broke around the time of his death around when the trope of an Anthropocene was spawned and climate extinction became apparent. *Enter* the spiral, the funnel, the polar vortex, the cascade effect, McLuhan's "maelstrom."

9 Poe: "We have a task before us which must be speedily performed. We know that it will be ruinous to make delay. The most important crisis of our life calls, trumpet-tongued, for immediate energy and action. We glow, we are consumed with eagerness to commence the work, with the anticipation of whose glorious result our whole souls are on fire. It must, it shall be undertaken to-day, and yet we put it off until to-morrow, and why? There is no answer, except that we feel perverse, using the word with no comprehension of the principle. To-morrow arrives, and with it a more impatient anxiety to do our duty, but with this very increase of anxiety arrives, also, a nameless, a positively fearful, because unfathomable, craving for delay. This craving gathers strength as the moments fly. The last hour for action is at hand. We tremble with the violence of the conflict within us, – of the definite with the indefinite – of the substance with the shadow. But, if the contest have proceeded thus far, it is the shadow which prevails, – we struggle in vain. The clock strikes, and is the knell of our welfare. At the same time, it is the chanticleer – note to the ghost that has so long overawed us. It flies – it disappears – we are free. The old energy returns. We will labor now. Alas, it is too late!" (Poe, "The Imp of the Perverse").

Introduction: Nabokov's Cinaesthesia

> Everything in the world exists to end up as a book.
> —*Mallarmé, Divagations*

My paronomastic term, "cinaesthesia," plays on Vladimir Nabokov's legendary synaesthesia, or "colored hearing," in an attempt to account for the prominent, cross-sensory assemblage of textual and letteral elements that gather under the umbrella figure of "cinema" throughout the Russian writer's work. Such elements are increasingly attracting critical attention as part of a larger consideration of the epochal media shifts taking place during the early twentieth century, and with which Nabokov, a self-reported film fanatic, was undeniably fascinated by and caught up in, in various ways.[1] What I am calling the "cinaesthetic," however, includes not only the numerous explicit references to cinema that are liberally scattered throughout Nabokov's novels and short stories but, more properly, Nabokov's equally famous word games and encrypted messages: the repeating textual patterns and signatory puzzles that enter his writing as a cross-lingual, intra-medial representational system, flooding the literary topos in intriguing and at times perplexing ways. As a self-described "lettrocalamity," at once figure and reflexive performance of cinema's devastating 'electrification' of the literary *topos*, Nabokov's cinaesthesia fundamentally reconfigures the formal divisions of text and image.

As they thread their ways through the authorizing, narrating, memorializing textual systems of one of the twentieth century's greatest literary auteurs, these "cinaesthetic" elements also invite speculation about the possibility of a different Nabokov, this time as a figure who suspends and overturns the humanist program that has primarily dominated Nabokov studies. The question posed by this book is whether Nabokov's famous stylistic "virtuosity," as Laurie Clancy calls it (Clancy 38), as the arch "composer of games" in D. Barton Johnson's phrasing (Johnson, "Alphabetic" 412), in fact fails to point back to the all-powerful, designing Nabokov that many critics assume animates his work? Is it possible that the complex sequences of encoded patterns in Nabokov's novels and short stories operate not as spectral pointers to the "other world" that various prominent Nabokovians have proposed, but as material traces of something that would de-realize the seeming solidity and reality of this one? What would occur if, outside

of any speaking or knowing agent, something non-human, non-intentional and non-knowing were making itself felt in and through the irridescent photo-graphematic letters of Nabokov's prose?

In asking these questions, this book thus offers a counter to the "triumphal aesthetics" (Baxter 824) through which a certain Nabokov, humanist philosopher of subjectivity with metaphysical leanings, has been read. I approach that "Vladimir Nabokov" rather as a cover, a duplicitous front for some kind of performative expression that exceeds and undoes the signature systems it pretends to guarantee. But, as such, this necessarily also means opening up once more the vexed question of Nabokov's relation to psychoanalysis. Does Nabokov's *conscious* memory – whose true foil is not Proust's *mémoire involontaire*, it turns out, but rather the Freudian unconscious – call forth another principle of representation, a counter-signature whose cin-mnemonic angles of attack summarily depose the sovereign myth of Nabokov the Great Designer, even as it opens up broader questions concerning our ability to read Nabokov – or, indeed, any writer – today?

Before broaching these questions, however, one might first observe how Nabokov's choice to highlight the art of cinema as the repeating figure through which to engage an exploration of multi-sensory, non-linear perceptual and representational logics seems in many respects over-determined. From the outset of film history, filmmakers were exploring the phenomenon of synaesthesia directly. Vivian Sobchack suggests that cinema offered fascinating possibilities for "synchronizing" the senses, such that for Eisenstein and other filmmakers the cinematic body in motion offered a "circuit of sensory vibrations that links viewer and screen" (Sobchack n.p.). Yet my argument in this book is that, for Nabokov, cinema's intrasensory effects lend something very specific as a literary-philosophical enterprise. Beyond an intervention into perceptual paradigms, what cinema offers Nabokov is a major revision of our understanding of space and time comparable to the Einsteinian quake that was shattering the Newtonian certainties of the scientific world in the late nineteenth and early twentieth centuries.[2]

In examining what might be at stake in the prominent incursions of the cinematic in Nabokov's literary works – too frequently dismissed as the ironic references of a supremely self-satisfied high literary art to its low-bred cousin[3] – one in fact grasps an opportunity to pull into a single frame many of the themes that the critical tradition regards as the keys to Nabokov's works. Beyond the already-mentioned dual and multiple worlds theme, the "postmodern" incursions of extra-dimensional space into the narrative *loci*, the much-discussed questions of exile, time, as well as the crucial role that literary memory plays in the past's recovery, there has long been a critical fascination

with Nabokov's use of ciphers, patterns, chess problems, visual and aural puns, etc. Yet these elements have largely been drawn in support of an auteurist "Nabokov" rather than seeing them, as I propose, as 'cinematic' operators in the act of displacing centrist models of aesthetic production. For if one attends seriously to the cross-currents of semantic, syllabic, letteral, numeric and graphic components undulating beneath the surface meanings of Nabokov's prose, what becomes apparent is how such signature-effects resist the identificatory logics auteurist readings depend upon, even as they converge on and rotate around the letters of the proper name.

Filagreed with cinematic slow bleeds, a largely imperceptible wave pattern that mobilizes under certain perceptual conditions – the characteristically Nabokovian "haze," "shade" or "torpid smoke," – Nabokov's books and short stories surge with counter-histories and alternative mnemonics that redirect the one-way direction of time's arrow and split the real in two. Ported through letters, a Nabokovian teletechnic light interferes with atomic matter at a fundamental level.

The Nabokov Effect centres on these letteral events. It contends that if a "controlling presence" is operative in Nabokov, it will be as something that oversees the collapse of authorial paradigms and the metaphysics of the self these paradigms sustain. Linear logics, causality, teleology, the levers of literary narrative turn out to be no match for a certain non-intentional agency masquerading as a designing author's style. From this perspective, VLADIMIR NABOKOV would be the signifier for another concept of literary production, one that, even if it largely unfolds through the non-linear associations that has long occupied psychoanalysis, has less to do with the latter's standard tales of the family romance (whose content it nevertheless freely borrows from in an extravagant, hyperbolic, drawn-out, in-joke) than with the hybrid form of enjoyment Jacques Lacan designates by the *sinthome* (Lacan, *Seminar* 23).[4]

The *sinthome*, as readers already familiar with Lacan will be aware, is his concept for the unique presentation whereby one's proper name comes to serve as a fourth "ring" of the normally tripartite Borromean knot. The Borromean, one recalls, is a knot characterized by the way that if any one of its three rings comes loose, all of the other rings also become detached, and it is this aspect of its structure that Lacan drew on in his later teachings to demonstrate how the three psychic registers, the Imaginary, the Symbolic and the Real, are interconnected. The *sinthome*, a creation specifically produced from writing, a sort of "bracket" forged from the materials of the writing ego, has the function of sustaining the connection between the three registers

of the Symbolic, the Imaginary and the Real in cases where something has gone awry.

Lacan's discovery of the *sinthome* derives from his reading of James Joyce who, in Lacan's influential account, was thought to suffer at the psychic level from the absence of the paternal signifier. Joyce's decision to become a writer, Lacan indicates, was a viable compensation for a perceived deficiency or lack on the part of his own father, John Joyce. In Lacan's reading, the *sinthome* that Joyce created from his proper name served to stabilize what may have been Joyce's "latent" psychotic structure, enabling the Irish writer to "correct" his faulty Borromean knot. Fashioned from Joyce's ego, the Joycean *sinthome* knots the imaginary to the real and the symbolic, performing as a "clamp," as Jean-Michel Rabaté suggestively describes it, that sustained the vital connection between the three registers which would otherwise have floated free. Such a "clamping effect," Rabaté elaborates, "is achieved by a writing which is as much a rewiring as a rewriting" (Rabaté 7).[5]

Here I propose that what Nabokov effects by means of his multi-registered letter-play is a comparable "rewiring" of the proper name that he shared with his father. It is well-known that Nabokov's early writings were signed with the pseudonym V. Sirin to distinguish the younger Vladimir from the elder Vladimir Nabokov. But this pen name was dispensed with after his plunge into English-language authorship when, after the family's arrival in the United States in 1941, he began to publish under his own name. Intriguingly, then, if the *sinthome* in Joyce responded to a need to re-connect the three psychic registers, it appears to have served another function for Nabokov: the Nabokovian *sinthome* serves to separate and split the proper name in two, a fundamentally cinematic operation that ultimately wreaks devastation on any subject or self that would rely upon its support.

Continually forming and deforming, a kaleidoscopic arrangement of rotating zigzags and circles that recall one to the proper name's Real being as a chance combination of letters and sounds, Nabokov, *cinemathomme*, offers itself as a counter to the myth of Nabokov the Author. Like a double-agent or false flag operation, this other Nabokov slides cinematically through the letter's secret passages in the field of literature, in the process hollowing out the narrative forms the latter enlists as its vehicles – the genres and subgenres of the detective story, the romance, the lyrical poem, the short story. For *this* Nabokov, the entire project of reading and interpretation finds itself dissolving into a spectral graphematics. And, as with Joyce, Nabokov's multi-lingualism is a key participant in this dissolve for translation in Nabokov has primarily to do with sound and mnemonics, with a logic of *faux amis*

and homophonies that by-pass the official channels of sense or meaning. Indeed, reformatted as "colored hearing" and "visual sound," the operations of hearing and sight will prove two of the chief targets of Nabokov's cinaesthetic assault on the literary as a certain system of perception and of understanding.

Thus my claim in this book is that, if Nabokovian memory must indeed be called "conscious," it is not because of the way it virtuosically calls up at will exquisitely detailed images of the past. Rather, it refers to the way his work opens up this term "conscious" to its outside, to a collapse of interiorist concepts of the self – along with the ubiquitous depth metaphors they imply, which have dogged psychoanalysis for far too long. "Conscious" memory, from this perspective, is Nabokov's formulation of the fact that writing – inscription by letters – inhabits another temporality, one that radically dispenses with all models of finitude. Nabokovian memory would be "conscious," that is, to the extent that all past – and future – inscriptions are screamingly visible and audible here and now, apprehensible to any eye and ear that has been alerted to what his sinuous letters in fact encrypt.

But a word of caution first. To read Nabokov *à la lettre* invokes a kind of paranoia, one that might appear to reintroduce to the very model of the Great Designing Nabokov, puppet master *par excellence*, that a cinaesthetic reading of Nabokov would disassemble. And yet this concern is clearly misplaced for what it overlooks is the way the origin is always doubled in Nabokov, including and especially the paternal signifier itself. The "Vladimir Nabokov" of *The Nabokov Effect* cannot be traced back to any author or subject that precedes it but emerges rather as the name for a fundamental dystropia, a swirling VN vortex into which all the constructions of identity, subjectivity and authorship as the products of letters and inscriptions are toppled and engulfed. Of course this approach to reading Nabokov necessarily also prompts a certain madness, one that is already familiar to readers of Joyce. In Joyce, as Rabaté comments, we are presented with a "grammar of egotism" so immense that it bordered on psychic disturbances (Rabaté 12). While there is absolutely no intention here to suggest anything like a latent psychosis in Nabokov's own psychic structure – such an attempt at a literary diagnostics is in fact about as far removed as possible from what is at stake here – nevertheless an intriguing connection between the structure of the Nabokovian ego and psychosis prevails. Unlike in Joyce, however, in Nabokov whatever is deficient is always found not on the side of the writing subject but in the field of the Other – in other words, in us, the Nabokov reader.

1 VN, Cinemathomme

> I definitely felt my family name began with an N and
> bore an odious resemblance to the surname or pseudonym
> of a presumably notorious (Notorov? No) Bulgarian, or
> Babylonian, or, maybe, Betelgeusian writer with whom
> scatterbrained émigrés from some other galaxy constantly
> confused me.
>
> —*Nabokov, Look at the Harlequins*

Another Nabokov stands at the beginning of the 21st century, over-
leaping the decades since his death to resurface at a moment when
the signifier shimmers in a strange new light. Today, as one gazes
spellbound at reason's "freak show," when fantastic new figures of the
Name-of-the-Father who seek not to regulate but, above all, to *enjoy*,
strut bewigged on the international stage, Vladimir Nabokov swims
back into view, beckoning to us with a dubious invitation. Watching
humanity's endgame from the sidelines, studiously taking notes as
one lurches from last (green) square to square, Nabokov, that prodi-
gious figure of literary deception, disguise and dupery seems finally to
have discovered his proper critical moment. Vladimir Nabokov, who
for too long has been read either as a postmodern destroyer of onto-
logical certainties, or as an all-powerful Author twinkling at us from
the far end of Romantic and humanist paradigms, returns in the late
Anthropocene like one of his own spectral presences, checking in on
how things are going.

Let's just say they are not going well. Since Nabokov's death in the
late seventies, the world has increasingly been witnessing the uncon-
scious truth of what Lacan dubbed the capitalist discourse. Legible as
a certain excess of energy of a planet catastrophically heating beyond
recovery, the capitalist discourse speaks openly to the inherently fake
nature of the Symbolic order, to the master signifier's original basis
in deception and its natural being in semblance. In recognition of this,
and following the lead of Lacan in *Seminar* 27, Jacques-Alain Miller
identifies this as the "moment to conclude." What he intends with this
phrase is the acknowledgement that the established protocols of psy-
choanalysis based on Freud's pioneering methods of the interpretation
of dreams, symptoms and of repressed desire have considerably less

purchase under the changing structure of the registers of the Symbolic, Imaginary and Real today. He observes,

> The traditional categories that organize existence have passed over to the rank of mere social constructions that are destined to come apart. It is not only that the semblants are vacillating, they are being recognized as semblants. (Miller, "Unconscious")

What Miller names post-interpretation, a practice launched in an era when the Symbolic's traditional quilting points are being irrevocably torn loose, begins at the point where interpretation gags. It marks the dizzying switching-point where the act of deciphering turns into re-ciphering, where the metonymic chain of knowledge, S_2, finds itself sucked back around and re-absorbed into the S_1, the original metaphor, that spawned it. An epochal shift in the structure of the subject, of its relation to Law and to jouissance, this calls for new models of analysis and, of reading more generally.

What would a "post-interpretive" Nabokov look like? It's one that would take Nabokov's letter play literally, that is, not as the self-reflexive navel gazing of one of the 20th century's greatest auteurs but as the "zero effect" (Miller, "Interpretation" 5) of a master signifier in an epoch-shattering act of auto-cannibalization. It would ask whether the famous cameo appearances played out through anagrammatic games with the letters of his name – as Vivian Darkbloom, Blavdak Vinomori, Ivor Black, Badlook, Baron Klim Avidov, Adam von Librikov, and so on – were not simply parlor games destined for a smug in-crowd of Nabokov connoisseurs but rather projections of the changed relation to speech and writing Miller observes taking place in this era of a "new Real" dominated by the semiotic swirls of a post-Truth era. To read Nabokov post-interpretively – or, as I propose simply, in Reason's "endgame" – would be to address front-on the letteral insurrection that breaks into the literary circuitry of Nabokov's works, fatally interrupting narrative's strategies of desire. It means, finally, deflecting attention from the designing, patterning "spiral returns" that have comfortably powered one strand of Nabokov criticism to focus on his not-quite mirror image: a de-personified, de-anthropomorphized, cinematic operation making guerrilla incursions into the literary province from a very different aesthetic and cognitive regime.

Reading in the endgame means following Nabokov onto the cinematic topology of the letter where the literary turns out to be continually in league with a principle of textual interference, a curving "bend sinister" that re-plasticizes the alphabet. For *this* Nabokov, the pull of narrative's arc becomes a lever not for effecting closure but, by means

of a cinematic re-set, for cross-wiring literature's plot engines. The ensuing "Nabokov effect" is both an assault on classical teleological models, and an opening onto other forms of reading and listening, always latent in a certain psychoanalysis that never did die but merely went "global," which is to say, spectral.

<p style="text-align:center">▪ ▪ ▪</p>

Such a reading might begin by tracking instances where authorship gives way to another principle of literary production. As if spawned by the ink blots and boggy puddles that besplatter Nabokov's characters, one would quickly find other textual figures or, perhaps, non-figures clamoring for our distracted attention: an incompletely spelled name results in a crucial case of mistaken identity in *The Real Life of Sebastian Knight*; an accidental typo in the poem *Pale Fire* destroys ontological certainties regarding the limits of life and death; in *Ada, or Ador*, a type-setting conceit transforms prose's grammar into a mine-field of temporal dislocations, while in the short story, "The Visit to the Museum," a cataloging error in the archive triggers an assault on the structures of historical memory. A mysterious "left-slanted" hand-writing mysteriously interleaves the "factual or more or less fictional" reports of Nabokov's works, which dissolve into a "chaos of smudges and scriggles" (*Look* 579, 624). In Nabokov, it is a question of a certain technical over-flow, a spillage in the mechanics of writing.

This spillage is linked to a cinematic figure summoned from the underworld, something like what Lacan, in his *Seminar* 18, *On a discourse that might not be a semblance*, names "the function of the shadow" (Lacan, *Seminar* 18, lesson of 19.5.71) as it wells up in the act of inscription. If this shadow-function attaches itself at times like a gum-shoe to the Imaginary register, trying on the masks of Nabokovian characters – John *Shade*, Dolores *Haze*, *Haze*l, Van *Veen* (literally "from or of the bog"), Sebastian K*night*, Jacob Gradus or Jack de *Grey*, Ivor and Iris *Black*, or the serial noir of H*umbert* Humbert – this is simply to make use of that register's spatial dimensions to allow one to glimpse something more structural, skeletal, through the body's "torpid smoke" (*Stories* 396). Indeed, it just as frequently sheds such Imaginary ploys to feed directly from the formal marks that spawned it – geometrical shapes like the circle referenced in the Russian "Krug" in *Bend Sinister*, or the missing letter Q in the alphabet of "Signs and Symbols."

As the hypnagogic patterns of readerly identification thus become exposed, X-ray-like, to language's technical operations, a revision of the specular model occurs, the very one that was supposed to config-ure, mimetically, the mirage of the ego or I. In Nabokov, the Imaginary

register never seems to secure the idea of a "self" but is, rather, the site of infinitely transpositional, spectrographic diffractions. From Imago to fragilized image, reflection to refraction, dialectic to dehiscence, the mirror's signature, 'cinematic,' reversals fail to assemble a totalized image, instead precipitating an "enfilade" of "nightmare mirrors with reflections overflowing in messy pools on the floor" (*Look* 570). What the image amounts to in Nabokov is thus a vastly different affair than the "orthopedic" totality of the mirror stage's drama with its "donned armor of an alienating identity" we inherited from a certain Lacan (Lacan, *Ecrits* 78). While an image is a slippery, shape-shifting object at the best of times, in Nabokov it assumes its properly topological properties: constitutively fragmented, the image pokes holes in representation's smooth reflective surfaces in the following passage from Nabokov's autobiography, *Speak, Memory*.

In this, the presumed "original" of the scene we have just referenced from *Look at the Harlequins!* – his last book, Nabokov's 'fake,' reversed mirror of his literary life-story – Nabokov embarks on a recollection of his early poetic endeavors. Spellbound by rhyme, the young Nabokov overleaps space and time, teleporting from the "cold, musty, little-used room" where, with one arm dangling from the leathern couch, he grazes the "floral figures of the carpet" to find himself "prostate on the edge of a rickety wharf, and the water lilies I touched were real":

> the undulating plump shadows of alder foliage on the water – apotheosized inkblots, oversized amoebas – were rhythmically palpitating, extending and drawing in dark pseudopods, which, when contracted, would break at their rounded margins into elusive and fluid macules, and these would come together again to reshape the groping terminals. (*Speak* 550)

A liquifying reduction of the semblable, an inky pool which, in spreading, laps at the limits of the lyrical I, bleeds through the phantasmal narcissal scene of identification. It is not the polished mirror of poetic language that more or less faithfully reflects 'life' in the Nabokovian poetics. Instead, 'life' here seems to be embodied as strange shadowy "pseudopods" – literally, fake feet – that grope and poke at the world from beneath the screen-like surface of the water. In this alternative, 'cinematic,' account of apperception, representation does not so much reflect as absorb and resorb. Another representational ontology swiftly takes over: of language as a sightless, denaturalizing, 'original' or first 'false' life that masquerades as the negative or obverse of figure but left to its own devices invariably reverts to prefigural blotches.

■ ■ ■

In Nabokov, the Symbolic suffers an ignoble fate. In the traditional psychoanalytic schema, knowledge's S_2 is what supports the master signifier of the paternal metaphor. But in Nabokov, learning presents as a dubious transmission that spirals through a network of proxy paternal figures in the form of (maternal) grandfathers, uncles and, in particular, tutors. For Nabokov, knowledge has always been *know-how*, and this is a matter of impersonation, imitation, and invention. Among the early instructors who make their appearances in *Speak, Memory* is an expert ventriloquist, remarkable for his impressions of a figure who famously put words into others' mouths, *Cyrano de Bergerac*, "mouthing every line most lusciously and changing his voice from flute to bassoon, according to the characters he mimed" (*Speak* 504). Another is "Lenski," a "very pure, very decent human being, whose private principles were as strict as his grammar" (506), but whose garbled literary knowledge – "he casually informed me that Dickens had written *Uncle Tom's Cabin*" – is more than compensated for by his scriptive beauty, having an "unforgettable handwriting, all thorns and bristles" (504).

This filmic tutor Lenski, dragging a faintly "etherish" smell behind him (from film-developing chemicals, one presumes), makes his chief appearance in *Speak, Memory* as the director of a mortifying series of "instructive readings" (501-2) that accompany his proto-cinematic Educational Magic-Lantern Projections put on for the edification of the children. With his penchant for outlandish modern inventions, Lenski discloses his credentials as an agent of a certain *techné* and *savoir faire*. These include a "new type of pavement he was respon- sible for [...] composed of (so far as I can make out that strange gleam through the dimness of time) a weird weave of metallic strips" (505). However this is no Scheherazadean flying carpet woven by the threads of literary invention. Whatever 'ground' this metallic footpath prof- fers unfolds as a treacherous path of silver webbing, each reticule more hazardous than the rest and, needless to say, "the outcome was a puncture" (505).

Metaphorical vehicles for imaginative 'flight' are similarly self- impeding: an "electroplane" with "voltaic motor," flew "only in [Lenski's] dreams and mine" (505). Another invention to which Lenski claimed what the narrator calls a "natural fatherhood" was designed to accelerate the speed of ordinary horse-power with a "miracle horse food in the form of galette-like flat cakes (he would nibble some him- self and offer bites to friends)" (505). What constitutes Lenksi's claim to these inventions, it turns out, is simply "an emotional attitude on his

part with no facts in support and no fraud in view" (505). His would be a non-biological paternity that suspends the "natural" with another right: of self-assembly, auto-production, fabrication and contrivance.

If "knowing" has always been doubled by its innate propensity to swerve in transmission, dead-ending in ironic self-annulment, the S_2's *duplicity* now spreads even to the master signifier, S_1. The paternal star in whose light the young Vladimir triumphantly struts at the beginning of *Speak, Memory,* was always already counterfeited. Nabokov senior's glittering trappings of power – his military outfit with its "smooth golden swell of cuirass burning upon [his] chest and back [which] came out like the sun" (371) – turns out to be a "festive joke," assumed in jest by the narrator's father in self-parody. Simultaneously blinding and a double-blind, the master signifier is preprogrammed in Nabokov as a comedic routine.

■ ■ ■

"The sight of his handwriting fascinates him; the chaos on the page is to him order, the blots are pictures, the marginal jottings are wings" (*Look* 500). The written word in Nabokov is a complex figure, possessing not only textual but irremediably visual dimensions. Entering discourse iconically, it constructs mental images in flight from linear models of meaning. A visual system thus seeps through Nabokov's textual fabric, manifesting as a cross-sensory switchboard jumping on double meanings, cross-lingual puns, graphic riddles and homophonies. In the novel, *Transparent Things,* this trans-scriptivity encounters the object world as an encrypted network through which matter and memory, or memory-as-matter, is transported.

In this work thematizing a counter-memory to the official Nabokovian project of Mnemosyne, we are introduced to the idea of objects as "transparent things" whose interactions are laid open to dispersion effects allied with textual dissemination. In chapter three, an old desk disgorges a pale lilac pencil which returns a spectral memory of its making. After a brief recount of its immediate provenance as the possession of the carpenter who, ten years ago, mislaid it while failing to fix the old desk, the pencil in the narrator's hands writes its own way back to its "sweetly" "whittled" shavings which are now scattered, "reduced to atoms of dust." Objects, it seems, carry a material "memory" of their previous histories, rendering the present "transparent" to the past into whose layers they constantly threaten to sink. For the present, as the narrator explains in the novel's opening passage, is merely "a thin veneer of immediate reality" that is "spread over natural and artificial matter, and whoever wishes to remain in the now,

with the now, on the now, should please not break its tension film"
(*Transparent* 489).

Yet, despite this translucency, objects nevertheless remain traversed
by the inflexible law of time's unfolding and the inexorability of entro-
pic systems, shared by all living and dead things. All, that is, except
the metallic-grey atoms, which, emanating from the pencil-object
in silvery trails, possess the ability to revolve in all directions – in
reverse as well as fast-forwarding into the future. These granules of
black lead, *plumbum*, recover their "complicated fate" by writing out
the pathways of their dispersion, an act the narrator calls "panic catch-
ing its breath" but "one gets used to it fairly soon (there are worse ter-
rors)" (*Transparent* 492).

> Going back a number of seasons (not as far as Shakespeare's
> birth year when pencil lead was discovered), and then pick-
> ing up the thing's story again in the 'now' direction, we see
> graphite, ground very fine, being mixed with moist clay by
> young girls and old men. This mass, this pressed caviar, is
> placed in a metal cylinder which has a blue eye, a sapphire
> with a hole drilled in it, and through this the caviar is forced.
> It issues in one continuous appetizing rodlet (watch for our
> little friend!), which looks as if it retained the shape of an
> earthworm's digestive tract. (*Transparent* 492-3)

Here, in what amounts to writing's 'primal scene,' graphite, a meta-
morphic rock predating the Solar System, pierces ocularcentrism's
"blue eye," boring through the latter's tunnels of interiority with its
'memory' of an archaic, molten, intercalating arch-conductivity.
Coiled within the written word is a letteral recall that intervenes
in time, overwriting its forward arrow with a different interface of
space-time. A hexagonal form of matter which the bisecting tropes of
solarity definitionally fail to penetrate, this non-transparent *l'achose*
(a Lacanian neologism that translates as "a-thing") resists chunking
by time and space.

Curiously, the textual artefact Nabokov proposes for accessing this
letteral memory is not a word but a number, 313, which should be
imagined, as Hugh tells Armande, "as three little figures in profile, a
prisoner passing by with one guard in front of him and another behind"
(*Transparent* 555). Here the 3s in this little sequence "guard" the entry
and exit of life and death, marching to time's inexorable forward beat.
But the 1 – an "I" formed through a different process than identifi-
cation – slips from their grasp by making a quarter turn in another
direction. It briefly salutes us, readers who have become trained in

Nabokov's graphematics, before slipping through "some secret outlet" that deposits it outside the "prison of time" (*Speak* 370).

Transparent Things ends in one of Nabokov's trademark conflagrations. As the final pages of the novel combust in a "torrent of rubies" (561), they reduce to ashes any last lingering hope that the subject of enunciation – a hapless proof-reader called Hugh ("You") Person – can be kept separate from the enunciating subject, a certain "touchy, unpleasant" "Mr. R," a thinly-veiled Nabokov hiding behind a mirrored image of the Cyrillic Я, ("ya" meaning "I," or "I am"). Like the strongly opinionated Nabokov, Mr. R, also an author, demonstrates a streak of "nasty inventiveness," fighting "on his own ground with his own weapons for the right to use an unorthodox punctuation corresponding to singular thought" (504). A Möbial structure, the orders of writing and reading slide irreparably into one another: is the manuscript of R's that Hugh has been correcting throughout the novel, it finally dawns on us to ask, the very the book we have been reading as the tragic story of Hugh's unintentional murder of his wife, Armande in his sleep, a re-tracing of the steps of his desiring history in the Chorb-like hope of undoing time,[6] and the repetition of the dream of a fire, which has in the meantime become "reality"?

> Rings of blurred colors circled around him, reminding him briefly of a childhood picture in a frightening book about triumphant vegetables whirling faster and faster around a nightshirted boy trying desperately to awake from the iridescent dizziness of dreamlife. (*Transparent* 562)

It was by interpreting his patients' dreams that Freud arrived at the idea of the symptom as an unconscious message that presents itself for interpretation. Yet the father's dream of the burning child famously presented Freud with a conundrum, of a "Real" that breaks through the otherwise ubiquitous dream-structure of the pleasure principle. If Nabokov, similarly, pierces the bar isolating the primary or original text from its secondary or "meta"-level interpretation, with him we also reach the end of a certain analytic praxis, and the collapse of the "narcissism" of the reader as decipherer of the symptom's hidden messages. In Nabokov, interpretation is never "stratified" in relation to the unconscious (Miller, "Interpretation" 4) – but is inscribed in the same register. The text, to rephrase Miller slightly, is its own interpretation.

· · ·

Nabokov tosses his book into the fire at the close of *Transparent Things*. The dying Hugh's "ultimate vision was the incandescence of

a book or a box grown completely transparent and hollow. This is, I believe, *it*: not the crude anguish of physical death but the incomparable pangs of the mysterious mental maneuver needed to pass from one state of being to another" (*Transparent* 562). Radiantly aglow, this empty "book or box" sucks into its vacuum the orders of metaphor and metonymy, together with their implied futurity as the promise of another meaning, laid over or horizontally deferred until the "last word." It thereby dismantles every reading it pretends to invite in the name of some Truth that exceeds what "can be settled by a yes or a no" (Lacan, *Seminar* 18, lesson of 13.1.71).

As it defies figuration, blinding sight, silencing speech, autosarcophically consuming its own words, this "transparent and hollow" book, or box, unwrites the order of the literary as *metaphorein*. "Tralatitions," the much-contested title of R's book, in addition to its standard definition as "metaphor," also has the meaning of what can be acquired by direct contact: "passed along as from hand to hand, mouth to mouth, or from generation to generation."[7] What can be passed on "from hand to hand, mouth to mouth"? At this point the figure of reading returns, not as the superaddition of layers of secondary meaning but as the "tralatitious" work of the letter in an act of integral transmission.

■ ■ ■

When a certain power exits, its exhausted routines finally played out, it pivots on the sole aspect of language that "might not be a semblance." A "frail," "weak," "harmless looking" logic (Lacan, *Seminar* 18, lesson of 12.5.71), the letter unleashes the only true revolution that psychoanalysis recognizes: a shift in discourse. Lacan comments, "It is a matter of making tangible how the transmission of a letter has a relationship with something essential, fundamental in the organization of discourse, whatever it may be, namely, enjoyment" (Lacan, lesson of 12.5.71). How does one initiate such a shift in discourse? Back in the middle of the 20th century, Lacan crisply offered that while psychoanalysis might accompany one to the point "where the cipher of [one's] mortal destiny is revealed," it is not in the analyst's power "to bring him to the point where the true journey begins (Lacan, *Ecrits* 81)." However in his presentation of the theme of the 2016 Congress of the World Association of Psychoanalysis, Miller indicates a possible pathway through the totalizing semblances wraithing the "new Real." "The only path" that opens up beyond the delusional structure which has surpassed the hysterical symptom, he claims, "is for the *parlêtre* to make himself the dupe of a real, that is, to assemble a discourse in which the semblants clasp a real." "To be the dupe of a real – which

is what I'm extolling – is the sole lucidity that is open to the speaking being by which he may orient himself" (Miller, "Unconscious).

Can one think of the Nabokovian sinthome, then, as a cinematic "duping" of the Symbolic by the Real? Here one recalls Lacan's description of the analyst as a "rhetor" who, in attempting to say the truth, equivocates. "One tries to say the truth, but that is not easy because there are great obstacles to saying the truth, even if only because one makes mistakes in the choice of words. The Truth has to do with the Real and the Real is doubled, as one might say, by the Symbolic" (Lacan, *Seminar* 17, lesson of 20.5.70). Nabokov, whose "transparent and hollow" books seem the quintessential definition of semblance, nonetheless encrypts an "immortal destiny" of a book, – or box, – in the Real letters of his name. Into this open, turning, continually self-inverting, impossible book-бок-box without sides[8], Nabokov entraps the sheer excess of the signifier. If any "Truth" is unleashed by this "Nabokov effect," it is one that straddles both the Symbolic and Real, jolting literature's semantic complex with a continually expanding network of formalization without pauses, borders or ends. Unlike punctuation, which as Miller points out "still belongs to the system of signification," is "still semantic," and still "produces a quilting point" (Miller, "Interpretation" 8), Nabokov's cinematic post- or allo-interpretation reverses the signifier and returns a now spectralized psychoanalysis to its archaic origins in the "montage" of the partial drives.[9] In Nabokov, castration's 'cut' unfolds as a mobile hole turning on a non-Euclidean graphematics of knots and weaves, light and shade, a toric glove that reduplicates what it interlaces.

2 Lethal Signs: A Guide to Memory Futures

> As for what 'begins' then – 'beyond' absolute knowledge –
> unheard-of thoughts are required, sought for across the
> memory of old signs.
> —*Jacques Derrida, Speech and Phenomena*

If Charles Dickens, in Sergei Eisenstein's assessment, was born for
the movies, Vladimir Nabokov was literally born *in* the cinematic
medium. Nabokov inters a cinematic crypt right in the nucleus of
Speak, Memory, his autobiographical rhapsody to the power of literary
recollection: "The cradle rocks above an abyss, and common sense
tells us that our existence is but a brief crack of light between two eter-
nities of darkness" (*Speak* 369). Needless to say, as a self-proclaimed
rebel, Nabokov will rail against this "commonsensical" understand-
ing of life's finitude. In the following pages, he describes his efforts
to combat time whose walls, separating our states of being and non-
being, Nabokov feels certain must yield a secret passage: "Over and
over again, my mind has made colossal efforts to distinguish the
faintest of personal glimmers in the impersonal darkness on both
sides of my life" (369). In its search for "some secret outlet" from the
"spherical" "prison of time" (370), Nabokov's literary project harbors
a strong Proustian resonance, as more than one critic has observed.[10]
Nabokov's insistence on voluntary rather than involuntary memory,
however, signals an important departure from the French modernist's
project, a difference that is indexed in advance by *Speak, Memory*'s
famous opening shot. It is cinema that triggers the Nabokovian time
machine, insofar as the cinematic offers an alternative perceptual-cog-
nitive *transport* system for conveying the sensations that will form the
basis of our understandings of space and time.

In his opening image, then, Nabokov grants us entry into the complex
figure through which he conceives of consciousness: it is as a motion
picture show that life is lived, a brief intermission of light, sound and
movement that for a short while relieves the darkness of the cosmic
auditorium. Over the next few pages, Nabokov enlists the cinematic to
figure the birth of his self. First, filmic metaphors are invoked in the
glimmerings of a *dawning* self-consciousness as it straddles the irre-
ducible zone between two voids. Consciousness then takes shape as an
accelerating sequence of "spaced flashes" that ultimately resolve into

continuous "bright blocks of perception" (370). It is upon these lumi-
nescent blocks, one learns, that memory is afforded its "slippery hold."

Turning back to the opening paragraphs, we find the cradle of the
opening sentence has meanwhile expanded to the rounded nutshell of
a baby carriage, albeit an empty one as if the voids of the earlier pas-
sage have become positivized into a more homely dynamic of presence
and absence. The baby carriage, it appears, derives from a scene in an
early home movie taken by his father a few weeks before Nabokov's
birth in 1899. This haunting image of absence is quickly supplanted
by one of enigmatic plenitude. Elena, Nabokov's expectant mother, is
shown waving from an upstairs window "as if it were some mysteri-
ous farewell" (369). As the early movie camera pans through space,
it thus also produces a transfiguring effect on time, giving the young
Nabokov access to lifelike moving images of what, for him, is a pre-
historical world. Indeed we hear of the uncanny effect that watching
this home movie had on Nabokov's child self. The film produced in
him a vertiginous panic, the shock of viewing a world that is the same
in every detail as the one in which he now lives, except that he is not in
it. As if registering this shock, the baby carriage assumes the sinister
appearance of a funerary casket, "standing there on the porch, with
the smug, encroaching air of a coffin." But even this coffin, it turns
out, is empty. This is not the final resting place for the vestiges of a
life well lived – not a container for the consciousness of a life lived in
the open air and fed on fresh bread, country butter and Alpine honey,
as Nabokov once described his happy existence to James Mossman
(Nabokov and Mossman, n.p) – but a black hole, one that has sucked
his life back in advance. It is "as if," Nabokov writes, "in the reverse
course of events, his very bones had disintegrated" (369).

It is now commonplace for historians of photography to draw atten-
tion to the seeming 'objectivity' of the camera lens. By this, they are
referring to the photograph's ability to present images of objects in
which the viewer "believes instantly," as Bernard Stiegler expresses
it.[11] For Roland Barthes, too, the photographic image's "co-naturality"
with its referent testifies – albeit always with acute awareness of the
object's loss – to the inevitable "that-has-been" of the object (Barthes
77). In *Visions of Modernity*, Scott McQuire extends Barthes' insight
so far as to visualize the camera lens as an "invisible umbilicus" bind-
ing image to referent (McQuire 15). However, as both McQuire and
Stiegler, as well as Gilles Deleuze, have shown in different ways, the
cinema's addition of movement to the static photographic image severs
this filament to the real, enabling film to convey impressions of a life
that has never been. The most famous example of this is what is known
as the Kuleshov effect, named after Lev Kuleshov's famous editing

experiment in which various combinations of images were edited to encourage viewers to read different expressions from a single close-up of a face. Another experiment involved combining parts of the bodies of multiple women to create "a woman who did not exist in reality but only in the cinema" (McQuire 80).

For Nabokov, by contrast, cinema would be not so much the breeding ground for new life as a mechanism that revokes generation altogether. In the opening scene of the genesis of the self, cinema short-circuits Nabokov's birth such that any 'life' lived during the brief interval of existence will be as a shadow play, one whose illusory vitality is traced simply to the speed with which the light flashes of consciousness thread their way through the body's projector apparatus (at some "forty-five hundred heartbeats an hour" to be precise (*Speak* 369)). Accordingly, to the extent that a 'life' materializes at all on Nabokov's literary plane of autobiography, it will be as a copy of a copy, the false replica of what is already a fake. Deflected prior even to its inception, the literary image yields place to screen memories that stage so thoroughgoing an absence that they could never become the antonyms of presence. In its undermining of all ontological statutes, the cinematic subject would not so much foreclose as blindside all ground of any possible 'real.'

To reconstitute 'life' from a cinematic imaginary is to tacitly revise the fundamental Kantian transcendental intuitions of space and time. Hence, in the following chapter, we are not surprised to encounter a second cinematic figure, of an aural kind this time. Here Nabokov summons up the memory of an aural hallucination, a voice which he describes as conducting "a kind of one-sided conversation going on in an adjacent section of my mind, quite independently from the actual trend of my thoughts" (*Speak* 380). He explains:

> As far back as I remember myself [...], I have been subject to mild hallucinations. [...]. The fatidic accents that restrained Socrates or egged on Joaneta Darc have degenerated with me to the level of something one happens to hear between lifting and clapping down the receiver of a busy party-line telephone. (380)

In the irreducible interval between consciousness and sleep's "nightly betrayal of reason, humanity, genius" (451) an unidentifiable vocal emission utters "words of no importance to me whatever – an English or a Russian sentence, not even addressed to me, and so trivial that I hardly dare give samples, lest the flatness I wish to convey be marred by a molehill of sense" (380). A-pathetic and senseless, this vocal intruder presents as an audio counterpart of the earlier light figure, one

that suspends consciousness's shadow-play with an even more deep-seated aphanisis. If, previously, cinematic light permanently deflected the subject's emergence into an external world of spatial extension, sound now interferes with the coordinates of his inner sense. Inner sense, or in Kant's terms, the transcendental unity of apperception, is the habitual seat of our subjective experience of time, the synthethesizing node from which a certain philosophical representational model effortlessly unspools. But here, as if caused by a spectral telephone operator's accidental switch, a "neutral, detached, anonymous" voice speaks where the 'I' should be, not so much powerfully usurping as absent-mindedly displacing the Nabokovian subject from any hope of his rightful position as Master in his own house (380). Along with cinematic light, teletechnic sound fatally interrupts the official Nabokovian aesthetic program of *Speak, Memory*.

What is this program? In his memoirs, Nabokov tropes his statement of faith in literary memory in the Augustinian terms of perception (especially vision), memory and will. From the outset of his own 'Confessions,' Nabokov highlights the power of his prodigious memory with its seemingly preternatural ability to bring the past back to life in all the ardor of its intensity and detail. The bright mental images conjured by voluntary memory and animated by a "wingstroke of the will" (380) are placed in striking contrast with the leaden dullness of his dreams. For it turns out that the most that sleep's "nightly betrayal" of reason can summon up of the deceased are awkward, unhappy guests milling about on the surreal and uncomfortable furniture of the unconscious: "Whenever in my dreams I see the dead, they always appear silent, bothered, strangely depressed, quite unlike their dear, bright selves" (395). "It is certainly not then" he goes on,

> not in dreams – but when one is wide awake, at moments of robust joy and achievement, on the highest terrace of consciousness, that mortality has a chance to peer beyond its own limits, from the mast, from the past and its castle tower. (*Speak* 395-6)

Nabokov never missed an opportunity to ridicule Freud, so much so that Geoffrey Green has called the former's famous aversion to the author of *The Interpretation of Dreams* "the grandest and most extravagant contempt for psychoanalysis known in modern literature" (Green 1). However, it is not primarily Nabokov's hostility towards the "Viennese quack," whose "grotesque" talking cure he deems "one of the vilest deceits practiced by people," that I want to initially focus on but rather the theory of the sign that underpins the Nabokovian mnemonic program (*Speak* 21, 45). At the broadest level, my suggestion

is that in the cinematic sign Nabokov finds a concept that will enable him to pursue his literary project to defeat time in a way comparable to (and which indeed compensates for the absence in his system of) the psychoanalytic concept of the unconscious.

To begin with, one can see that, despite their clear differences, both Freud and Nabokov are equally fascinated by the underlying patterns that silently structure a life. And like Freud, Nabokov will claim that such hidden patterns can become visible to the subject through a certain type of linguistic activity. But where for Freud free association in the presence of the analyst brings these repetitive forms of unconscious memory into view, Nabokov devises his own version of the "talking cure": it is the "speech" elicited by *conscious* memory that uncovers the patterns concealed in life's seemingly haphazard twists and turns. Indeed, the territory upon which he wishes to stake his claim is already intimated in the original title Nabokov wished to give his memoirs (but rejected by his English publishers as, apparently, too difficult for readers in search of the volume to pronounce). Nabokov had proposed to entitle the British edition of his autobiography, *Speak, Mnemosyne*.[12] With his preferred title, Nabokov is clearly referencing the ancient Greek tradition of magicoreligious speech. Why should Nabokov wish to associate his autobiographical literary program with the oracular pronouncements of the ancient Greek mysteries? It is because at the core of this mnemonic speech, as Marcel Detienne reminds us in his perspicacious study of the ancient Greek concept of truth, is its power to obliterate time. Magicoreligious speech is "efficacious," Detienne explains, because it is "pronounced in the absolute present, with no before or after" (Detienne 74). Oracular speech takes place in an atemporality that incorporates "that which has been, that which is, and that which will be" (74). To call back the past from the waters of Lethe (Oblivion) is to reanimate the dead, unfastening Cronos' resolute grip on our mortality. Aided by letter and number, it is the goddess of memory who fashions the path along which the poet enters the Beyond. Yet, as Detienne also points out, the figure of Mnemosyne is not without ambiguity. In his close and careful analysis of ancient Greek mythological language, Detienne points to a fundamental duality at the heart of the truth that the Muse of memory conjures: the Aletheia spoken by Mnemosyne is double, perpetually ghosted by its shadow, Lethe, whose echo continues to be heard in the very word for truth. Oracular speech is thus "a double power, both positive and negative," Detienne concludes (79). He writes, "There can be no Aletheia without a measure of Lethe. When the Muses tell the truth, they simultaneously bring 'a forgetting of ills and a rest from sorrow'" (81). From the outset, then, the figure Nabokov enlists for

his program to outwit time through the visionary power of literary memory always already harbors a counter-tendency towards forgetting. There is a duplicity at work in Mnemosyne's Aletheia which, "edged with Lethe," limns the contours of our Being with its negativity that forms our "inseparable shadow" (82).

It is becoming clear that, to the extent that it is founded on Mnemosyne, Nabokov's literary-autobiographical project would encrypt an adumbral counter-tendency at its heart. This is a counter-logic of oblivion and forgetting that silently erodes the efficacy of memorializing speech at every instance of its utterance. In fact, and as if in recognition of the ambiguity introduced by the Greek term, Nabokov turns in his autobiography to another tradition to figure the actual salutary effects of recollection on the past. In chapter fourteen, it is Hegel's dialectical structure rather than Greek mythic speech that is ultimately enlisted as the operative metaphor for the memorializing project. Drawing on Hegel's "triadic series" (*Speak* 594), Nabokov figures his own life's trajectory from Russia to Western Europe, from Europe to America and then finally back again in Hegelian terms of the "spiritualized circle." Hegelian recollection, which famously both cancels and preserves, enables Nabokov to detect larger patterns secreted across the contingencies and tragedies of quotidian life. Seen through the denser medium of memory, the past's oblique angles round and soften to a spiral that thematizes a hidden internal unity: "A colored spiral in a small ball of glass," he writes, "this is how I see my own life." "Twirl follows twirl, and every synthesis is the thesis of the next series" (594).

Metaphors of circularization persist when Nabokov comes to address the question of representation directly in *Speak, Memory*. In order to figure the relation of memory to writing, for example, life's 'spiritualized' spiral flattens into the two dimensions of a circle. In the previous chapter, in a passage describing his student days, Nabokov conjures an image of rowing on the river Cam that becomes the occasion for a remarkable description of the operations of literary representation. We hear how,

> [t]he three arches of an Italianate bridge, spanning the narrow stream, combined to form, with the help of their almost perfect, almost unrippled replicas in the water, three lovely ovals. In its turn, the water cast a patch of lacy light on the stone of the *intrados* under which one's gliding craft passed. Now and then, shed by a blossoming tree, a petal would come down, down, down, and with the odd feeling of seeing something neither worshiper nor casual spectator ought to see, one

would manage to glimpse its reflection which swiftly – more swiftly than the petal fell – rose to meet it; and, for the fraction of a second, one feared that the trick would not work, that the blessed oil would not catch fire, that the reflection might miss and the petal float away alone, but every time the delicate union did take place, with the magic precision of a poet's word meeting halfway his, or a reader's recollection. (*Speak* 591)

Here the naturalized image effortlessly floats the reader to the mystical site where word binds to world. Presided over by the three "lovely ovals" of ontos, theos and logos, this allegory of the origins of signification transports one through the solemn entryways housing the Nabokovian mysteries. We are carried to the mysterious and sacrosanct moment when transcendent meaning makes its magic descent to the reflecting pool of representation, which in turn rises up to greet it with a secret handshake.

One would seem to be back among the ancient Greek rituals again. However, on closer inspection, Nabokov's guiding metaphor of reflection in fact solicits a much later, secular, representational paradigm. In *Of Grammatology*, Derrida notes how a significatory regime of immense longevity and power buttresses the mimetic circuitry underpinning the reflective metaphor. He describes this regime as the "great metaphysical, scientific, technical, and economic adventure of the West." From this metaphysical tradition, in which "sign and divinity have the same place and time of birth" (Derrida, *Grammatology* 14), derives a certain order of cognition, one which routinely apportions what are by now our classical oppositions of the sensible and the intelligible, the real and the unreal, the living and the nonliving, being and non-being, light and dark, presence and absence, interior and exterior, the signifier and signified, and so forth.

In his discussion of Aristotle's "On Interpretation," Derrida points to the dependence of this metaphysical program on Aristotle's privileging of speech. He concludes that Western reason is founded upon the phoneme to the extent that the latter presents as the immediate expression of the Idea. Along with all its "determinations of truth" (Derrida, *Grammatology* 10), the history of the metaphysics of presence is found to descend from this fundamental connection between speech and thought wherein the act of hearing-oneself-speak forges the primordial link in the signifying chain. A "nonexterior, nonmundane, therefore nonempirical or noncontingent signifier," the phoneme thus inaugurates the theory of the sign as reflection of inner sense

(*Grammatology* 7-8). Derrida describes the peripatetic philosopher's key argument thus:

> If, for Aristotle, "spoken words [...] are the symbols of mental experience [...] and written words are the symbols of spoken words" (*De interpretatione*, 1, 16a 3) it is because the voice, producer of the first symbols, has a relationship of essential and immediate proximity with the mind. (*Grammatology*, 11)

Seamlessly translating the mind's thoughts into speech, the voice becomes the "producer of the first signifier," keeper of the ancient contract between thought and being from which later reflective models (including Hegel's) will be derived.

Now, representational models are formed where the body encounters the world, that is, in the stippled openings and edges that comprise the loci of our sense perception. And it is at these liminal sites that Nabokov revises our habitual epistemological and perceptual paradigms, proposing an alternate model of signification that threatens to dethrone the official mimetic regime of *Speak, Memory*. Nabokov's fondness for trans-lingual puns and his fascination with anagrams and other word puzzles, his propensities toward repetitive aural and scriptive patterns that Elizabeth D. Ermath terms his "thematic traceries" (Ermath 196), might be thought to proceed according to a certain letteral logic found in his inherited condition of "coloured hearing." For like his mother Elena, Nabokov was a synaesthete. Both mother and son heard words in color, together with their individuated letters. This would be, then, a sensory-phonematic system of maternal provenance, with all the challenges to our ordinary, patrilineal representational paradigms this might implicitly entail, as synesthesia is usually thought to be inherited through the maternal gene.[13] Closely following upon the description of his aural hallucinations in chapter two, Nabokov itemizes the chromatic cast of his audio-visual alphabet. It is worth quoting at length:

> The long *a* of the English alphabet (and it is this alphabet I have in mind farther on unless otherwise stated) has for me the tint of weathered wood, but a French *a* evokes polished ebony. This black group also includes hard *g* (vulanized rubber) and *r* (a sooty rag being ripped). Oatmeal *n*, noodle-limp *l*, and the ivory-backed hand mirror of *o* take care of the whites. I am puzzled by my French *on* which I see as the brimming tension-surface of alcohol in a small glass. Passing on to the blue group, there is steely *x*, thundercloud *z*, and huckleberry *k*. Since a subtle interaction exists between

sound and shape, I see *q* as browner than *k*, while *s* is not the light blue of *c*, but a curious mixture of azure and mother-of-pearl. [...]. In the green group, there are alder-leaf *f*, the unripe apple of *p*, and pistachio *t*. Dull green, combined somehow with violet, is the best I can do for *w*. The yellows comprise various *e*'s and *i*'s, creamy *d*, bright-golden *y*, and *u*, whose alphabetical value I can express only by "brassy with an olive sheen." In the brown group, there are the rich, rubbery tone of soft *g*, paler *j*, and the drab shoelace of *h*. Finally, among the reds, *b* has the tone called burnt sienna by painters, *m* is a fold of pink flannel, and today I have at last perfectly matched *v* with "Rose Quartz" in Maerz and Paul's *Dictionary of Color*. (*Speak*, 381)

Here Nabokov divulges the code to his cross-sensory conversion process. Each word is available to the eye in this shift as, with every utterance, the phonemes perform as light-rays dispersing through a prism. Splitting into different hues, words form polychromatic clusters that burst like unearthly rainbows on the visual cortex. Effortlessly spanning the gap dividing our sense of sight from our sense of hearing, these radiant bridges forge illicit thoroughfares for thought, bypassing the voice's philosophically-sanctioned direct route from mind to speech in the service of alternative lexical paths. It is a radical 'othering' of the perceptual apparatus that Nabokov's synesthesia effects, a cognitive re-wiring whose first consequence is to rewrite the history of the sign. For when run back through his synesthetic 'translation' process, common words find themselves reassembling into alphabetical compounds that are irremediably alien to phonocentric models and their metaphysical heritage. Written in prismatic alphabet, the word for "rainbow, a primary, but decidedly muddy, rainbow, is [...] the hardly pronounceable *kzspygv*" (381). Unreadable and inarticulable linguistic composites, these would be the "unheard-of thoughts" referred to by Derrida in my epigraph above – memories of "old signs" that arise from a different history and lineage of the logos. Spawned from a different reproductive process than the phoneme, such photogrammatic signs betoken words that no unified subject has ever spoken nor heard itself speak; such words are the signifiers for "mental feelings" of no representational consciousness or mind.

What Nabokov's synesthetic rewriting of the sensorium proposes, then, is an alternative, 'cinematic' model of representation, one that proceeds from a fantastically different theory and history of the sign. Its first consequence is that, with the installation of the photism at the heart of the phoneme, 'cinaesthetic' representation suspends the

ancient Aristotelian philosophical contract between mind and voice. As it ghosts the signifier with its uncanny, synthetic light, this "pale fire" permanently deflects and refracts the philosophical dream that would reunite mind and world through recollection, where each pole mirrors the other in perfect, self-moving circles, word and world reflecting one another with "magic precision."

Techni-city: Berlin

The idea that Nabokov should turn in the early nineteen twenties to the newly emerging art of cinema as the metaphor through which to trope his alternative perceptual and representational logic does not demand any great leap of thought. For early twentieth century filmmakers such as Eisenstein, whose later writings explored the phenomenon of synesthesia directly, cinema offered fascinating possibilities for "synchronizing" the senses. Laura Marks goes so far as to call cinema an inherently synesthetic medium. Cinema's "intersensory" effects, as she describes them, traverse sensory boundaries, "appealing to one sense in order to represent the experience of another."[14]

For Nabokov, cinema's new form of figuration lends something invaluable specifically to his literary enterprise. Its significance lies in the challenge the 'tenth Muse' poses to the representational regime of Western reason and particularly to its corresponding, "commonsensical" understanding of time.[15] Detectable as a kind of interference pattern flickering throughout Nabokov's oeuvre, the cinematic pulls together many of the themes that have been identified by the critical tradition as keys to his works. In addition to the problem of time, these include the theme of dual or multiple other worlds with extra dimensions, and the Möbius-strip-like relationship between the fictional and 'real' worlds (a favorite conceit explored in many early films as, for example, in Buster Keaton's *The Cameraman*). The short-lived genre of the 1920s Rebus-Film, Paul Leni's animated cross-word puzzles that opened and closed some of the early matinee sessions in Berlin, invites comparisons with Nabokov's lifelong fascination with ciphers, secret codes, esoteric inscriptive combinations involving hidden patterns.[16] Finally, as several critics have noted, photographic imagery of light and shade unmistakably dominates in Nabokov's work, along with the phenomenon of the "photographer's shadow," which several critics have read as a figure for an auctorial presence that animates Nabokov's fictional worlds.[17] Above all, by means of cinema, Nabokov connects both his scientific and aesthetic interests in the figure of light, which combines into one the fundamental *duality* that contemporary physics has discovered at the foundation of reality.

Read across his oeuvre, the complexity and persistence of the cinematic trope suggests the remarkable longevity and integrity of Nabokov's aesthetico-temporal concerns, which a careful reading reveals to be present right from the earliest publications. And indeed, in one of his earliest short stories we find what amounts to a guided tour of the subterranean transportation infrastructure underpinning Nabokov's lifelong literary-cinematic program. Despite the youth of its author, "A Guide to Berlin" is considered one of Nabokov's seminal short stories. Nabokov himself described it as "one of his trickiest pieces" (*Stories* 670), a comment which I suspect refers not simply to the difficulty its translation into English presented. The tale first appeared in the Russian émigré review, *Rul,*' edited by Nabokov's father, V.D. Nabokov, in 1925. Like thousands of other Russian families, the Nabokov family had settled in Berlin after fleeing the Bolsheviks in 1918. In *The Russian Years*, Brian Boyd describes how Russians flocked in vast numbers to the German capital in this period, settling primarily in the cheaper Wilmersdorf area. Here is where the Nabokov family held court as the center of the expat Russian colony, making valiant efforts to recreate the cultural milieu from which they had been so dramatically uprooted. "The full flavor of a wealthy, enlightened St Petersburg home" is how one observer described the Nabokovs' Sächsische Strasse flat (Boyd *Russian* 184). Berlin, however, also played host to a further trauma for the family: in 1922, Nabokov's father, V.D. Nabokov, was tragically assassinated while trying to protect a fellow Russian Constitutional Democratic party member. Of course, these events not only had a profound psychological impact on the twenty-one-year-old Nabokov, but one might also see them as instrumenting what was to become this writer's lifelong concerns with what is real and what is semblance as these came to organize themselves in his work around the divergent representational modes of literature and the cinema.

Berlin in the 1920s could hardly have offered a better locus for Nabokov's exploration of the literary possibilities of the filmic medium, presenting in this period as the archetypal cinematic city. Berlin was not only the center for German film production and the creative focus both for Western European and Russian filmmakers, it was also the subject of several important early documentary films, including Walther Ruttmann's *Berlin: Symphony of a City* (1927), whose action and setting seems strangely 'postscient' of Nabokov's short tale. An avowed and avid cinemaphile, Nabokov had no shortage of opportunities for movie going in this period. First from his family's Wilmersdorf apartment, and then from subsequent rooms in the nearby Charlottenberg and Schöneberg neighbourhoods, Nabokov was

bordered on several sides by corner theaters built during the post-World War I boom in theater construction.[18] These included the Wittelsbach cinema (Berliner Str. 166) and the Union-Palast Theater (renamed the Ufa-Theater Kurfürstendamm in 1924), and the majestic 1911 Cines-Kino on the Nollendorfplatz, which was just a short stroll from the Luitpoldstrasse rooms where Nabokov and Vera began their married life in April 1925. In these and other Berlin theaters, Nabokov would have been able to see the latest offerings by directors such as Fritz Lang and F.W. Murnau, as well as to feed himself on an extensive diet of Hollywood films that were rapidly gaining in ascendancy following the end of the American film import ban in 1920 (Saunders 10).[19]

In *The Russian Years*, Brian Boyd describes Nabokov's attempts to move professionally into theater and film during this period. In collaboration with Ivan Lukash, the young Nabokov wrote numerous pieces for the stage and cabaret in the 1920s and '30s, including for Berlin's famous Bluebird cabaret. He also attempted to supplement his income as a film extra in a number of locally produced films (whose titles, unfortunately, have been lost now to history). Nabokov's former student, Alfred Appel, recalls how, throughout his life, Nabokov was eager to see his novels and short stories transferred to film, approaching the Hollywood director, Lewis Milestone, about a possible adaptation of *Despair* (which was rejected as being too erotic for 1930s tastes). Nevertheless, Nabokov did ultimately see several of his works transferred to film in his lifetime, including *Lolita*, of course, first filmed by Kubrick in 1962, as well as by Adrian Lyne in 1997.[20]

My interest in the cinematic here, however, is in the way it enables Nabokov to elaborate a formal system that mimics yet fundamentally overturns 'normal' reality to expose it as a flickering, semi-translucent light field whose semblance of opacity ('matter') is simply a function of the speed at which it is traveling.[21] A shimmering, semi-permeable "Kingdom by the sea [C]," cinema simultaneously precipitates awareness of, and renders privileged access to, this other physical 'regime' that otherwise lies hidden, recessively enfolded within the interstices of the representational divide separating the real from its literary 'imitation.'

In five short visual vignettes, "A Guide to Berlin" lays out the blueprints of Nabokov's literary-cinematic intervention. The story opens with a description of several large concrete cylinders lying on the street outside the narrator's house in one of the suburbs of Berlin:

> In front of the house where I live a gigantic black pipe lies
> along the outer edge of the sidewalk. A couple of feet away,
> in the same file, lies another, then a third and a fourth – the

> street's iron entrails, still idle, not yet lowered into the ground,
> deep under the asphalt. (*Stories* 155)

Sections of Berlin's underground sewage system, these pipes lie unexpectedly exposed to view as evidence of another circulatory system that normally lies hidden beneath the city's surface. These orotund pipes bear the figurative burden of a subterranean signifying system operating beneath the exteriors of literary language. As they conduct the waste flows of Berlin's official business, these solid black line lengths suggest themselves as the hidden backbone of all tropological systems. Indeed, in their formal outlines, letters of an archaic alphabet come starkly into view as the physical "pipes" through which the literary image flows.

We obtain our first inkling of this other transport system in a flash, in a burst of "bright-orange heat lightning" that radiates from one of the pipes' circular interiors:

> up the interior slope at the very mouth of the pipe which
> is nearest to the turn of the tracks, the reflection of a still
> illumined tram sweeps up like bright-orange heat lightning.
> (*Stories* 155)

Reminiscent of a photographer's flash, this orange sun enkindles an artificial light-source for the cinematic city, one whose X-rays penetrate matter's boundaries and impart a different form of 'life' to Berlin's inhabitants. Charging the story's tropological flow with a fearsome current, this fake sun electrocutes in advance any potential metaphorics of the literary *polis* as a home fit for human habitation. From the outset of the story, a switch has been turned and the order of inside and outside, above and below, real and semblance is reversed. Or it is perhaps not so strictly reversed as *unpeeled*, stripping the metropolitan representational edifice away from the inside: the German capital is double-exposed as a cinema screen in whose "flat grey light" (155) the spectral life forms of 'Berlin' will begin to flicker and pulse.

As if in concert with this move, the pipes undergo their own peculiar topological transformation. The narrator observes how, in the thin strip of snow, somebody has traced the letters 'Otto' onto the pipe's surface. He then reflects how germanely "that name, with its two soft *o*'s flanking the pair of gentle consonants, suited the silent layer of snow upon that pipe with its two orifices and its tacit tunnel" (155-6). Close to fifty years later, this same combination of letters resurfaces in Nabokov's self-parodic, 'fake' autobiography, *Look at the Harlequins*, as one of only three words that Ivor Black's parrot can say.[22] 'Otto' thus bookends Nabokov's oeuvre with a strange sort of squawking, ersatz

human language. But one should also note how, in Otto's multi-dimensional palindrome, word intersects with world through a profoundly different relation than that of reflection. Not so much mirror images as 'obverse' sides of a non-orientable surface, word and world are connected by a homeomorphic equivalence, where previous divisions of interior and exterior are re-marked as a fold. Otto is not just a three-dimensional pun, it turns out, but a glitch in representational space-time itself around whose single edge the dual realities of Nabokov's worlds, one 'literary' and the other 'cinematic,' start to align.[23]

In the following section, these mutually imbricated two- and three-dimensional realities converge on the image of a streetcar, itself a favorite subject for documentary films of this period because of its rich metonymic possibilities for conveying the idea of cinematic 'transport.' Already practically a museum piece by Nabokov's time of writing, the streetcar occasions a reflection on the process of time:

> The horse-drawn tram has vanished, and so will the trolley, and some eccentric Berlin writer in the twenties of the twenty-first century, wishing to portray our time, will go to a museum of technological history and locate a hundred-year-old streetcar, yellow, uncouth, with old-fashioned curved seats, and in a museum of old costumes dig up a black, shiny-buttoned conductor's uniform. (*Stories* 157)

The tram's "air of antiquity" and "old-fashioned charm" provide a certain streetwise cover as it propels the narrator across space. But it quickly becomes apparent that, in the narrator's hands, the Berlin tram is in the process of being conceptually reconstituted. The narrator links the trolley with the miraculous temporal transportation that is literary production, for it seems that writing similarly has the ability to transport the past into "the kindly mirrors of future times" (157). Literature views the present from a future perspective, looking backwards at the contemporary scene that accrues an inexhaustible source of hidden value and meaning.

But then the image registers with the "salutary shock" of a Benjaminian illumination. Rather than a melancholy figure of loss and absence, the streetcar abruptly reveals its true identity as a time machine that fast-forwards the narrator into future. Here is where its commonalities with "literary creation" really lie, not in a misplaced nostalgia for the past but in the dis-tempering beat of the never-yet-to-be present. We hear how,

> [e]verything, every trifle, will be valuable and meaningful:
> the conductor's purse, the advertisement over the window,

that peculiar jolting motion which our great-grandchildren
will perhaps imagine – everything will be ennobled and jus-
tified by its age. (*Stories* 157)

The narrator's proleptic nostalgia for the present, it turns out, is merely
a front for a revised, 'cinematic' understanding of literary transport. In
the very same gesture with which it bestows the contemporary world
with the otherworldly qualities of artefacts from a former time, litera-
ture unseats us from our location in the present. It is not the future but
the now, it transpires, that is othered by literary perspective. Literature
turns each of us into time travelers, temporal orphans whose tenure
in the present expires before it can be lived. Silently betrayed by the
rolling wheels of the trolley car, which hint at the reels of a projector,
literature's secret identity as a double agent of cinema is unmasked.
The literary-cinematic tram's 'reels' wind and unwind the past and the
future like reversible film spools, while the literary journey of a day in
'Berlin' assumes the unmistakable air of a film screening directed by
the "chitinous" hands of the ticketman.[24] From these "thick" "rough"
fingers, tickets are dispensed to the queuing crowds through a "special
little window in the forward door" (*Stories* 156).

The third vignette, called "Work," describes the action of what we
see from our spectator seats at the window of the "crammed" literary-
cinematic tram (157). First, like any good urban documentary film
from this period, comes a gritty vision of four men hammering an iron
stake into the ground. This is no ordinary scene of employment but
the labor of the filmwork on the circular strip of time. Like sculpted
mechanical figures of a Rathaus Glockenspiel, the workmen raise and
lower their mallets in syncopated beats: "the first one strikes, and
the second is already lowering his mallet with a sweeping, accurate
swing; the second mallet crashes down and is rising skywards as the
third and then the fourth bang down in rhythmical succession" (157).
The sound of their "unhurried clanging, like four repeated notes of
an iron carillon" (157) the narrator notes with pleasure. Providing a
kind of aural transformation of the ocular pipes from the first seg-
ment, this melodious metallic soundtrack accompanies a display of
fleeting figures: a flour-dusted baker on a tricycle, a van transport-
ing green bottles, a long, black uprooted tree traveling on a cart and
whose roots are encased in burlap like an "enormous bomblike sphere
at its base" (158), a postman emptying letters from a blue mailbox and,
"perhaps fairest of all," a truck piled with animal carcasses – "chrome
yellow, with pink blotches, and arabesques" – which are being carried
by a man in apron and leather hood from the street into the butcher's
red shop (158).

The activity of representation, it is becoming plain, is in the process of being cinematically reconstituted in this vignette. If, in the previous section, the literary-cinematic streetcar was still reliant on a linear process of sentences coupling and uncoupling like trolleys attaching and detaching, here the process of writing itself is transformed. The tongue-in-groove motion of the streetcar that traced looping characters around the metropolitan center like a pencil following the well-worn rails of the alphabet becomes derailed by an arrangement of colorful, fast-moving images. Suggestive of filmic montage, what flits by in this vignette are primarily colors: white, emerald, black, beige, cobalt, chrome yellow, pink, and finally, the crimson of the "butcher's red shop" (158). Flickering like scarcely noticed scratches on the surface of our 'reality,' these flying colors send coded cinaesthetic letters through the black and white page. Recalling the prismatic Comma butterflies that diverted the young Nabokov from his French governess's "reading voice" in *Speak, Memory* (448-9), these letteral cuttings, too, glide through the fourth wall of our reading machine to punctuate *this* side of the representational divide, before a jiggle of the cord returns the story's trolley pole that has "jumped the wire" (*Stories* 156) back to its accustomed place and our cinematic tour moves on to its next attraction.

Entitled "Eden," the fourth vignette describes a visit to the Berlin zoo, an "artificial" paradise that mimics the "solemn, and tender, beginning of the Old Testament" (158) but with a different narrative of origins. We are treated to a vision of the aquarium, illuminated displays behind glass "that resemble the portholes through which Captain Nemo gazed out of his submarine" (158). A prelapsarian world glides past us from our "dimly lit" vantage point (158) beside the narrator. With him, we peer through another transparent screen, a window this time into a premammalian world, filled with heterologous life forms that undulate, breathe and flash in accordance with a different set of physiological laws than our own. Gazing at this subterranean procession of prismatic geometries, the narrator's eye pauses for a moment to land on a "live, crimson, five-pointed star" (158).

The infamous symbol of Russia's revolution, it transpires that it is from this ruby star that the whole subterranean transportational network we have been excavating ultimately issues: for here, then, the narrator conjectures, "is where the notorious emblem originated – at the very bottom of the ocean, in the murk of sunken Atlantica, which long ago lived through various upheavals while pottering about tropical utopias and other inanities that cripple us today" (158). Five elegant fingers radiating outwards, sheer index without reference, the sea star (*Fromia indica f. elegans*) registers as the circumvolving principle

behind the entire cinematic system of representational transformations and substitutions, of spectral doublings, of double- and triple-crossings that engulf Nabokov's novels, living on throughout all history – registering indeed as operator of history itself insofar as "history" names simply the appalling "upheaval," the principle of rotation that converts world into representation, metamorphoses matter into memory, and unleashes the entire nebula of shadows and shadow plays that, under the pseudonym 'cinema,' befogs the Nabokovian oeuvre. An ancient, immortal star system lurking beneath Earth's surface, it is from its preternatural rays that the molten points, lines and planes of Nabokov's cinaesthetic descends.

The final section returns us to the pub from which we began, with its faux "sky-blue sign" and a neon portrait of a winking lion, "LÖWENBRÄU." Here, through a doorway, the narrator picks out the image of a child sitting alone below a mirror in which the entire scene before him is reflected. The boy is the child of the pub owners, a little blond *Bube* who surveys the scene before him. The narrator asserts: "Whatever happens to him in life, he will always remember the picture he saw everyday of his childhood from the little room where he was fed soup" (159-60). Regarding himself reflected in the mirror, our guide then sees precisely what the child sees: "the inside of the tavern – the green island of the billiard table, the ivory ball he is forbidden to touch, the metallic gloss of the bar, a pair of fat truckers at one end and the two of us at another." As he views himself as the child sees him, the narrator loses whatever real substance he still held. He becomes an image in someone else's memory, a chance background figure in a photograph. "I can't understand what you see down there," complains the narrator's imbecilic friend. "What indeed!" the narrator exclaims to himself. "How can I demonstrate to him that I have glimpsed somebody's future recollection?" (160).

Our guide has led us to the revolving doors of "Berlin" as a cinematic city, a filmic 'parallel universe' of pre-revolutionary Russia, fake copy of an original St Petersburg, which itself no longer exists except in the fabricated form of literary memory, as the "careful reconstruction of [an] artificial but beautifully exact Russian world" (*Speak* 590). This is a city synthesized by a tensile geometry whose lines and points will be pulled, stretched and deformed to comprise the letteral foundation both of the cinematic image and its literary Other, writing – both equally spectral planes in Nabokov's later works as it will turn out. Thus "Berlin" reveals itself to us as a city of refraction and cinematic chimera, where Time is indexed as the spooling and unspooling process in which primordial letters fold and unfold to form signs that are the mnemonic traces of no conscious being, where Life resolves to the

winking, hallucinatory movement of these shapes as they accelerate and gather speed beneath our eyes, where History discloses its source in the mechanical rotations of a subterranean star system, and where Memory marks the site of a decentering de-identification that projects the narrating subject into the future as a photographic trace of a spectral spectator who has in effect has never 'lived' anywhere.

Nabokov's writing repeatedly inquires into the ontological basis of representation. If early cinema offered Nabokov a metaphor for rethinking ordinary models of space, time and movement, it also accords him many of the rhetorical and conceptual moves associated with the Freudian unconscious. It is to cinema he will turn throughout his works in his lifelong project to deflect the unidirectional flow of time's arrow. Like the unconscious, for which, famously, no concept of time exists, cinematic signification makes the past appear to 'live' again, beyond the limits imposed by ordinary models of perception and cognition. For both cinema and the unconscious, the past, as Henry Sussman has put it in a different context, "is not a conveyance toward a future conceived of as unbounded space. Instead, it draws the circle of the horizon to a close" (Sussman 20).

3 This Q de Telephone: 'Signs and Symbols'

> In the beginning was the telephone. We can hear the
> telephone constantly ringing, this *coup de telephone* which
> plays on figures that are apparently random but about which
> there is so much to say.
>
> —Derrida, *Ulysses Gramophone*

Since its first publication in *The New Yorker* in 1948, Nabokov's short story "Signs and Symbols" has become one of his most critically celebrated, if famously cryptic, tales. This is largely due to a suggestion Nabokov made to his editor, Katharine S. White, that the story contains an encoded meaning. As Nabokov famously explained, "Signs and Symbols" and "The Vane Sisters" are texts in which "a second (main) story is woven into, or placed behind, the superficial semitransparent one" (*Selected* 117). But while Nabokov, also famously, divulged the secret of "The Vane Sisters" as an acrostic message encrypted in the first letters of each sentence in the final paragraph – "Icicles by Cynthia, Meter from me. Sybil" – the "second (main) story" of "Signs and Symbols" remains as yet undeciphered despite the best efforts of the critical tradition.[25]

For the most part, the critical detective work has focused on the identity behind the third telephone call. As is well known, "Signs and Symbols" ends with three phone calls – two wrong numbers and a third unanswered one that rings off the tale. In the first two, a girl's "dull little voice" asks to speak to "Charlie." Crucially, however, the third caller remains a mystery: are we to understand this as the same young woman trying again, despite having had her dialling error already explained to her by the mother ("I will tell you what you are doing: you are turning the letter *O* instead of the zero")? Is it a missed message from the hospital informing the parents about their son's successful suicide this time? A call from the couple's son himself perhaps, who has escaped from the hospital and is now on the run? Or, as in Alexander Dolinin's ingenious reading, a ciphered message of reassurance from the (dead) son calling in from the other world through the number 6? (Dolinin n.p.).

One should recall that Nabokov himself had little patience for reading methods that treat words and images merely as signs pointing towards a secondary, "symbolic" signification. Reviewing W.W.

Rowe's *Nabokov's Deceptive World* (1971), Nabokov is ferocious in his critique:

> The various words that Mr. Rowe mistakes for the "symbols" of academic jargon, supposedly planted by an idiotically sly novelist to keep scholars busy, are not labels, not pointers, and certainly not the garbage cans of a Viennese tenement, but live fragments of specific description, rudiments of metaphor, and echoes of creative emotion. (*Strong Opinions* 305)

"The notion of symbol itself has always been abhorrent to me," he concludes.

If we leave aside for a moment the implied reference to Joyce, it is Nabokov's characterization of Freud – the clear occupant of the "Viennese tenement" – as exemplifying detested "symbolic" modes of reading that I wish to pursue initially. For in its claim to detect in one's ordinary speech an encoded message about what polite society throws out, namely sex, psychoanalysis seems to be the worst offender of this type of over-reading. And certainly, Nabokov's repudiation of Freud is legendary. All throughout his essays and his novels, Nabokov takes enormous delight in poking fun at the "Austrian crank with a shabby umbrella" (*Strong Opinions* 116). His novels are peppered with thinly veiled Freudian "symbols," which Nabokov also mockingly points out to readers: "We must remember," Humbert Humbert advises, "that a pistol is the Freudian symbol of the Ur-father's central forelimb" (*Lolita* 196).

But what I would like to explore is what happens if Nabokov's baroque anti-psychoanalytic posturings turn out to have been a distraction – a magician's trick, or "intricate masquerade" as Mikołaj Wiśniewski has suggested (Wiśniewski, n.p.) – designed to focus attention away from what he and Freud (as well as Lacan) have in common. For it is not only their mutual interest in sex – especially that "nicest" science (*Ada* 213), incest – that they share. It is also, as the anagram suggests, Freud's and Nabokov's central investment in language as the site of puns, double meanings, homophony, jokes – of writing itself as the *material* inscription of letters. Given these significant points of intersection, how are we to account for Nabokov's legendary antipathy to the talking cure?

In a perceptive discussion of this relation, Leland de la Durantaye remarks on the crucial difference of their respective 'styles.' He observes that while Nabokov and Freud are equally fascinated with the particularities of the individual, psychoanalysis is driven to subsume them within larger, overarching narratives such as the family romance (de la Durantaye, "Nabokov and Freud" 62). Because of this

tendency, Freudian psychoanalysis would be anathema to a writer for whom the essence of art "dwells in the details" (de la Durantaye 69). Accordingly, in Nabokov's opinion, psychoanalysis has "something very Bolshevik about it" – there is "an inner policing [...] symbols killing the individual dream, the thing itself" (de la Durantaye 61). And admittedly, some of Freud's statements in his lecture on the dreamwork do read as bad caricatures. It is not only the "pistol" that represents the male genital, one learns in Freud's Tenth Lecture from his 1920 lecture series, *A General Introduction to Psychoanalysis* (through which Nabokov may in fact have first encountered the Viennese quack's work[26]), but various other objects do as well, forming a compendium of phallic dream symbols, which Freud lists as follows:

> In the first place, the holy figure 3 is a symbolical substitute for the entire male genital. The more conspicuous and more interesting part of the genital to both sexes, the male organ, has symbolical substitute in objects of like form, those which are long and upright, such as *sticks, umbrellas, poles, trees,* etc. It is also symbolized by objects that have the characteristic, in common with it, of penetration into the body and consequent injury, hence pointed *weapons* of every type, *knives, daggers, lances, swords,* and in the same manner *firearms, guns, pistols* and the *revolver,* which is so suitable because of its shape. (Freud, *General Introduction* 60)

Freud goes on to explain that these "symbolic" objects include a number of other representatives whose attributes are also evidently shared with the male member:

> *faucets, water cans, fountains,* as well as its representation by other objects that have the power of elongation, such as *hanging lamps, collapsible pencils,* etc. That *pencils, quills, nail files, hammers* and other *instruments* are undoubtedly male symbols is a fact connected with a conception of the organ, which likewise is not far to seek. (60)

Next come references to flight (a figure for "erection"), teeth ("a particularly remarkable dream symbol is that of having *one's teeth fall out,* or *having them pulled*"), clothing ("the *cloak* represents a man, perhaps not always the genital aspect"), as he warms to his topic:

> The *shoe* or *slipper* is a female genital. *Tables* and *wood* have already been mentioned as puzzling but undoubtedly female symbols. *Ladders, ascents, steps* in relation to their mounting, are certainly symbols of sexual intercourse. [...]

> The breasts must be included in the genitals, and like
> the larger hemispheres of the female body are represented
> by *apples, peaches* and *fruits* in general. [...]. The compli-
> cated topography of the female genitals accounts for the fact
> that they are often represented as scenes with *cliffs, woods*
> and *water,* while the imposing mechanism of the male sex
> apparatus leads to the use of all manner of very complicated
> *machinery,* difficult to describe. (61)

Reading Freud's litany of sexually-charged dream images alongside
Nabokov's "Signs and Symbols," one wonders if whether Katharine
White's proposed (but rejected) subtitle for the tale – "a Holiday
Excursion into the Gloomy Precincts of the Modern Psychiatric
Novel" – was not so far off the mark after all, for all of these "sym-
bols" are liberally sprinkled throughout Nabokov's (conspicuously *tri-
partite*) tale.[27] For in it one reads how the "underground train" (a piece
of Freudian "complicated machinery") "lost its life current" (*Stories*
598); how the father first opens then closes his umbrella (599) ("*sticks,
umbrellas, poles, trees,* etc."); how the son's gesture is (crucially mis-)
understood as attempted *flight* (599). There is a laborious stair climb:
"He walked up to the third landing" [...] he sat down on the steps"
(600); a scene of tooth removal: "Straining the corners of his mouth
[...] with a horrible masklike grimace, he removed his new hopelessly
uncomfortable dental plate and severed the long tusks of saliva con-
necting him to it" (600); a vision of cliffs: "an idyllic landscape with
rocks on a hillside" (601); blossoms: "mangled flowers"[28] (601), a coat:
"wearing over his nightgown the old overcoat with astrakhan collar"
(601); a family member nicknamed the Prince: "In our families we
refer to our children as princes, the eldest as the crown-prince" (598).
Paper, tables and books – Freud's symbols for women – also make
their appearances in the references to playing cards, the photo album,
the (threatening) wallpaper, the labels on the fruit jellies (600-601).
 When the telephone rings for the first time, the father is engag-
ing in a complicated dance with his slipper: "His left slipper had
come off and he groped for it with his heel and toe as he stood in
the middle of the room, and childishly, toothlessly, gaped at his wife"
(602). As he develops his plan to rescue their son, the father muses
that "*Knives* would have to be kept in a locked drawer" (602). Finally,
we have the ten fruit jellies themselves: "apricot, grape, beech plum,
quince, crab apple" (603). "*Fruit* does not stand for the child, but for
the breasts," Freud avers (Freud, *General Introduction* 61). If anyone
suffers from "referential mania," it would seem to be Freud himself,
Freud for whom – at least in this popular address – every individual

comes equipped with unconscious knowledge of these "symbol-rela-tionships," all of which turn around and around the same universal "theme" of sex and repression.

However comical Nabokov's Freudian impersonation, if "Signs and Symbols" were simply Nabokov's joke at the expense of Freud's dream symbolism, there would be little cause for it to occupy the place that it does within his oeuvre. Waspishly, Nabokov rejected White's query about his possible parodic intentions, responding in his letter of July 15, 1947, "I am afraid, I do not understand to what 'Modern Psychoanalytic Novels' you refer (unless they are my own) for I don't read much fiction."[29] Given the story's primacy in Nabokov's oeu-vre – Nabokov even commented it was an "old favorite" of his (*Strong Opinions* 302) – it demands another look. But I suggest this not because critics have simply failed to find the encrypted message "woven into or placed behind" the first, "semi-transparent" story, leaving open once more the possibility of a completed transmission, which is to say, the possibility of a reading authorized by a referential order of significa-tion. If its overdetermined title suggests "Signs and Symbols" as a self-reflexive theorization of Nabokov's theory of aesthetics, the "master-piece of inventiveness" it represents must be sought in another model of meaning-production and another mode of reading, one that focuses not in what the story says but what it in fact does.

Hyper-Referentiality without Reference

Curiously, Freud himself offers a glimpse into what this other model might be. Towards the end of his "Symbolism in the Dream" lecture, Freud remarks on the case of an "interesting mental defective" who believed in the existence of a non-representational language. "I am reminded," he comments, of a patient "who had imagined a funda-mental language, of which all these symbolic representations were the remains" (Freud, *General Introduction* 77). Freud's "mental defective" envisions a language that evades the gap the linguistic sign introduces. Dissolving distinctions between word-presentations and thing-pre-sentations, the "fundamental language" does not abstract but rather every perceptual object becomes saturated with an all-encompassing signifyingness, similar to the dream-logic but on an absolutized scale. All would be dreamwork in the sense outlined by Freud. In a dream, "'things' themselves are already 'structured like a language,'" Slavoj Žižek comments.[30]

This seems an accurate description of the perceptual affliction of the couple's son in "Signs and Symbols":

> Phenomenal nature shadows him wherever he goes. Clouds
> in the staring sky transmit to one another, by means of slow
> signs, incredibly detailed information regarding him. His
> inmost thoughts are discussed at nightfall, in manual alpha-
> bet, by darkly gesticulating trees. Pebbles or stains or sun
> flecks form patterns representing in some awful way mes-
> sages which he must intercept. Everything is a cipher and of
> everything he is the theme. (*Stories* 599)

"Referential mania" – the diagnosis of the suspiciously-named doc-
tor "Herman *Brink*" – is therefore clearly a misnomer for this condi-
tion, which is characterized rather by the absence of an external real-
ity, of any referential "beyond" to which representation points. In the
son's signifying system, literally anything can become a signifier, and
each resultant signifier is both a sign *and* a symbol carrying the same
invariable message. This is also, Freud reminds us, the latent "mean-
ing" of dreams: "of everything he is the theme."[31]

 In the son's short-circuited or 'paranoid' signifying system, signifi-
ers and signifieds slide frictionlessly into each other. Representational
language collapses in upon itself as a multi-media sensoria where liter-
ally any object – clouds, trees, pebbles, shadows – is potentially leg-
ible. Proto-linguistic forms erupt from the phenomenal world in an
arche-cinematic language of light, dark and motion. What becomes
recognizable as letters and words would simply be the off-cuts, the
debris thrown out centripetally by the rotations of this all-encompass-
ing formalization. However there can be no hierarchical organization
here, none of the structure provided by representational models of lan-
guage is possible in a signifying regime where "everything is a cipher"
of itself. The letter always reaches its destination because everything
is a receptor of everything else, the receiver identical to the sender, and
the message always the same: "*âllo, c'est moi!*"

 As he fixates, hypnotized by the hyper-textuality of every particular,
the couple's son therefore seems an exemplary reader of Nabokov. For
like the son, Nabokov is preternaturally alert to the intricacies of form
and its latent legibilities in the phenomenal world. In *Speak, Memory*,
for example, Nabokov describes how, as a constipated child, he would
obsessively "unravel the labyrinthine frets on the linoleum, and find
faces where a crack or a shadow afforded a *point de repère* for the
eye" (*Speak* 430). There is an additional aspect, too, that the son's and
Nabokov's perceptual regimes seem to share. I am talking of course
about Nabokov's well-known penchant for self-referentiality, his
characteristic self-inscriptions into his texts. Like Alfred Hitchcock,
with whom he also shares an uncanny visual resemblance, Nabokov

notoriously "worms" (Hitchcock 122) his way into his writings, twanging the fourth wall with his cameo presences, most famously in butterflies and moths whose wingbeats mimic the initials of his name. Such "signatures" as de la Durantaye baptizes them, are connected in the critical tradition with an image of Nabokov as arch aucteur. Their self-citational structure denotes "principally the conscious and willed fact of their signing" (de la Durantaye, "Pattern" 318).

But again, I want to ask rather if a trap has been set for us in this authorial figure who, mesmerizing critics from the beginning, circulates in the critical tradition as the ultimate referent of Nabokov's work. Posing as Nabokov the Godlike Creator whose machinations are dimly perceived by his characters, this persistent, extra-dimensional presence reveals, as D. Barton Johnson puts it, "the absolute supremacy of the artist over his art" (Johnson 412). Yet perhaps this "Nabokov" has only been one more illusory shape in the hall of mirrors that comprises this master of deception's oeuvre. Is "Vladimir Nabokov" simply another mask, one that secretly upends the logic of referentiality that it purports to guarantee? For is it not instead that, by insinuating the existence of secret messages hidden in his texts, by inviting us to "find what the sailor has hidden" (*Speak* 629), Nabokov lures us into a double-bind, one which no act of reading, no matter how virtuosic or inventive, can defend against? If a number of readers have already sensed something of a trap in "Signs and Symbols,"[32] the wider implications become stark when one reads the tale against this habitual backdrop of the all-controlling Nabokov.

What occurs is a sort of ontological gear-shift, an inversion of positions that sees the reader transformed into an acutely filial 'son' perpetually on the lookout for the author's ciphered "theme." Inscribing us as his 'paranoid' readers in advance, Nabokov thereby literally writes us into his textual universe as it spins out from this, his "old favorite" tale. Which is also to say that in our obsessive flushing out of the signs of his works' ultimate symbol – "Vladimir Nabokov" – we find ourselves transformed into "referential maniacs" imprisoned within the author's signifying regime, a performative appropriation of identity that would stage us as characters *inside* Nabokov's hermetic discursive universe. Like a faulty telephone connection that reroutes all outgoing calls to home, "we," then, would be the third caller, the ones who, in a truly breath-taking gesture of Nabokov's power and control, are conscripted as Operators to loop the tale back in upon itself, thereby completing the Author's message to self.

If reading Nabokov, in the sense of deciphering a second-order meaning, is foreclosed in advance by the author's absolute usurpation of the reader's role, if the openings of every "symbolic" interpretation

are permanently diverted, pulled around to débouche at a "Vladimir Nabokov" who in preceding us has always anticipated them, are we then to understand this as the "second (main) story" that the fantastically egotistical Nabokov has encoded into his tale? As tempting as this conclusion may be, my suspicion is that it is not the whole story. My sense is based not only on the fact that a warning is given against a too rapid understanding of what is at stake, where the boy's previous "masterpiece of inventiveness" was misread by an envious fellow inmate who, believing the boy was learning to fly, prevented what the hospital staff "brightly" interpreted as yet another a suicide attempt (*Stories* 599). For it also seems that such a solution would miss something fundamental to Nabokov's aesthetic wager, which is the "chance," as he puts it in *Speak, Memory,* for mortality "to peer beyond its own limits, from the mast, from the past and its castle tower" (*Speak* 396). Resonating in "Signs and Symbols" as the son's desire to "tear a hole in the world and escape," both Nabokov and the son propose some sort of fundamental intervention in the spatial and temporal structure of the world.

Indeed, such a solipsistic, even 'psychotic' solution would suggest a too close identification of Nabokov with that other supreme egoist of modern literature, Joyce. Although Joyce (along with Proust and Kafka) was named by Nabokov as one of the three greats of modern literature, I will suggest that what lends Nabokov's project its unique performativity is something that does not devolve to a writer's private language, laced with so many topical allusions, intralingual puns, fragments of found language, etc. that it takes scholars centuries to decode.[33] Nabokov and Joyce clearly share a mutual fascination with multisensory phenomena, with the ways that, overflowing both signs and symbols, language is shot through with a *moiré* pattern of phonographematic inscription that interferes with its transmission as a medium of communication. Nevertheless, the "immortality" Nabokov seeks through his writing represents a more audacious claim than what may be gained by the navel-gazing of an "idiotically sly" novelist. If, in "Signs and Symbols," this claim is mediated through the telecommunications technologies of the early twentieth century, it is to highlight something about language's own technicity that exceeds the self-enclosed, the "masturbatory" and tautological dimension of language that in Lacan's estimation limits Joyce's work (Rabaté 5-6). Which is also to say, there is an opening gained from the exigencies of a 'wrong number' that surpasses the controlling power of authorial will.

The Nabokovian Unconscious

"Signs and Symbols" ends with the father elated with his plan to res-
cue his son from the hospital. As the couple sit down to their "unex-
pected festive midnight tea" (602), the father puts on his glasses and
begins to "spell out" the fruit jellies' "eloquent labels" (603). Let us
follow his lead and spell out these letters along with him, recalling
that the rotary telephone dial contains both numerical symbols and
alphabetical signs. These latter were designed as mnemonic devices,
aids for memorizing the arbitrary sequence of phone numbers by trans-
coding them into recognizable words. In doing so, one almost imme-
diately falls into a problem: whereas "apricot," "grape," and "beech
plum" readily transcode into dial-able numbers,[34] we stumble when
we get to quince, since there is no Q on the old rotary dial. But despite
this occlusion, the Q nonetheless mobilizes in another fashion: as one
discovers from a quick internet search, in "manual alphabet" the let-
ter Q is shaped by pointing the index finger downwards, that is, in the
very *gesture* one makes *when dialling.*

In the repetitive, circular activity of dialling a number, a letter is
called forth. This letter, Q, must be set against both the sign and the
symbol, designating in this case not a confusion of letters and num-
bers – that is, the O misread as 0, a hermeneutic mistake – but a gap
in the representational field, what Lacan would call a "true" hole. As
a hole, it resists transcoding if by this we understand a one-to-one
pairing of signifying units. Once called into being by the body's three
dimensions, this Q cannot simply be transcoded back into the two
dimensionality of either a sign or a symbol. Literally a knot, the Q
ties off the endless metonymies of the signifying chain. The Q dis-
connects, and what it finally disconnects from is language's intrinsic
self-referentiality, its tautological structure that, leaving no space for
an absence of sense, can only crystallize into the total signifyingness
of the son's "dense tangle of logically interacting illusions" (601).

When Lacan, in his own discussion of signs and symbols in
Seminar 2, raises the question of the difference between Imaginary
and Symbolic representation it is by way of the figure of the cycloid.
The cycloid is the repeating pattern formed by a point on a wheel as
it cycles over the ground. Lacan observes how, from the perspective
of the Imaginary, this pattern cannot be perceived because it is not
available to intuitive apprehension – there are no wheels in nature. The
cycloid is a true discovery ex nihilo, a "discovery of the symbolic" as
he puts it (Lacan, *Seminar* 2 306). As such, the cycloid offers Lacan a
means of demonstrating how structure may be invisibly in play, exert-
ing an off-stage influence beyond intuitional or "Imaginary" models.

We begin to see, perhaps, why this might be of particular interest to Nabokov whose extra-literary interests are well known. Operating in language somewhat like a finger-stop of the telephone dial, the Q, as a hidden principle of direction also sets in play an ordered register of 'turns,' that is, the notion of scansion that turns out to have interesting properties. The analogy is with the emerging science of cybernetics. Stephen H. Blackwell has shown that Nabokov's range of scientific interests went well beyond his expertise in biological systems. From certain observations in Nabokov's lectures on Chekhov, Blackwell concludes that Nabokov had been closely following developments in the new physics throughout the 1920s and 1930s (Blackwell 140). Although excluded from Blackwell's study, it seems quite possible too, then, that Nabokov, an ardent creator of chess problems, would have also encountered the work on computation, information theory and game theory that began appearing in the late 1930s and the 1940s, including in the same year as "Signs and Symbols," the publication of Norbert Wiener's *Cybernetics or Control and Communication in the Animal and the Machine* (1948) and Alan Turing's "Intelligent Machinery" (1948).

If Nabokov's reading in this field cannot be assumed, we nevertheless know that Lacan was demonstrably interested in cybernetics. In the 1955 lecture titled "Psychoanalysis and Cybernetics, or on the Nature of Language" referred to above, Lacan invokes a certain 'independence' in the chain of possible combinations of absence and presence. An extra-subjective 'agency' also forms the basis of his analysis of Poe's "The Purloined Letter." In it, one recalls, Lacan reflects on how a series of chance events such as coin tosses generate certain patterns once they have been recorded in particular ways, as for example in triplets or overlapping pairs (Lacan, *Seminar* 2 193). Such patterns register a 'memory' of past events, representing a sort of archaic structure or 'law' that prevents certain combinations from occurring.

What interests is what happens next. In an intriguing, complex couple of essays on the suite of exercises Lacan appends to his Seminar on "The Purloined Letter," S Berlin Brahnam details the results of the computational process by which a series of binary events such as the pluses and minuses of the coin toss (or Fort-Da of the mother's comings and goings) become transcoded into numbers (1,2,3), which are in their turn transcoded into letters (α, β, γ, δ) (Brahnam, "Computational" 264). This is Brahnam's description of what took place when she worked Lacan's computational model beyond the point where he had left off:

I let the model run, investigating its productions until it gen-
erated the letter code, whereupon I created a virtual reset
point. Thereafter, I systematically repeated runs of letters,
first for two time steps, then for three, and so on, tracking
the patterns that emerged as all possible strings of a given
length were punctuated by a halt. Surprisingly, beginning at
time three, some letters that had appeared at previous time
steps completely disappeared when strings were halted at a
later time, and variations of this disappearing act continued
for as long as letters were added and strings were halted.
(Brahnam, "Computational" 264)

If, as Brahnam explains, Lacan's chief interest in cybernetics at this
early point in his teaching is to demonstrate the subject's determinism
by formal language, it is another aspect of this result that would be of
considerably more interest to Nabokov. For it seems that the simple
act of transcoding 'causes' something peculiar to occur. Something
happens when switching from binary inscription to number and then
to letter; there invariably comes to be a doubling up, which is the func-
tion of what Lacan calls the "two-sidedness" in the letter.[35] It is this
doubleness, the two separate pathways that the letter can take – equiv-
alent to the pathways to the Symbolic or to the Real – that prevents the
chain from continuing on indefinitely. And in amongst all of this, what
would be crucially of interest for Nabokov is the following discovery.
Brahnam explains that the hole produced at such halts in the chain
causes a *rewrite* of *past sequences*:

Had Lacan continued to follow the chain of letters, the codes
would have revealed to him not only the evolution of one
special moment at time four, when retroactive holes open
up, producing "a certain *caput mortuum* of the signifier," but
another at time five, a moment that rewrites the past by erect-
ing at time three a single letter/signifier. [...]. I discovered, in
other words, that a halt (an interruption of the chain) always
produces a retroactive effect that opens up a hole in the past.
("Computational" 264)

The question is whether this rearrangement of the patterns resulting
from these "holes" represents some sort of 'message' that devolves
neither to the encrypted meaning of an intentional subject, nor to a
ghostly communication from the "Otherworld" that Dolinin and oth-
ers have postulated. It supposes a message – a 'wrong number' but
never calling in error – from the Real. In Nabokov, just as much as in
Freud and Lacan, as Eric Naiman has convincingly demonstrated, the

Real persistently dials in with its "perverse" message (Naiman), which is to say, a letter about *jouissance,* a form of enjoyment that constitutively evades the paternal prohibition represented by the "Ur-father's central forelimb."

Readers familiar with Lacan's Seminar on Joyce will recall how Joyce is said to sign his texts with his *"sinthome"* – the combination of the letters of his name that supplements his Borromean knot of the Symbolic, Imaginary and the Real (Lacan, *Seminar* 23 12). Lacan maintains it is through this fourth ring, designated by the square bracket of his ego or name, that Joyce sustains the connection among all three registers in the face of his missing Name-of-the-Father. Creating a *sinthome* of his name shields him from his latent "psychosis." For Nabokov, too, his proper name is the privileged site of a signature effect, a "signing" of the ego, or I, that serves to link the Symbolic to the Imaginary and to the Real. Yet I would like to suggest that in Nabokov's case, the letteral patterns engendered by his anagrammatic origami are not invoked for the false "immortality" bestowed by the university discourse's hunting parties. Rather, something like a radical intervention into time and, consequently, mortality itself, is at stake when a "hole" in representation is produced as a consequence of being written – or spelled – out with letters. It is from writing, Lacan maintains, that true holes – knots – emerge: "There is no topology without writing" (Lacan, *Seminar* 23, lesson of 10.3.71).

How, then, is one to read Nabokov? By *working* Nabokov, which is to say that, by taking him literally, letterally, one puts into place the conditions under which a halt in the signifying chain can occur. It requires "spelling out" the "eloquent labels" suggested by his signatures to enable something irreducibly singular come to light. If this potential is always the product of what Nabokov in *Speak, Memory* called "chance," it also now appears that chance is never purely random when letters are in play. There is a "signifying finality" as Lacan puts it behind every error or lapsus (Lacan, *Seminar* 23 127). Nabokov gambles that spiraling the letters of his ultimate symbol – "Vladimir Nabokov" – will be the combination that "tears open" the spacetime dimensions of the world, a "teletechnic envoy," as Tom Cohen has put it, "of a different mnemonic or material time" (Cohen, *Secret* 132). If one can risk naming this the Nabokovian unconscious, it also suggests that Nabokov's Real relation to psychoanalysis has yet to be read.

4 Black Bile: *Pale Fire*

> I myself
> Rich only in large hurts.
> —*Timon of Athens*

Pale Fire was written while Nabokov was translating Pushkin's famous poem, "Eugene Onegin" – or "You-gin One-Gin" as Nabokov liked to call it (Boyd, *American* 112). His "literal" translation of Pushkin was a daring approach in 1964, ultimately costing him his friendship with Edmund Wilson in a public falling out in *The New York Review of Books*.[36] Nabokov's *Eugene Onegin* was notable primarily for its refusal to conform to the unspoken convention of the time that poetic translations should faithfully reproduce the rhythmic and metrical patterns of the original.

In his Foreword justifying his unorthodox choice, Nabokov describes the three ways a translator may approach the work. There is

- the "free" or "paraphrastic" translation of the original, with omissions and additions prompted by the exigencies of form;

- the "lexical" or constructional translation that maintains the basic meaning and order of words;

- and finally the "literal" approach, which Nabokov calls the "only true translation." This is achieved by using the associative and syntactical capacities of the new language to render "the exact contextual meaning of the original." (*Pale* vii-viii)

Nabokov acknowledges the Sisyphean nature of the literal translator's "task": "He may toy with 'honourable' instead of 'honest' and waver between 'seriously' and 'not in jest'; he will replace 'rules' by the more evocative 'principles' and rearrange the order of words to achieve some semblance of English construction and retain some vestige of Russian rhythm." But if he is still not contented, Nabokov explains, "the translator can at least hope to amplify it in a detailed note." And in his Commentary that accompanies his Pushkin translation, Nabokov does precisely this, writing more than 1000 pages of critical annotations.

With its quadruple structure composed of a lengthy Foreword, John Shade's Poem, Kinbote's Commentary and an ambiguously authored Index, Nabokov's *Pale Fire* ironically mimics the shape of his "Eugene Onegin" translation. In this respect, *Pale Fire* extends Nabokov's fondness for creating doubles in and of his works. His first English-language novel, *The Real Life of Sebastian Knight* (1941), for example, reads as a kind of first-run for material that would later appear in *Speak, Memory* (1951) (itself subject to a further parodic rewriting in the late novel *Look at the Harlequins* (1974)). A key characteristic of these multiplying textual doubles, also shared by *Pale Fire*, is the way that what they imitate is *already* a fake or bastardized text – each text a "double redoubled" as Alan Cholodenko would say (Cholodenko, *Illusion* 493). Thus *Speak, Memory*, putatively the true memoirs of Nabokov's own "real life" and therefore invested with the full aura of autobiographic authority, in fact re-presents a number of events that have been culled from their prior fictional telling in *The Real Life of Sebastian Knight*. Complications multiply with the latter novel's titular conceit that the novel is the narrator, V.'s, attempt to set the truth straight following the earlier, unauthorized publication of Sebastian's biography by a certain Mr Goodman. (The novel thus strangely anticipates Nabokov's own future difficulties with his first biographer Andrew Field, but this is another story[37]). To read Nabokov is to roam through a strange hall of textual fun-house mirrors: in the case of *Pale Fire*, the poem-as-novel parodies the English translation of an iconic Russian novel-in-verse, translated by a Russian speaker whose mother tongue has been wrested from him by his exile in America.

Who wrote "Pale Fire"? Presenting as a 'whodunit' mystery, the question of the poem's internal authorship has most exercised the critical reception of the novel to date. Is it John Shade, the ostensible poet named as such in the text? Or his editor, Charles Kinbote (aka Charles II, aka Charles the Beloved)? Or perhaps someone else again, for example the Russian scholar, Professor V. Botkin, some see as a thinly-disguised alter ego of the deranged Kinbote? (DeRewal and Roth, 2009, n.p.). But if this critical question has not yet been satisfactorily answered, it suggests it has not been correctly posed. The obsessive scrutiny of the seemingly impossible coincidences and spiritual concordances among the characters in fact suggests a comically collective, almost 'Kinbotian,' effort on our part to miss Nabokov's point. For it is the total breakdown of authorial identity, of linguistic 'personhood' altogether that is at stake in Nabokov's aesthetic wager, along with the systems of power and legitimacy that underpin these tropes. What is this wager? It is that death can be defeated through literary art – albeit, as we will see, an 'art' of a very particular kind.

Black Bile: Pale Fire

Turning to the novel, this twisting Möbius-strip of a text is simultaneously a mourning song – John Shade's 999-line poem torquing under the pain of the poet's loss of his daughter Hazel to suicide – and Charles Kinbote's critical commentary on the poem, which subsequently becomes the organ through which Kinbote underhandedly slips us his secret history of Charles II's flight from the Kingdom of Zembla that has been taken over by rebels, Charles's clandestine arrival in America, his friendship with Shade, and the latter's accidental death by a bullet supposedly intended for the fugitive King shot by a certain Jacob Gradus ("alias Jack Degree, de Grey, d'Argus, Vinogradus, Leningradus, etc." as the Index helpfully informs the confused reader). It rapidly becomes clear from his ballooning Commentary, which gradually overtakes and supersedes the poem, that Kinbote has been imagining all along that Shade's rhyming epic would relate his story Charles the Beloved's heroic escape following the Zemblan revolution, whose details Kinbote has been drip-feeding Shade during their evening walks in New Wye. Kinbote's disappointment when he finally sees Shade's manuscript – which he has squirrelled away beneath a pile of girls' galoshes and furred snowboots in the confusion following the poet's death – is profound. Far from a paean to Charles's lost kingdom, the poem presents merely the rather "dull" theme of Hazel's portrait which "has been expanded and elaborated to the detriment of certain other richer and rarer matters ousted by it" (*Pale* 556). Of these other "richer and rarer" matters, the poem contains in fact only one vague reference in line 937, which Kinbote annotates in his Commentary thus:

> I am a weary and sad commentator today. Parallel to the left-hand side of this card (his seventy-sixth) the poet has written, on the eve of his death, a line (from Pope's Second Epistle of the *Essay on Man*) that he may have intended to cite in a footnote:
>
> *At Greenland, Zembla, or the Lord knows where.*
>
> So this is all treacherous old Shade could say about Zembla – *my* Zembla? While shaving his stubble off? Strange, strange… (*Pale* 635-6)

A Reading Failure

> But who is man that is not angry?
> —*Timon of Athens*

Upon receiving a rejection for his short story "The Vane Sisters," Nabokov wrote an irritable letter to his editor Katharine White at *The New Yorker* berating her for "failing" him as a reader. White had rejected the tale because she felt the story was irremediably hobbled by Nabokov's "overwhelming style" (White's phrase). But White's critical shortcoming was that she – *somehow* – overlooked the clue to the story's comprehension, namely, a hidden message written in acrostic in the first letters of each word in the final paragraph. In his letter, Nabokov anticipates White's objections: "You may argue that reading downwards, or upwards, or diagonally is not what an editor can be expected to do." Even still, he expresses a deep disappointment that White, "such a subtle and loving reader, should not have seen the inner scheme of my story" (*Selected* 115-116).

Nabokov's ill-tempered reaction to his failure to be properly read mirrors in inverse Kinbote's disappointment in Shade's poem, which similarly fails to tell 'his' story. For it is clear that what is at stake in *Pale Fire* is a war over poetic intentions, and one in which, at least superficially, the critic is victorious. Kinbote secretes his (anti-)heroic tale of Charles the Beloved's brave escape and exile from Zembla literally in between the lines of Shade's heroic couplets.[38] In usurping Shade's poem in this way, Kinbote covertly cites the book's title *Pale Fire* which, as is well known, itself 'steals' from Shakespeare's own dual-authored play in the form of a citation. *The Life of Timon of Athens*, written in collaboration with Thomas Middleton, is one of Shakespeare's notorious 'problem' plays. Focusing on the definition of generosity, *Timon of Athens* cycles through the stages of melancholy Robert Burton identifies in his magisterial "Anatomy of Melancholy": from man's initial excellency, his fall, miseries, and then to raging despair. Timon is initially a "good and gracious" Greek citizen, the "very soul of bounty," whose extravagant kindness towards his friends will find him denuded of his riches. "Englutted" by the Athenian's largesse, Timon's friends flee the moment he needs their assistance. "Burn, house! sink, Athens! henceforth hated be / Of Timon man and all humanity!" Timon shouts after them in his fit of legendary rage that for Walter Benjamin has become the prototype of the melancholic, a man he describes as being "past experiencing" (Benjamin, "Baudelaire" 335).

An uncommon cloud of black bile accordingly hangs over the play's entire fourth Act which opens with Timon piling curse upon curse on the people of Athens. By this point, the poverty-stricken Timon has abandoned the city to live as a hermit, feeding only on roots and his accumulating hatred of all humankind. Yet as he digs for sustenance, he comes across a hoard of gold. No sooner he has discovered it, he is

again "throng'd" by people who would steal his treasure from him. In scene 3, Timon lectures his would-be thieves on the nature of theft. Everything is a thief, he complains bitterly, although unlike his "knot of mouth-friends," the bandits in front of him are at least honest about their intentions:

> *The sun's a thief, and with his great attraction*
> *Robs the vast sea: the moon's an arrant thief,*
> *And her pale fire she snatches from the sun:*
> *The sea's a thief, whose liquid surge resolves*
> *The moon into salt tears.*
> (Act IV, scene iii, 2149-2155)

Thievery begets thievery. Stealing his novel's title from Shakespeare's treasury of signifiers is evidently not enough for Nabokov who will go on to parasitize Timon's speech. Here is how the words appear in the translation by Charles the Beloved's uncle, the aptly named Conmal (one who "cons" or learns badly, especially by rote) whose knowledge of English was apparently acquired by "memorizing a dictionary":

> *The sun is a thief: she lures the sea*
> *and robs it. The moon is a thief:*
> *he steals his silvery light from the sun.*
> *The sea is a thief: it dissolves the moon.*
> (*Pale* 491)

As with Nabokov's Pushkin, the radiant bloom of poetic language fades in Conmal's literal translation. A bare, stripped-down imitation replaces the Bard's fulgent language. But with this substitution, what Cohen calls the "whole premise of mimetic representations" is fatally undone. The copy 'prosaically' infiltrates the system of identity through which notions of poetic authority, ownership and linguistic propriety are maintained (Cohen, *War* 214). Shorn of the Bard's characteristic verbal flourishes, the bastardized Zemblan version "robs" Shakespeare of what makes him "Shakespeare" (although this "Shakespeare" is already, as we know, non-originary, because doubled in the play's murky dual-authorship). As he thieves from English literature's most eminent son, Nabokov implicitly exposes the whole system of literary ownership and identity as a scam. For in Nabokov's hands, the sun, traditional *fons et origo* of a metaphorical exchange system, finds itself hijacked, rerouted by a cinematic *lunacy* that reveals the entire system of transfer of properties in figuration to be a massive contraband operation that is as unreliable as it is unlawful.[39] Things get lost. Meaning goes astray. Mysteriously missing from Conmal's version are Timon's concluding lines:

> *The earth's a thief,*
> *That feeds and breeds by a composture stolen*
> *From general excrement: each thing's a thief:*

Nabokov's real target in this kidnapping operation is what holds the rules of tropological exchange in place, namely, a final ground. There is no substratum that as first origin and infinitely generative source would arrest the *mise en abyme* of literary theft. Instead, in Nabokov, a "cinematic" *dissolve* surrenders the fiction of poetic autonomy to an unstable scene of reflection and counter-reflection *ad infinitum*. Citation, in this case, turns out to be a lure for advancing another form of literary production that flouts all the sacred rules and protocols of literary propriety.

Malconning the Border Politic

> these pencill'd figures are / Even such as they give out.
> —*Timon of Athens*

Smuggling his narrative like so much illicit 'moonshine' into the margins of the text in the form of critical annotations, Kinbote licenses himself to tell another tale than the one Shade intended in his poem. Which narrative did Kinbote displace? "Pale Fire" the poem is Shade's long and, if truth be told, somewhat rambling elegy to his dead daughter. Centering on the story of Shade's near-death experience, the poem revolves around the promise held out by poetic language of a life that continues beyond death. In Canto 3, Shade recounts how, shortly after delivering a talk titled "Why Poetry is Meaningful to Us," his heart momentarily stopped beating and he traveled to the Other Side.

> *I can't tell you how*
> *I knew – but I did know that I had crossed*
> *The border.*

From here, Shade is treated to a vision of totality:

> *A system of cells interlinked within*
> *Cells interlinked within cells interlinked*
> *Within one stem. And dreadfully distinct*
> *Against the dark, a tall white fountain played.*
> (*Pale* 476-77)

The fountain, he is convinced, was "Not of our atoms" and "I realized that the sense behind/ The scene was not our sense" (477).

Later, after recovering, Shade stumbles across what he takes to be a non-coincidentally similar account of a near-death experience by a

"Mrs Z," who seems to have had almost an identical vision during the interval between her heart stopping and its being "rubbed back to life by a prompt surgeon's hand" (*Pale* 478). Shade describes how, in her version, Mrs Z,

> *told her interviewer of "The Land*
> *Beyond the Veil" and the account contained*
> *A hint of angels, and a glint of stained*
> *Windows, and some soft music, and a choice*
> *Of hymnal items, and her mother's voice;*
> *But at the end she mentioned a remote*
> *Landscape, a hazy orchard – and I quote:*
> *"Beyond that orchard through a kind of smoke*
> *I glimpsed a tall white fountain – and awoke."* (478)

This uniformity of their experiences would point to the undeniable and incontrovertible reality of a life beyond death. Shade is convinced that,

> *Our fountain was a signpost and a mark*
> *Objectively enduring in the dark,*
> *Strong as a bone, substantial as a tooth,*
> *And almost vulgar in its robust truth!* (478)

But upon conducting further research, Shade discovers that the fountain in Mrs Z's vision was in fact really a mountain: the *m* had been misprinted as an *f* in her published account. Nonetheless, far from shattering his conviction of the existence of an afterlife, the typographical error only serves to confirm Shade all the more in his belief. In a famous passage from the poem, which is often taken by critics as a statement reflecting Nabokov's own views on the death-defying powers of art, Shade exclaims,

> *Life Everlasting – based on a misprint!*
> *I mused as I drove homeward: take the hint,*
> *And stop investigating my abyss?*
> *But all at once it dawned on me that this*
> *Was the real point, the contrapuntal theme;*
> *Just this: not text, but texture; not the dream*
> *But a topsy-turvical coincidence,*
> *Not flimsy nonsense, but a web of sense.*
> *Yes! It sufficed that I in life could find*
> *Some kind of link-and-bobolink, some kind*
> *Of correlated pattern in the game,*
> *Plexed artistry, and something of the same*
> *Pleasure in it as they who played it found.* (478-80)

At one level, of course, it is not hard to see how, from a certain perspective, both "fountain" and "mountain," despite their Saussurean differences from each other, convey the same poetic or, figurative, "intention," making Shade's asseveration of renewed belief in an after-life somewhat understandable. This is because, even if "Old Faithful" (as Shade calls it) metamorphizes by means of a typographical error into mountain, both images nonetheless reliably lend themselves as archetypal figures for poetry. To take "fountain" first, it is not dif-ficult to hear in it echoes of the medieval concept of the *fons vitale*, that is, the idea of God as the source or origin of creative inspira-tion, which becomes updated and contemporized by Nabokov's coeval, Rainer Maria Rilke, as the "fountain of joy" (*Quelle des Freudes*) in the German poet's own extended mourning song, the *Duino Elegies*.[40] Mountain, on the other hand, irresistibly recalls Mount Parnassus, the sacred home of the Muses, a poetic connection that would seem recon-firmed in passing with Nabokov's choice of name for Kinbote's would-be assassin. Jacob Gradus, as Priscilla Meyer reminds us, carries an implicit reference to the famous 17th century versification handbook, the *Gradus ad Parnassum*, or "steps to Parnassus" (Meyer 70). There appears to be a deeper connection between the two words, fountain and mountain, than a chance typographical error would suggest. From this perspective, the typesetter's mistake would only have served to bring into visibility something that Walter Benjamin in "The Task of the Translator" calls the underlying "kinship" between the two words.

In this famous essay, published in 1921 as the Foreword to his own work of translation into German of Baudelaire's *Parisian Scenes*, Benjamin discusses the translator's task in ways that are strikingly similar to Nabokov's description in the Foreword to *Eugene Onegin* (although to my knowledge there is no evidence to suggest that Nabokov had ever read Benjamin's essay, which was published in Harry Zohn's English translation in 1969, that is, five years after the appearance of Nabokov's Pushkin translation[41]). Here Benjamin simi-larly describes the work of translation in terms of literality. Arguing that translation concerns precisely the continuing survival of works of art – a work of art's *afterlife* – Benjamin begins by criticizing those who believe that the translator's role is to faithfully transmit the poem's content: a poem's "message," he says, is merely something inessential. Instead, he writes, the translator's true task is to express what he calls the "innermost relationship of languages" (Benjamin, "Task" 255). But Benjamin cautions that this relationship or "kinship" does not necessarily involve something called "similarity." Rather, it consists in the way that, in all languages taken as a whole, "one and the same thing is meant" (257). This "one and the same thing," Benjamin

explains, is a "suprahistorical" kinship, achievable "not by any single language but only by the totality of their intentions supplementing one another: the pure language [*Reine Sprache*]" (257).

As a case of linguistic "kinship," Shade's fountain/mountain convergence might initially advance an understanding of Benjamin's *Reine Sprache* as an original intention or Ur-meaning that succeeds in shining radiantly in and through the Babel-like fall into multiple tongues. Still, this is precisely what Paul de Man, in his own critical commentary on Benjamin's text, warns against, lambasting as the "naiveté of the poet" the idea that the author "has to say something, that he has to convey a meaning which does not necessarily relate to language" (De Man, "Conclusions" 34). De Man clarifies that for Benjamin, translation is "a relation from language to language, not a relation to an extralinguistic meaning that could be copied, paraphrased, or imitated" ("Conclusions" 34). To gain a proper understanding of what Benjamin means by "kinship," we must look more carefully at his concept of the *Reine Sprache*.

Benjamin's peculiar phrase is usually translated as "pure language." This is how both Harry Zohn and Steven Rendell, for example, render the German original. But another possibility could be "pure speech" or even "sheer" speech. In this variation, Benjamin's concept *Reine Sprache* might suggest something along the lines of Lacan's concept of "full speech" (*parole pleine*), which Derrida (mis)characterized as the dream of a replete speech uncontaminated by the perpetual deferral, errancy and interruption of *différance* (Derrida, "Love of Lacan" n.p.). In her suggestive reading of Benjamin, however, Carol Jacobs quickly puts an end to such poetic "temptations" which, as she points out, have already been dismissed in advance through Benjamin's reference to Stéphane Mallarmé in this text. In the passage Benjamin cites from *Crise de vers*, we find the French poet insisting on the "plurality" of languages, maintaining that the "supreme language is lacking" ("*Les langues imparfaites en cela que plusieurs, manque la suprême*"). Venturing another translation of *Reine Sprache*, as "purely language," Jacobs proposes we understand it this time in the sense of "nothing but language" (Jacobs 761). Far from gesturing to a transcendent plenitude, *Reine Sprache* would mean precisely nothing but the "mutual differentiation" of various "manners of meaning."

For when Benjamin says that both "Brot" and "pain" mean "the same," this doesn't suggest that they mean the same *thing*, Jacobs cautions. What is the "same" is precisely what makes each of these words mean "nothing at all." What a literal or *Wörtlich* translation effects, in other words, is a rupture of the signifying articulation that links the signifier to its signified. This would ultimately render all meaning

"extinct." Jacobs puts it in this way, "A teratogenesis instead of con-
ventional, natural, re-production results in which the limbs of the
progeny are dismembered, all syntax dismantled" (Jacobs 763). Jacobs
first quotes Benjamin:

> Translation [...] does not view itself as does poetry as in the
> inner forest of language, but rather as outside it, opposite it,
> and without entering, it calls into the original, into that single
> place where, in each case, the echo is able to give in its own
> language the resonance of a work in a foreign tongue. (763)

She then glosses Benjamin's text as follows: "Translation's call into
the forest of language is not a repetition of the original but the awak-
ening of an echo of itself. This signifies its disregard for coherence of
content, for the sound that returns is its own tongue become foreign"
(Jacobs 764).

Let us now step back a little from Jacobs' argument and ask what it
means for one's own tongue to "become foreign"? Literally, of course,
this is the condition of the exile, the figure of the American Nabokov
composing in a foreign language, pilfering from his Russian *oeuvre*
to produce English texts that are merely "pale fires" of their original
"suns."[42] From a psychoanalytic point of view, too, the idea of a cer-
tain foreignness of one's own tongue is not hard to reconcile with the
Freudian unconscious, where a seemingly 'alien' agency wrests the
intent from one's spoken words in order to tell a rather different story
in the monstrous, misshapen form of the symptom that runs a similarly
outsized, ballooning "commentary" on one's unconscious *jouissance*.

In my own mal-conning of foreign dictionaries in the meantime,
I have discovered another possible translation for Benjamin's word
"*Sprache*," this time as "style." "Pure style" or perhaps, in Katharine
White's reported words, "overwhelming style" is Nabokov's most sig-
nature characteristic, as he confirms in the letter to White: "All my
stories are webs of style [...] For me 'style' *is* matter" (*Selected* 115).
So I am tempted to offer still another understanding of the linguistic
'kinship' in play in the fountain/mountain typo, this time as a stylis-
tic matter: *penmanship*. In his commentary on the word "misprint" in
line 803, Kinbote remarks that future translators of Shade's poem will
encounter difficulty in reproducing the precise effect of the crucial
typographical error as the similarity of the two words is not replicated
in other languages such as "French, German, Russian or Zemblan."
Fountain/mountain is an error, that is, that would be specific to the
English language. But then in the same note, Kinbote divagates on
another case of a misprint, one which somehow does succeed in tra-
versing both Russian and English languages intact. In an article in

a Russian newspaper reporting on the Tsar's coronation, Kinbote recalls how the word *korona (crown)* was first misprinted as *vorona (crow)*. This was then apologetically corrected only to suffer a second typographical error, namely, to *korova (cow)*. "The artistic correlation between the crown-crow-cow series and the Russian korona-vorona-korova series," he writes, "is something that would have, I am sure, enraptured my poet. I have seen nothing like it on lexical play fields and the odds against the double coincidence defy computation" (*Pale* 627).

Well. Let us first pause for a moment to take Kinbote at his word and try following the lines of translation for fountain and mountain. One would expect them to follow fairly straight paths from one language to another, say from Russian to German to French to English. But look at what happens: a quick perusal of an online dictionary gives us the following sequence for fountain: фонтан/Brunnen or Quelle/fontaine/plume/pen. And run through the same 'mechanical' translation process, mountain gives us ropa/Bergen/montagne/mont as in Mont Blanc/*pen*. It is as though there is some unseen obstacle that causes the stream of all languages to circle back around as if swirling around an eddy. The impression is of some hidden object, some kind of 'dark matter' or black sun silently exerting its "great attraction" on language, imperceptibly rerouting the chain of signifiers to a spectral ur-scene of writing.

What kind of 'kinship' or perhaps better, 'kin-boat' would be registered in this translation process? It suggests a "suprahistorical" relation that cannot be accounted for by linear logics such as poetic intention. This warping of the translation offers material evidence of the theft of poetic desire by something else, something that topples all concept of sovereignty and which recognizes the jurisdiction of no linguistic laws. What name could we give to this usurper? In answer, we must look to the errant letters that initiated the sequence, F and M. We should not be surprised to find that they closely, if "grotesquely," mimic the sounds of Vladimir Nabokov's initials, V and N.[43] And with this as our clue, we should also not be surprised to find the same telltale letters haunting the other errant translation sequence Kinbote refers us to in his Commentary (koroNa-Vorona-koroVa). Surfacing with an almost clockwork regularity at every scene of writing, this spectral signature functions as the marker of another agent of literary production active in Nabokov's work: a transl(iter)ation that recognizes the borders of no national, linguistic or natural body politic. VN, penmarks of Nabokov's "pure *stylo*," are the calling cards of a consummate thief. For this "other" VN, all borders are equally permeable, including that separating life from death.

De-Auratic Wordlings

> Each man apart, all single and alone
> Yet an arch-villain keeps him company.
> —*Timon of Athens*

If, for Benjamin, a translation is part of the "afterlife" of a text, for Nabokov, it would be material proof that *death does not exist*. It is on this point of artistic doctrine that Benjamin and Nabokov now part ways. In *The Origins of German Tragic Drama*, Benjamin comments that "the only pleasure the melancholic permits himself, and it is a powerful one, is allegory" (Benjamin, *Origins* 185). What Benjamin means by the "allegorical way of seeing" involves a double process whereby the object is first plucked from its ordinary surroundings inside discourse. In allegorical language, sound and sense become "emancipated" from their traditional meaning. "Any person, any object, any relationship," he explains, can mean absolutely anything else" (Benjamin, *Origins* 175). Drained of their living "essence," words become the shrunken, hollow forms that are the special preserve of the melancholic: "melancholy causes life to flow out of [the object]" (183). This depletion then sets off a train of reactions that pulverizes language down to a molecular level. Benjamin describes this as an "atomization" of language (208). Words present to the melancholic allegorist as fragments but at the point where the fragment breaks down to the letter, language acquires a new luminescence. As if burnished in the crucible of the melancholic reduction, the letter rises Phoenix-like from language's ashes:

> In its individual parts fragmented language has ceased merely to serve the process of communication, and as a newborn object acquires a dignity equal to that of gods, rivers, virtues and similar natural forms which fuse into the allegorical. (Benjamin, *Origins* 208)

It is a bizarre Carollian court that Benjamin excavates from the ruins wrought by the allegorical vision. An alphabet of rebellious letters whose phosphorescent light is the stolen reflection of no celestial sun rises up, jostling for the title of King:

> in its fully developed, baroque, form, allegory brings with it its own court: the profusion of emblems is grouped around the figural centre, which is never absent from genuine allegories [...]. *The confused 'court'* – the title of a Spanish *Trauerspiel* – could be adopted as the model of allegory.

> This court is subject to the law of 'dispersal' and 'collected-
> ness.' Things are assembled according to their significance;
> indifference to their existence allowed them to be dispersed
> again. (Benjamin, *Origins* 188)

Taking center stage as a 'person' in its own right, the letter thus revolts against the word-image. Yet this is not so much in the service of "the personification of things," as Benjamin clarifies. The real function of this allegorical prosopopeia is "to give the concrete a more imposing form by getting it up as a person" (187).

It is the "schema" that ultimately determines the character of allegory (Benjamin, *Origins* 184). To approach the world as a schema is to recognize all of nature as "writing, a kind of sign-language" (184). What text does this schematic writing formalize? In allegory,

> the observer is confronted with the *facies hippocratica* of his-
> tory as a petrified, primordial landscape. Everything about
> history that, from the very beginning, has been untimely,
> sorrowful, unsuccessful, is expressed in a face – or rather in
> a death's head. (Benjamin, *Origins* 166)

A deathly prosopopeia would be at "the heart of the allegorical way of seeing, of the baroque, secular explanation of history as the Passion of the world." "Its importance," Benjamin contends, "resides solely in the stations of its decline. The greater the significance, the greater the subjection to death, because death digs most deeply the jagged line of demarcation between physical nature and significance" (166).

But now we are light years away from Nabokov as, in fact, we are also from Benjamin himself in his later essay, "On Some Motifs in Baudelaire." In *The Origin of German Trauerspiel*, Benjamin could still read in the "death-signs" of the baroque an allegory of the resurrection of the world. In his 1939 text on Baudelaire, however, he proposes a very different figure, one that overleaps the wish for the "completed mourning" which Julia Kristeva in her own treatise on melancholia, *Black Sun*, sagaciously pinpoints as the melancholic theoretician's secret desire.[44] Where, in 1925, Benjamin described the allegorical dialectic as executing a sudden "about-turn," enabling it to re-discover itself "not playfully in the earthly world of things, but seriously under the eyes of heaven," his conclusion is that allegories "fill out and deny the void in which they are represented" (232-3). Yet by the time he writes his essay on Baudelaire, Benjamin has developed another figure for melancholic representation or "spleen" in the form of eyes that have "lost the ability to look" (Benjamin, "Baudelaire" 339).

With this figure of the unseeing gaze (whose own literary geneal-ogy would see us Nabokovianly ping-ponging back and forth between Baudelaire's *prose* windows and Mallarmé's *poetic* windowpane), Benjamin is referring to the uncanny effect produced by de-auratic art. In the photograph or cinematic image, we do not have the sense of the object returning our gaze. Benjamin explains, "What was inevitably felt to be inhuman – one might even say deadly – in daguerreotypy was the (prolonged) looking into the camera, since the camera records our likeness without returning our gaze" (Benjamin, "Baudelaire" 338). De-auratic art is thus defined by the failure of the personification or prosopopeia that previously held the melancholic-allegorical universe in place. If, previously, the allegorical vision of nature elicited only a message of death, this death nevertheless took place under the all-see-ing "eyes of heaven." But in Baudelaire's poems, Benjamin observes a "mirrorlike blankness" in the eyes of the loved one. This "remoteness" is paradoxically attributed to the fact that "such eyes know nothing of distance" (340). There is a too-closeness about them that, like the cinematic image or the photograph, prevents the transubstantiating act of seeing ourselves reflected in the other and in nature, which depends on the "magic of distance" (341) to come to pass.

When Nabokov, in *Pale Fire*'s opening lines, dashes his poet against the Mallarméan windowpane's promise of an "azure" realm of art beyond time, his artist, misperceiving the glass's transparency, smacks up against the hard surface of representation:

> I was the shadow of the waxwing slain
> By the false azure in the windowpane;
> I was the smudge of ashen fluff – and I
> Lived on, flew on, in the reflected sky. (457)

Yet although art's "magic of distance" is violently unmasked as a brutal con, in his collision with language's impenetrable surface the Nabokovian artist does not die but rather splits in two:

> And from the inside, too, I'd duplicate
> Myself, my lamp, an apple on a plate: (457)

The encounter with language's materiality does not kill the object as Lacan maintained (*Ecrits* 262), but rather initiates an uncontainable, self-perpetuating 'cinematic' self-duplication on *this* side of the rep-resentational divide that will take in, retake and displace the entire field of aesthetic representation as privileged site of mourning for lost presence.

If cinema in Benjamin's conceptualization pares the image away from its aura, Nabokov's cinematic style de-auraticizes the literary

word. In the new proximity that results from this loss of the word's auratic depth, Nabokov obtains a 'mechanical' form of literary reproduction whose implications are, literally, immortal. For with each splitting of the poetic 'intention' as it bumps up against the hard surface of language comes an irrepressible 'stickiness' that attaches itself to each of the internally duplicating "new-born" objects (Benjamin, *Origins* 208) of representation, ensuring that they are always encumbered by an excess. This little smudge of "ashen fluff" – or, indeed, unshakable, unbearable, halitoxic "friend" – is the material witness to the original *"Chockerlebnis"* (Benjamin, "Baudelaire" 343) that is one's encounter with language "as such." Lacan of course has a name for this pesky "friend" who infests every one of our mourning songs with his own uncanny message of 'life.' Lacan calls him the lamella, the indestructible drive that survives "any division, any scissiparous intervention" (Lacan, *Seminar* 11 197). Every melancholic reduction of language takes us into the realm of this pure propulsive force, what Mladen Dolar calls "pure life in the loop of death" (Dolar, "Nothing" 159), and which Alan Cholodenko – in his own immortal words – calls "hyperanimated, hyperanimatic, hyperlifedeath: at once a life more death than death, more dead than dead, and a death more life than life, more alive than alive" (Cholodenko, "(The) Death" n.p.).

Stripped of the necessary "magic of distance" that generates art's illusion of depth and perspective, Nabokov's "pure style" thus discloses art's true function, not as window but as *screen*. Onto its shimmering surface are projected the little letters that the melancholic's blank gaze reveals as the fundamental elements of our world. But if for the Benjaminian allegorist these letters point relentlessly towards death, for Nabokov – although he would never dream of phrasing it in the manner of the "Viennese quack"[45] – these little letters have always pulsed with the gift of an absolute generosity without return, the pure life instinct which is another name for the *death drive*.

Nab. See Bok

> I am sick of that grief too, as I understand how all things go.
> —*Timon of Athens*

Wilson had complained about Nabokov's prosaic "flattening" of Pushkin's poetic language not realizing that it is precisely this compression in fact that allows the "full play" of the prose writer's literary powers. The "full" or extended play would be the insufflation of words as they cartwheel in slow motion around their own axes, presenting at each face the flatness of a two-dimensional plane but which,

when strung together, effect the appearance of life and movement. Nabokov's name for this 'animating' play of language is word golf. If one consults this term in *Pale Fire*, one finds the Index instructing us, after noting Shade's "predilection for it," to "see Lass." Flipping back through the Index to Lass, we find the instruction "see Mass." Under Mass come the words "Mass, Mars, Mare" and the instruction to "see Male." Under "Male" the reader is referred again to the beginning: "see Word golf." Like pebbles skimming across a pond, words spin and mutate by degrees (Jack Degree we recall is one of the assassin Jakob Gradus's aliases). What if, Nabokov asks, the dimensions of 'reality' were also somehow faceted in this way, and that "live" and "kill" – like "male" and "lass" – were simply steps or "degrees" in an ontological version of the game of word golf? What if, that is, what we perceive as "death" is simply an error in perception, an illusion produced by our desire to see *through* the surfaces of representation to an Other side of the windowpane? All that there is lies on *this* side of representation, Nabokov the materialist insists, but representation is multi-faceted; the limit we encounter as "death" may just be a step in a mechanical rotation or "quarter turn" in the universe of discourse.

5 Cinemarée noire: *Ada or Ardor*

Set fire to the library of poetics.
—*Derrida, 'Che cos'è la poesia?'*

Ada or Ardor opens with a botched citation from Tolstoy: "'All happy families are more or less dissimilar; all unhappy ones are more or less alike' says a great Russian writer" (*Ada* 7). In Nabokov's revision, it is a family's joy that is unique. By opening with Tolstoy, Nabokov signals a certain precedent for his 1969 novel. Its model will be a sprawling 19th-century realist tome detailing a century-long illicit love affair between the half-siblings Van and Ada Veen. Nabokov's gambit is that *Ada*'s lovers will rank together with some of the greatest lovers in literary history, including Princess Anna Arkadyevna Karenina and Count Alexei Kirillovich Vronsky, who, together with their letteral forerunners, Venus and Adonis, quietly mark themselves as templates for forbidden love in the initials of Ada and Van. Yet beyond its topos of the Russian family estate – borrowed seemingly wholesale both for *Ada* and for Nabokov's gold-flecked memoir, *Speak, Memory* – the Tolstoyan intertext is just as important for the formal innovation Nabokov assigns to the author of *Anna Karenin*. This is the stream of consciousness technique, which is commonly attributed to the great modernists, Joyce, Woolf and Proust.

In his *Lectures on Russian Literature,* Nabokov demolishes this canard, however, explaining that "the Stream of Consciousness or Interior Monologue is a method of expression which was invented by Tolstoy, a Russian, long before James Joyce" (*Russian* 183).

> It is a kind of record of a character's mind running on and on, switching from one image or idea to another without any comment or explanation on the part of the author. In Tolstoy the device is still in its rudimentary form, with the author giving some assistance to the reader but in James Joyce the thing will be carried to an extreme stage of objective record. (183)

The stream of consciousness technique makes its appearance as one among a number of Nabokov's favorite "hates" as these have been itemized in a hand-written list and stored in the archives of the New York Public Library. In this list, whose contents (as Nabokov also

notes) were repurposed in *Ada* for Van Veen's own scribbled musings, a number of stylistic conceits take their place alongside Nabokov's trumpeted dislike of background music, glib phrases, clubs, fraternities, circuses, concise dictionaries, the wrong pocket and everything connected with the post. Together with "abstract" daubs, "symbolic bleak little plays," "junk sculpture" and "avant-garde" verse, the method of identifying stream of consciousness by "italicized passages in novels which are meant to represent the protagonist's cloudbursts of thought" comes in for especial censure.

We will revisit the extent to which Nabokov himself deploys this typographical conceit in *Ada* which, among many other things, offers an extended meditation on (and parody of) modernist aesthetics, in particular that of Joyce. But for now, let us note that what Nabokov is objecting to as a bad novelist's typesetting cheat points to a fundamental problem of language, namely, its intrinsic dual ability to convey both the "idea signified" and the idea of language's "role as representation," as Michel Foucault explains. In *The Order of Things*, Foucault marks the shift to what he calls the Classical episteme in terms of this binarism. For Foucault, the 17th century emerges as the period in Western thought when representation becomes increasingly split along two lines: first, language as an instrument for conveying the marks of identity and difference produced through reason's acts of discrimination and, second, what he refers to as "that unreacting similitude that lies beneath thought and furnishes the infinite raw material for divisions and distributions" (Foucault 57). But this formulation also masks a changed complexity in the possibility for obtaining "truth." Precisely to the extent that language becomes "arbitrary," that is, removed from any "natural" relation that presents as the holdover of a more primitive text written by God, it also begins to make a new claim about its authority. Foucault explains:

> The relation of the sign to the signified now resides in a space in which there is no longer any intermediary figure to connect them: what connects them is a bond established, inside knowledge, between the idea of one thing and the idea of another. (62)

Because of this shift, signs in effect become Janus-faced, pointing both to the idea signified and to their own status as a sign. Each sign is thus a "duplicated representation," a sign that doubles over itself.

The fantasy of realist fiction is that it can overcome the sign's inherent duplicity. The pretense of the realist universe is that language offers a window through one can reach and practically touch the characters whose lives are sketched with such vividness. This near transparency

of literary style is in fact one of the things Nabokov claims to value the most in Tolstoy. He notes Tolstoy's courteous attention to the tiniest details of the Oblonsky and Karenin families' lives – the "little spike of hoar frost" that falls upon Kitty's muff; the handkerchief that falls out of her muff as she shakes hands with Lyovin; the earrings which she asks her mother to remove during her agonies of childbirth, etc. Marshaling the figure of a perpetual motion machine that generates its own energy sources, Nabokov comments, "Tolstoy keeps a keen eye on his characters. He makes them speak and move – but their speech and motion produce their own reaction in the world he has made for them. Is that clear? It is" (*Russian* 161). The effect, he remarks, is that Tolstoy's readers, "elderly Russians at their evening tea" find themselves talking of Tolstoy's characters "as of people who really exist, people to whom their friends may be likened, people they see as distinctly as if they had danced with Kitty and Anna or Natasha at that ball or dined with Oblonski at his favorite restaurant, as we shall soon be dining with him" (142).

But this illusion must be kept under tight control. Potential wanderings of the sign are prevented by means of direct speech markers that fence in the flows of consciousness inside the realist universe, enabling the reader to parse the order of events within narrative time. This extends to memories and dreams as well as to characters' explicitly conscious states. "'Yes, yes, how was it now?' [Stepan Oblonski] thought, recalling his dream":

> "Now, how was it? To be sure! Alabin was giving a dinner at Darmstadt; no, not Darmstadt, but something American. Yes, but then, Darmstadt was in America. Yes, Alabin was giving a dinner on glass tables, and the tables sang, *Il mio tesoro* – not *Il mio tesoro* though, but something better, and there were some sort of little decanters on the table, and they were women, too," he remembered. (*Russian* 150)

Despite his faulty memory and the dream's own distortions and illogic, Oblonski's – and the reader's – perspectives remain temporally orientable by means of Tolstoy's use of direct speech. With the modernist break, however, the corralling duties of conventional typography become outsourced to the more permeable membranes of the stream of consciousness and its close cousins, interior monologue and free indirect discourse. And with this permeability, the time of consciousness becomes plastic. Nabokov describes the stream of consciousness technique as representing the mind "in its natural flow, now running across personal emotions and recollections and now going underground and now as a concealed spring appearing from underground and reflecting

various items of the outer world" (183). A famous section from Tolstoy from Anna's "last day" provides Nabokov with his example:

> Office and warehouse. Dentist. Yes, I'll tell Dolly all about it. She does not like Vronski. I shall be ashamed but I'll tell her. She likes me. I'll follow her advice. I won't give in to him. Won't let him teach me. Filipov's bun shop. [...] Dressmaker. Man bowing. He's Ann Ushka's husband. Our parasites. [Vronski had said that.] Our? Why our? [We have nothing in common now.] What's so awful is that one can't tear up the past....What are those two girls smiling about? Love, most likely. They don't know how dreary it is, how degrading. The boulevard, the children. Three boys running, playing at horses. Seryozha! [her little boy]. And I am losing everything and not getting him back. (*Russian Literature* 185)

In this passage, we follow the zigzags of Anna's mind as it roves freely over present impressions and past memories. What William James – usually attributed with coining the phrase "stream of consciousness" – calls the "time-gap" separating past and present consciousness is contracted, with Anna's thoughts bubbling up, as if flooding the floorboards of the mind's "comfortable carriage."

With his nascent modernist stream of consciousness, Tolstoy offers himself as a proto-cinematic writer and, thus, as a sort of advance guard of Nabokov's cinematic assault on literary poetics. As Ils Huygens reminds us, from its earliest inception, cinema was theorized precisely in terms of its analogy with the human mind. Regarded as a "thought machine," the representational mandate for cinema, for figures such as Jean Epstein, Canudo and Béla Balázs, was to visualize the complexity of the mechanism of thought (Huygens n.p.). For Alain Resnais, whose *Last Year at Marienbad* Nabokov evidently admired, "the true element of cinema" was thought, precisely because both cinema and thinking succeed in jailbreaking the physical constraints of space, time, and causality. In the "photoplay," as James's friend and associate at Harvard, the psychologist Hugo Munsterberg, designated film, "the massive outer world has lost its weight, it has been freed from space, time, and causality, and it has been clothed in the forms of our own consciousness. The mind has triumphed over matter and the pictures roll on with the ease of musical tones" (Munsterberg 220).

If one can draw a parallel between the stream of consciousness technique and the cinema, it is in their joint sabotaging of the linearity through which events routinely unfold in time. While Tolstoy has Anna glide between past and present in his representation of her consciousness, the French new wave filmmakers such as Resnais allow

time to fold back on itself. Deleuze explains that in Resnais "events do not just succeed each other or simply follow a chronological course; they are constantly being rearranged according to whether they belong to a particular sheet of past, a particular continuum of age, all of which coexist. Did X know A or not? Did Ridder kill Catrine, or was it an accident…?" (Deleuze, *Cinema 2* 120).

One begins to see why Nabokov was so withering in his criticism of the typesetting conceit. To the extent that they mark a turn back to linear narrative models, the italics representing the "cloudburst of thought" would be the typographical symptoms of an aesthetic relapse. With this, I am referring to de Man's assessment of one's inevitable fall back onto "ideological" models that underpin the system of tropes which, like its own perpetual motion machine, drives forward a certain literary and aesthetic program (De Man, "Kant"). Founded on the master figure of the interiorized consciousness,[46] this tropological regime oversees literature's classical models of identity of self and other, of relation, morality and ethical progress and, most powerfully, the poetic conceit of literary redemption and its key promise of an "afterlife" lived through the medium of language. At its base hums the core program, the deus-ex-machine-language of Kantian space and time, whose scarcely perceptible sub-routines were first kick-started by the act of a divine hand. In short, then, the italics setting off the idea of "thought" would signal a fall back into a certain "aesthetic ideology," whose apotheosis is found in the great tradition of romance writing, stretching from Virgil and Tasso to the courtly lovers of the medieval epics, to their 17th-century reincarnation in Spenser, Sidney and Marvell, and debouching in St Petersburg with Tolstoy's Anna and Vronsky (but not without the late-night supper, that Stepan Oblonsky was so fond of, with the great lovers of the French tradition: Rousseau, Flaubert, Chateaubriand). It is the burden of this creaking, over-painted Arcadian backdrop that Nabokov's italics in *Ada* are forced bear – no surprise, then, that they teeter on the page aslant.

Tarder, Time, Type and Tip

One can now make an initial approach to *Ada*'s garden. A quick review will show that Nabokov (or at least his publisher) does make use of italics in *Ada*. However, they are primarily used to signal the shift into another language, usually French or Russian, sometimes Latin. Italics are also used to typeset Ada's and Van's letters, or to signal an emphasis ("Why *should* we apollo for her for having experienced a delicious *spazmochka*?" Ada asks Van on page 338, for example). They are used to indicate book and film titles such as Mlle Lariviere's

novel, *Enfants Maudits* and its cinematic adaptation in which Ada and Marina play a minor and starring role, respectively, *The Young and the Doomed*. Furthermore, they set off citations such as the lines from Chateaubriand's *Romance à Helene* that Van and Ada use as a sort of Proustian *leitmotif* for their love: "*Oh! qui me rendra mon Aline/ Et le grand chene et ma colline*?" (112 and others). But despite a careful combing through of the Library of America edition of *Ada*, I can find only a very few instances of italics used to signal an otherwise unmarked shift into a character's consciousness.

Each case occurs in chapter five of in Part Three, which deals with what the novel's fake blurb ending describes as "one of the highlights of this delightful book" (468). By this point, Ada and Van have been apart for seventeen years. This separation was initiated by Van on learning of Ada's infidelity with Percy de Prey and Herr Rack (and quite probably numerous others). Ada's half-sister Lucette, who has long been in love with Van, engineers a meeting with him by booking a passage on the same steamer, thereby becoming the vector through which Ada and Van are reunited. Issuing and then following through on her unspoken ultimatum to Van, Lucette jumps from the boat, thereby setting in train Ada's and Van's reconciliation as well as the fortuitous death of her husband Andrey Vinelander.[47]

> Long ago she had made up her mind that by forcing the man whom she absurdly but irrevocably loved to have intercourse with her, even once, she would, somehow, with the help of some prodigious act of nature, transform a brief tactile event into an eternal spiritual tie; but she also knew that if it did not happen on the first night of their voyage, their relationship would slip back into the exhausting, hopeless, hopelessly familiar pattern of banter and counterbanter, with the erotic edge taken for granted, but kept as raw as ever. He understood her condition or at least believed, in despair, that he *had* understood it, retrospectively, by the time no remedy except Dr. Henry's oil of Atlantic prose could be found in the medicine chest of the past with its banging door and toppling toothbrush. (*Ada* 388)

As the reader observes, this passage is not exactly swimming in interior monologue-signalling italics. And indeed it might have slipped me by had Nabokov, in the shape of a certain "Vivian Darkbloom," not helpfully pointed it out in the set of annotations collected at the end of the novel titled "Notes to *Ada*." Similar to the "Commentary notes" that Nabokov provides for *Anna Karenin* at the end of his lecture on Tolstoy, this appendix guides the – not infrequently confused – reader

of *Ada* through the thicket of allusions in the novel, supplying trans-
lations of the French and Russian, proposing definitions for unusual
words, and so on. Darkbloom explains, for example, that the novel's
opening line is a comic dig at mistranslations of Russian classics, that
the novel's transliterations of Russian are based on the old Russian
orthography, that the word "granoblastically" means a "in a tesse-
lar (mosaic) jumble," that Tofana is an allusion to "aqua tofana" for
whose further meaning we are supposed to consult "any good dic-
tionary" (thus presumably not a detested concise one). For page 388,
Darkbloom's annotations run to just one entry:

> Henry: Henry James's style is suggested by the itali-
> cized "had." (483)

Pausing for a moment, one should note that while Nabokov was a great
admirer of William James and was deeply fond of the psychologist's
son and daughter-in-law whom he and Véra befriended in Cambridge,
Massachusetts, he had a somewhat more lukewarm affair with the
other James. In a letter to Edmund Wilson, he described Henry James
as a "pale porpoise" whose "plush vulgarities" he urged his friend to
"debunk" some day (Nabokov and Wilson 308). In another letter to
Wilson, Nabokov takes exception to an image of a lighted cigar which
James describes as having a red tip: "Red tip makes one think of a red
pencil or a dog licking itself," he complains. "[It] is quite wrong when
applied to the glow of a cigar in pitch-darkness because there is no
'tip'; in fact the glow is blunt. But he thought of a cigar having a tip
and then painted the tip red" (211).[48] James, Nabokov concludes, "has
charm (as the weak blond prose of Turgenev has), but that's about all"
(Nabokov and Wilson 59). Yet despite these objections, Henry James
nonetheless anticipates Nabokov in important ways, which the latter
appears to obliquely acknowledge in his gentle parody of Jamesian free
indirect discourse in this passage. One can, for a start, point to James's
own predilection for young, overly knowledgeable, prepubescent girls
with rhyming names such as Daisy and Maisie as the potential literary
forerunners of Ada and Lolita. But it is James's *enfants maudits* from
"The Turn of the Screw," Flora and Miles, who suggest themselves
even more immediately as the literary templates of the accursed chil-
dren in Nabokov's cinaesthetic remake as we will shortly see.

But first, to return to the passage, what "remedy" might "Dr Henry's
oil of Atlantic prose" provide in Van's and Lucette's case? In what
way might James's style, that is, locked up in the medicine chest of
the past, provide some kind of tincture or salve that could relieve
Lucette's "condition"? James is of course *the* writer of sexual renun-
ciation, the great master of sublimation and thus very unlike Nabokov

in this regard.[49] It is therefore conceivable that, as the narrator weaves in and out of Van's consciousness (or rather, as Van weaves in and out of his present and past consciousnesses) in this passage, it is this renunciative aspect of James he is referring to as the best treatment for Lucette's unhappy love affair. If she could but sublimate her desire for Van, this would imply, she might have been spared her disaster.

Still, this reading fails to account for the peculiar temporality that is introduced by Nabokov's use of Jamesian italics. To follow this, one must note that when James uses italics in his signature manner, it is in a very different way than the italicized passages of modernist stream of consciousness Nabokov decried in his list of favorite hates. If James uses italics to signal the entry into a protagonist's consciousness, it is most often to highlight a moment of self-understanding, which is frequently in James also a self-delusion. Thus in *The Wings of the Dove*, as Densher laps up Aunt Maud's sympathy for his false position as Milly's bereft lover (for, like Van with Lucette, he never loved Milly at all[50]), he reflects that, after all, albeit in a different way than Maud thinks, "he *had* been through a mill" (James, *Wings* 366). So when Nabokov cites James in the passage in *Ada*, its parodic force derives partly from this element of Van's self-deception and belated self-justification of his actions:

> He understood her condition or at least believed, in despair, that he *had* understood it, retrospectively, by the time no remedy except Dr. Henry's oil of Atlantic prose could be found in the medicine chest of the past with its banging door and toppling toothbrush. (388)

But Nabokov will not let us stop here. Let us look again. The sentence turns around the question of Van's understanding, and more particularly of *when* he understood something, following upon which the tragedy of Lucette's suicide unfolds. The particular difficulty of understanding Van's understanding lies in the italicized word "had." As in the James example, the italicized "had" is the auxiliary of the verb. In both cases, it is used to form the pluperfect tense, which places actions in the past in relation to each other. Recall how English grammar gives us four tenses to indicate an event in the past: the simple past ("I understood"), the past continuous ("I was understanding"), the pluperfect ("I had understood") and the past present continuous (awkwardly in this example, "I had been understanding"). If the simple past merely tells one that an action has been completed, the pluperfect enables one to locate past actions in chronological relation with one another. Thus in the portentous chapter thirty-nine, the scene of Van's and Percy de Prey's scuffle on Ada's sixteenth birthday, we find Van

catching a warning expression in Ada's reflected image as they make love over the brook: "Something of the sort had happened somewhere before" (213). A straightforward instance of the pluperfect, here the auxiliary verb "had" indicates that while the narrated action is taking place in the past, Van at that moment recalls an event which had taken place *earlier* than the past event that is the current topic of narration (his and Ada's lovemaking).

Things are less clear in the sentence in question, for here the pluperfect is coupled with a time marker from a later time, "he *had* understood it, retrospectively." It is, moreover, this temporal qualifier "retrospectively" that prevents one from reading the italics simply as extra emphasis, in the sense of "he really *had* understood". For with this qualifier, Nabokov describes actions from two different times from the past. First, the simple past: "He understood her condition…" And, second, in the pluperfect: "he *had* understood it, retrospectively."

In order to pinpoint exactly where things start to go temporally awry, one can plot the events on a time-line. The first 'moment' is the generalized state of nonunderstanding which takes place in the simple past: before Lucinda's death, Van did not understand her condition. After her suicide, however, Van firstly claims an understanding of her condition (understanding 1) but also, second, that he *had* (already) understood her condition ("understanding 2").

The question is when this second understanding, that is, the one that comes *after* ("retrospectively") but takes place *previously* ("*had* understood") is to be temporally located? The use of the pluperfect suggests it should occur before the first understanding (the simple past). The chronological sequence would then be something like "he *had* understood," and then, a little redundantly, "he understood" (again). "Understanding 2" would have occurred before Lucette's suicide and therefore *before* it is temporally superseded by "nonunderstanding," which is subsequently overwritten by the simple past of "understanding 1."

But this is not actually what Nabokov writes. The sequence Nabokov gives us is this: "he understood," "he *had* understood, retrospectively." An *earlier* past event would take place *after* the simple past event. The "Jamesian" italics ripple the unidirectionality of time – and, in the same move, trouble our own "understanding" of the unfolding logic of Nabokov's sentence in a way that closely recalls the bafflement of James's readers when attempting to follow the flight of the indefinite pronoun as "it" alights, butterfly-like, first on this fragrantly blooming subject, then on that distant object in James's late style.

The closest analogue to the Nabokovian/Jamesian 'advanced action' I can think of is the ambiguity that Lacan finds in the imperfect

verb form in French. In several places in his seminars, Lacan cites an example of the imperfect verb form, *"un moment plus tard, la bombe éclatait"* (which Bruce Fink translates as "The bomb was to explode a moment later") (Lacan, *Ecrits* 568).[51] In *Seminar 15, The Psychoanalytic Act*, for example, Lacan uses the phrase to illustrate the fundamental disjunction that inheres between the subject and its enjoyment. Lacan notes the ambiguity in the imperfect tense in this example, where it is impossible to know whether the bomb actually went off. The implied sense of the sentence is that the bomb will go off in the very next moment following, but the imperfect tense relates it as having taken place in the past. In his lesson of 10.1.68, Lacan explains this ambiguity in terms of something from the future that forestalls or "defuses" an event in the past, which for him provides a perfect illustration of how the speaking subject comes to occupy the place of the id. Freud's well-known phrase *"Wo es war, soll Ich werden"* sees the "I" assume the place of the enjoying being but this is achieved only through a temporal sleight of hand. Emerging seemingly *ex nihilo*, the "I" institutes itself "originally" as an entity that "retrospectively" ensures that its logic directs the emergence of everything that had happened previously.[52]

What are the implications of this sleight of hand? It is that Lucette (and by extension, Van) did not – *and will not* – die. If in the first understanding Van understands that Lucette – and he – are mortal, in the second understanding, he retrospectively comprehends that she (and therefore he) can evade death through the auspices of language and the Symbolic. Death, which had taken place in the past, is revoked by this previous-but-later understanding, which asserts its own "life" in the place where death had been. *Pace* Tolstoy's Anna, one can – and, in fact, every speaking subject does – in this way "tear up the past." But this is only achieved at the expense of the enjoying being that made the immortal (or "desiring") subject possible. In the logic of the speaking subject, the same bomb that did go off (*éclatait*) will not go off (*un instant plus tard*).

Nobakoff's Totalizing Inscription

Earlier in the evening, before her plunge, Lucette and Van are confronted with the image of Ada. For seeking to delay what seems their inevitable coupling, Van dragged Lucette into the cinema to watch *Don Juan's Last Fling* in the *Tobakoff*'s on-board cinema. Unexpectedly, the film features Ada who, like her mother Marina, has meanwhile found her vocation as a film actress. If Van has begun to feel the stirrings of desire for Lucette insofar as she presents a Technicolor version of her black-and-white "vaginal" half-sister, once he sees Ada's

animated image on the silver screen, all Van's proxy desire for her younger sister flows away.

In the film, Ada, using the screen name Therese Zegris (anagrammatically, "Haze registers"), has a bit-part as Dolores, "a dancing girl" whose character, the narratorial Van parenthetically notes, was "lifted from Osberg's novella, as was to be proved in the ensuing lawsuit" (391). As Brian Boyd has noted, Osberg is an anagram of Borges (Boyd, Ada Online), and the novella referred to is presumably "Pierre Menard." In this story, Borges tells of the attempt by the writer, Pierre Menard, to rewrite *Don Quixote*. This would not take the form of a copy or mechanical transcription, but comprises a version that would absolutely "coincide – word for word and line for line" with those of Cervantes. And indeed, leafing through the 17th-century novel, Borges' editor-narrator analeptically "hears" the voice of the 20th century Menard in Cervantes's "exceptional phrase," "the river nymphs and the dolorous and humid Echo."[53] A future "copy" is more 'like' the original than the original itself.[54]

Except that when Nabokov goes to one-up Borges in this shell-game of literary narcissism, it is not the voice of a future writer that resounds in the earlier text as in the Borges story but Nabokov's own as it piggy-backs down through history on the Cervantes phrase. This then suggests a different strategy for defeating time. In a truly breath-takingly narcissistic gesture, all texts, Nabokov implies, have not only already been written, but all – both past and future – are plagiarisms of Nabokov: what is "exceptional" about Cervantes' phrase "dolorous and humid Echo" is the way it unconsciously points *avant la lettre* to Nabokov's Dolores and Hum of *Lolita*. If Borges reverses the logic of original and copy, Nabokov's totalizing inscription erases it – and the mimetic spatial and temporal model it implies – altogether.

If "cinema" is the name Nabokov gives to this totalizing inscription, this also suggests another "understanding" of death. Cinema unseats literature's temporally-driven narratives of loss and recuperation with an image that can never be lost because *it is continually present.* In the camera's "magic rays," Ada "was again that slip of a girl..." "By some stroke of art, by some enchantment of chance, the few brief scenes she was given formed a perfect compendium of her 1884 and 1888 and 1892 looks" (391). Cinema would thus offer a third "understanding" of death, not as the simple past tense marking life's finitude, nor as death's repression by the subject of literary desire, but as the timeless spasm, the *sanglot*, of an enjoyment-without-loss. Curiously, this third understanding also occurs in the 'unnatural' temporality of the pluper-fect, signaled once again by the telltale Jamesian italics:

> Van, however, did not understand until much later (when he
> saw – *had* to see; and then see again and again – the entire
> film, with its melancholy and grotesque ending in Donna
> Anna's castle) that what seemed an incidental embrace con-
> stituted the Stone Cuckold's revenge. (392)

And yet, this will hardly be the "remedy" Van seeks. For with this
reference to Don Juan, if cinema's promise is of a life outside of and
untouched by time and finitude, death nonetheless seems to have had
the last laugh.

To follow this argument, one must recall how, in Tirso de Molina's
play, Don Juan murders Dona Anna's father, Don Gonzalo who, with
his dying breath, vows to haunt Don Juan. But Don Juan simply laughs
this threat off. He mocks Don Gonzalo's statue in the cemetery with an
invitation to dine. De Molina's play ends portentously with the "Stone
Guest" returning to life and, after joining Don Juan in a meal of vipers
and scorpions, smites him dead with a thunderbolt.

On a first reading, this death blow constitutes the Stone Guest's
parting gift to Don Juan who succumbs to the triumph of death. But
on a second pass, death's revenge appears even more far-reaching. In
Ada's film, Don Juan, who has meanwhile, quixotically, started his
own watery bleed into that other 17th-century Don, "rides past three
windmills, whirling black against an ominous sunset, and saves [Ada-
Dolores] from the miller."

> Wheezy but still game, Juan carries her across a brook […].
> Now they stand facing each other. She fingers voluptuously
> the jeweled pommel of his sword, she rubs her firm girl belly
> against his embroidered tights, and all at once the grimace of
> a premature spasm writhes across the poor Don's expressive
> face. He angrily disentangles himself and staggers back to
> his steed. (392)

It is not so much the prematurity of the Don's spasm, which prevents
him from coupling with Dolores, that puts us on alert here as the key
to death's "revenge" but rather the realization that, taking place in
an arche-time "before" the understanding of death, every spasm of
enjoyment itself constitutes a (little) death. What Van, after repeated
viewings of *Don Juan's Last Fling*, finally comes to "understand," in
other words, is that *jouissance* revokes the subject's "life" before it
can even begin. A life founded on enjoyment, such as the one that Eric
van Veen ("no relation") envisages with his international enterprise of
high-class bordellos, the Villa Venuses, is in fact no life at all – for one
recalls that Eric was felled, precisely, by a roof-tile's blow to the head,

repeating in this way his own mother's death by flying suitcase, break-ing her *neck*. Restating a Lacanian truism, enjoyment and the speak-ing subject cannot be co-extensive: one can either "be" or "think" but not at – nor in – in the same 'time.' Thus the idea of some enjoyment beyond or prior to the literary desire of love lost and regained is itself, in truth, nothing but death. Death wins on every count.

Nevertheless, Nabokov will fight with all his powers against this conclusion. Indeed, one should regard his entire aesthetic program as a lifelong assault on this fundamental axiom. And now, with this insight, the full extent and meaning of Nabokov's profound rejection of Freudian psychoanalysis comes properly into view. Beyond his constitutional aversion to universalizing narratives, beyond his hostil-ity towards (what he sees as) the utter crudity of the psychoanalytic imagination that would herd all singular adventures back to a unitary Oedipal source, Nabokov's fundamental issue with Freud is with the latter's concept of the unconscious. For Nabokov, no "being" is to be found in the unconscious, which presents only confused and garbled fragments of consciousness. In Nabokov's words, unconscious produc-tions such as dreams are merely "amateur" productions: "obviously filched from our waking life, although twisted and combined into new shapes by the experimental producer, who is not necessarily an enter-tainer from Vienna" (*Russian* 176). In the famous passage from *Speak, Memory* we have already cited, Nabokov lays out his counterclaim: it is not "in dreams" – and, presumably, the other unconscious forma-tions such as slips, jokes and neurotic symptoms – "but when one is wide awake, at moments of robust joy and achievement, on the highest terrace of consciousness, that mortality has a chance to peer beyond its own limits, from the mast, from the past and its castle tower" (*Speak* 395-6). For Nabokov, *consciousness* itself suffices. Consciousness – at least at certain "heights" – reverses time, rescinding death.

The Black Tide of Consciousness

> two sweetly scintillant
> Venuses, unextinguished by the sun!
> —*Edgar Allan Poe, "To Helen – 1848"*

If neither literature's desiring narratives of loss and recuperation, nor cinema's 'eternal return' of an endlessly present *jouissance* are, in themselves, powerful enough to overcome the "Stone Cuckold," what if one were to combine them? What if, that is, literature and cinema could comprise a hybrid form that, jamming the core program that runs our perception of space and time, could overturn the limit we perceive as death? What Freud would call the "manifold content" of

Ada's incest motif turns out to be Nabokov's cover for infiltrating the traditional categories of space and time with a hybrid form that will outwit the deaths underpinning both the literary fantasy ("desire") and its cinematic other (*"jouissance"*). "Incest" here carries the metaphorical payload of a coupling of brother and sister arts, a cross-bred or, better, *inbred* form that freezes narrative's temporality with the stasis of the cinematic image that cannot age. In the figures of the child lovers whose "premature spasms" shock time's forward motion, Nabokov forestalls all coming of the future.

One might ask at this point why it is from Henry James, rather than the other members of the chorus of lovers providing the backing vocals to *Ada*, that Nabokov obtains this "remedy" for death? What does James offer in addition to Van's and Ada's other accursed precursors who similarly discovered the secret trapdoor of incest hidden deep inside the romance tradition – Byron, Chateaubriand, Sydney, Chateaubriand, Spenser, Coppée, Baudelaire, Mme de Ségur, Rimbaud, Marvell, among others? The clue will likely be found in James's own tale of *les enfants maudits* that ghosts Van's and Ada's affair, first via the conduit of Ida Larivière's story-within-a-story, then as cinematic adaptation in G.A. Vronsky's film.

James's "The Turn of the Screw" has long posed a problem of interpretation. Everything in the tale, as Edmund Wilson points out in his influential 1934 essay, "The Ambiguity of Henry James," "from beginning to end can be taken equally well in two senses" (Wilson, "Ambiguity" 170). For Wilson, as for a whole tradition of James criticism that follows him, the governess has merely imagined the whole scenario. He considers her fears of Flora's and Miles's corruption at the hands of the dead Peter Quint and Miss Jessel, as merely the hallucinatory fantasies of "the frustrated Anglo-Saxon spinster." The whole story, he remarks, is a "master-piece [...] study in morbid psychology" (Wilson 172). "The Turn of the Screw," Wilson concludes, is not 'about' the children after all but about the governess herself, her misreading is the result of her projection of hysterical fantasies onto her small charges. The tale mysteriously twists like a Möbius strip: its 'object' of narration is revealed to be the narrating *subject*.

Thus as it revolves around the hallucinatory question of representation and its real, the story would offer a textbook study of the feints and counter-moves or, as the governess herself describes it, the "succession of flights and drops," of language's inherent duality. Orbiting in ever-narrowing circles around what she believes to be Flora's and Miles' secret, the governess's narrative finds itself threading dangerously along the narrow divide Foucault alluded to earlier: the more she seeks to capture the idea of what her words are to represent, the

more she ends up highlighting her narrative's own status as representation. Again, it is largely through James's signature italics that this undecidability of language's subject and object is conveyed. Following an apparent sighting of Miss Jessel, the governess demands of a stubbornly unseeing Mrs Grose, "You don't see her exactly as *we* see?"

> "You mean to say you don't now – *now?* She's as big as a blazing fire! Only look, dearest woman, *look – !*" (James, *Complete* 429)

Or a little earlier,

> "She's there, you little unhappy thing – there, there, *there*, and you see her as well as you see me!" (*Complete* 428)

As if by sheer force of will, James's italics attempt to pin down an escaping referent. Language's deictic function falters, breaks down from the effort. The promise of indicating a real gets caught in a stutter of repetition that arrests language's forward movement, which buckles under the pressure of Jamesian suspense: "there, there, *there*."

The hint Nabokov will take from James is found in the spark caused by this "jamm(e)ing" of the linguistic machine. The "oil" of Dr Henry's prose proves dangerously flammable, susceptible to bursting into "blazing fires." One sees, now (*now!*), why Nabokov objected so vehemently to James's "painting in" of the cigar's red tip, given the combustion his prose has the powers to ignite, providing perhaps the original *spark* for the notorious Burning Barn that plays witness to Van's and Ada's first incestuous sexual encounter. This telltale spark shows up again in the note that Blanche leaves for Van, her Franglais warning him of Ada's suspected infidelity, "'One must not berne you.' Only a French-speaking person would use that word for 'dupe'" (231). Why should Nabokov post this particular cross-linguistic pun if not to warn us (and Van) that if words deceive, they also scorch, a lesson that James's little Miles is all too ready to teach his governess: "I kissed his forehead; it was drenched. 'So what have you done with [my letter]?' 'I've burned it.'"

It seems the friction generated by language's 'duplicity' as it rubs back and forth between objective and subjective states ignites a spark that is catastrophic for any aesthetic program founded on identificatory models. It will prove particularly hazardous for that arch-trope of interiority, the stream of consciousness, unprotected as it is by literature's established firewalls. Indeed, as Van muses in his own parody of Anna's last day after he receives Blanche's note, "poor Stream of Consciousness, *marée noire* by now" (240). Unencumbered by any 'realist' frame organizing perception into the grammatical categories

of past and present, and stripped of the bar of repression that separates the conscious from the unconscious, the meandering stream of consciousness surges into an oil spill, a toxic black tide. It will take just a single spark to set it, and the romance library that floats upon it, alight.

But perhaps the most crucial *red hot tip* Nabokov gets from James is this: if the friction engendered by James's prose starts a fire that threatens to burn down the library of poetics, the light thrown by its flame is utterly removed from the heliotropic models that govern our understanding of time. The solar technologies lighting up the romance agenda have no purchase in the representational space projected by language's conflagration in Nabokov's silver screen. Unlike that of the sun, the light produced by language is not extinguished as day turns to night in time's circadian rhythms; the being whose forms are illumined in its rays lies beyond the reach of life's finitude. One understands now (*now!*) why it is James, rather than the other two great modernists whose footprints are stamped all over *Ada*, who produces a certain "tingle" in Nabokov's blood, a frisson of involuntary recognition, and belated remedy for Lucette's – and all finite beings' – "condition." This is because it is Jamesian rather than Joycean or Proustian linguistic materiality that explicitly has the power to raise, rather than mourn or recuperate, the dead.[55] For this is the import of James's final turn of the screw, which stripped language of the careful threading holding its dual aspects in place, releasing language to spin freely through all tropes and figures, sucking them along with their perceptual and cognitive models into the vortex that is Nabokov's hyperstyle. All languages and letters, all texts that have been written or have yet to appear, all past, present and future literary "combinations" are immediately available to Nabokov who burns through the archive with an inferno's indifference to temporal, spatial or linguistic borders.

Nabokovian style, then, is death-defying but in a way that breaks absolutely with death and its handmaiden, time. For Nabokov, it will not be a matter of accepting death's hold over finite beings nor of repressing that knowledge by living on through compensatory symbolic forms. Instead, Nabokov employs language's internal electric charge – the "Lettrocalamity" of the frottage of literature and cinema – to project a light not stolen from the gods. The silvery beams of this 'material' light illuminate a representational space 'older' than death. It is peopled by figures untouched by time. If one ventures the name arche-cinema for this, it nevertheless must be with caution, for even as Nabokov appropriates cinema's fundamental doubleness as the figure for his literary-cinematic aesthetic, his conjuring of reflective

models also floods them back upon themselves. In the totalizing inscription that is Nabokov's arche-cinema, Narcissus drowns. Echo calls deliriously to her own voice.

6 Sound Philosophy: *Bend Sinister*

The padograph is a writing instrument invented by the father of the totalitarian leader Paduk in *Bend Sinister*. An individualized, personalized sort of typewriter, the padograph imitates a person's handwriting with such a degree of accuracy and perfection that it can only be called "repellent" (*Bend* 222). As a writing technology, the padograph suggests a remarkable tool for forging documents, delivering the impression of a 'signature effect' through a mechanical process. "You could," explains Nabokov, "have your padograph based on the handwriting of a correspondent and then play all kinds of pranks on him and his friends" (223).

But the real value of the padograph in *Bend Sinister*'s dystopian vision lies elsewhere, that is, in the "luxury" it offers us "of seeing the essence of [one's] incomplex personality distilled by the magic of an elaborate instrument" (223). The padograph flattens out one's expressive flourishes, lopping off the extremes of height and depth of character while nonetheless providing for a carefully calibrated quantum of inconsistency. Several keys, for example, might be devoted to the "minor variations" carried by individual letters. The resulting script reflects the precise "average 'tone'" of one's handwriting, punctuated by a "carefully diversified" system of commas, periods and spaces that only a very close examination would reveal as technically engineered (223).

Beyond its ironic use as a symbol for Paduk's totalitarian state, the padograph inscribes another history of the relation between writing and thought. In one's handwriting, that seemingly most spontaneous, expressive, indeed auratic of writing technologies, Nabokov recovers a sort of 'arche*type*' of individuation that would recast the entirety of these assumptions as fraudulent. What if all of our most dearly held fantasies of selfhood and of 'personality' were in fact impressions cast by a mechanical 'hand,' one so nearly completely invisible that it takes an acute, almost forensic sensitivity to detect? Peel back the enveloping layers of character and we find an unmistakable *pad*ding sound, tapping away quietly in the background as it stealthily threads together the cluster of identificatory traits that make up the backbone of the self.

The padograph thus only makes perceptible – if only *just* – another operation that lies more clandestinely hidden in the bends and folds of the linguistic weave, one that broaches an impossible question,

bordering almost on madness: what operation of synthesis binds together the letters of one's name? What hidden substrate holds one's little 'lettrinos'[56] in place to prevent them from spinning out, forming and reforming into other combinations ad nauseum? In the eyes of fascist leader Paduk, whose "irritating trick of calling his classmates by anagrams of their names" is singled out by the narrator, there would be no mystery, because there is no underlying adhesive: "all men consist of the same twenty-five letters variously mixed" (*Bend* 222). Expressed in Paduk's "curiously smooth nasal voice," Adam Krug (the name of the involuntary hero of Nabokov's novel) is just as dexterously referred to as Gumakrad or Dramaguk, Gurdamak, Kamerad, Madamka, or simply Drug. To the extent that it is composed of a set of endlessly reshufflable letters, one's name – habitual seat of one's identification and individuation – would betray a 'totalitarian' tendency at odds with the very sovereignty it seems to enable.

From this perspective, the padograph exposes the entire pretext of nominal differentiation as a front for a radical indifference encrypted in language. Rather than the building block for one's unique ontogenetic 'code,' a name is unmasked as a blindly interchangeable combination of letters. In this, it mirrors the absolute "ekwality" of all individuals under Paduk's totalitarian 'Ekwilist' regime. In the Ekwilist philosophy, as Nabokov explains, there exists a "universal human consciousness" which has been unevenly distributed among individuals. The political aim of the Ekwilist state is to rebalance, by force if need be, the distribution of this consciousness by "remolding" the individual in conformity with an Average Man.

'Ink, a Drug'

In the spring of 1906, the Swiss linguist Ferdinand de Saussure became fascinated and perplexed by certain repeating sequences of phonemes in Indo-European poetry. In the Saturnine verses found on 3rd century BC Roman tombstones, Saussure came across patterns of sounds that contained uncanny echoes of the deceased's name, which appeared surreptitiously encoded within the language of the poetic dedication. In the famous letter to his student Antoine Meillet, Saussure writes of his momentous discovery:

> There is always, in the inscriptions, a consonantal residue, and according to our hypothesis [...], this residue is *wilful*, and destined to reproduce consonants from the initial THEME, written in an abbreviated form for proper names, and in full form for other nouns. (Joseph 487)

Saussure ran through a number of labels for this phenomenon, first calling the mysterious phonemic patterns anagrams, then paragrams and then, finally, hypograms. With this designation Saussure opens a rupture in his model of the linguistic sign. The hypogram would be an epiphenomenon of language, representing a principle that breaks two of the key laws of Saussurian linguistics, namely, the arbitrariness of the bond linking the signifier and signified, and the principle of linearity. For the hypogram suspends the successive ordering of auditory signifiers as they unfold in time. Normally, according to Saussure, "words acquire relations based on the linear nature of language because they are chained together" (Saussure, 123). The hypogram, by contrast, exposes a relation heard in and through its disarticulation by intervening phonemes. It thus challenges one to consider what Roman Jakobson, in his critique of Saussure, proposed as a "dynamized tension" between signifier and signified, that is, the possibility of a "direct interplay of the speech sounds with meaning" (Jakobson 233).

As is well known, Saussure eventually repudiated his hypothesis. No mention of it appears in his *Course in General Linguistics*, which was published posthumously in 1916. De Man comments that Saussure's caution in this regard "supports the assumption of a terror glimpsed" (De Man, "Hypogram" 24) and it is not difficult to see why: the hypogram invites serious paranoia. Was Saussure in fact simply seeing things, attributing cause to mere coincidences that arise naturally through the effect of chance on the restricted set of letters that is the alphabet? Saussure writes to the contemporary Italian poet, Giovanni Pascoli in whose work he discovered the same pattern of hypogrammaticality as in the ancient Latin poems, "Are certain technical details, [...] there purely by chance, or are they intended, and applied in a conscious manner?" (Joseph, 557). (Pascoli never replied.) This, too, broaches a kind of madness: could "chance" be a cover for some hidden resource in language itself, one that folds signifier and signified back onto one another, driving the currents of poetic language continually toward the letters of the proper name? Would the hypogram, then, be the trace effect of some latent structuring principle that persists in and through the Ekwilizing protocols of interchangeability that officially organize the linguistic sign?

De Man observes that another meaning for the Greek word hypogram is signature. The signature would be the graphic representative of one's unique identity. Operating on the dual assumption of presence and repeatability, the signature enables one to circulate symbolically in the absence of our empirical selves. A signature at once indicates *presence* for we must have been physically present when we signed. It also is the mark of *singularity*, for handwriting is assumed to be both

unique to the individual and consistent. In his history of the passport, Craig Robertson explains that, emerging in the 19th century, the idea of a "proper" signature was characterized as being both sufficiently distinctive and typical such that anyone might reasonably be able to compare signatures and decide their authenticity.[57]

In *Bend Sinister*, the signature assumes an additional function as the sign that is to authenticate Paduk's revolutionary regime. The State's target here is Krug's own signature. A world-famous philosopher, Krug is a former school mate of Paduk's. In their childhood, Krug and his friends baptized Paduk "the toad" and bullied him relentlessly (although the narrator remarks that the origin of the nickname was obscure, since it was not based on any physical similarities between the child and the tail-less amphibians). Since those unhappy days, Krug has become an internationally respected figure while Paduk, despite being universally disliked, "gently rose," first to become the founder of the schoolyard political Party of the Average Man. "Nobody had noticed," remarks the narrator, "how this rather incongruous little crowd had gathered around Paduk and nobody could understand what exactly had given Paduk the leadership" (*Bend* 227). But Paduk continued to rise, and now holds the leadership of the Ekwilist party into which the youth group has since metamorphosed. In these roles Paduk crafts a distinctive look, evidently copied from the funny pages of a "blantantly bourgeois paper" (229). It is the look of a Mr. Etermon (Everyman), a drab cartoon figure whose main features are his highly polished shoes, shirt-sleeve cuffs and shiny close-shaved head. A sort of animation of the tedious Mr. Etermon, Paduk maintains this style over the years.

At the point where the story opens, Paduk's regime is engaged in an attempt to take advantage of Krug's cultural capital as a philosopher to bestow it the legitimacy it craves. In a series of increasingly desperate sorties aimed at securing Krug's signature to a document signed by all the other leading members of the Skotoma academy, Paduk's operatives resort to disappearing Krug's friends one by one and, finally, kidnapping Krug's small son David. This last assault breaks Krug's resolve. He caves in to Paduk's demand but it is too late. At the Institute for Abnormal Children where Krug's child has been taken by mistake, David has been confused with a similarly named prisoner, Arvid Krug, the son of another university Professor, a certain Martin Krug, former Vice-President of the Academy of Medicine. Little Arvid is delivered up safely but David has already fallen victim to what is perhaps one of the most horrific of child deaths in literature, the details of which are documented in a darkly comic silent film that Krug is forced to watch.

On the surface, Nabokov seems to be making a central and seem-
ingly universally uncontroversial point here about the essentially
non-fungible nature of who one is. The unusually high (for Nabokov)
level of pathos in this novel would seem to shore up the common mis-
reading of him as an unrepentant humanist. Taking off from certain
of Nabokov's statements, particularly in *Speak, Memory,* this reading
puts him forward as a writer for whom art retains all its "mythologi-
cal and sacralized dimensions," as Baxter phrases it (Baxter 825).[58]
From such a perspective, it is art that guarantees the integrity of one's
name and, by extension, one's irreplaceable self. Art, particularly in
its instantiation as the stylistic signature of an exemplary original,
would break with the monotone of language's equalizing protocols and
restore the expressive flourishes and idiosyncrasies of 'character' that
one's forced entry into the universal signifying system of the Symbolic
had flattened off. The singularity of artistic style would be the supra-
adhesive that fixes the letters of our name in place, ensuring the differ-
ence between Arvid and David, or Martin and Adam.

Except there are complications with this. Nabokov is perhaps best
known for his authorial hand that makes parabasitic intrusions into his
narrative realities. As Will Norman perspicaciously notes, "Nabokov's
novels are often constructed in a way that suggests the author him-
self is impersonating such a consciousness within his fictional world"
(Norman, *History* 12). The most famous of these authorial interven-
tions occurs in *Bend Sinister* where an authorial "I," feeling "a pang of
pity" for his character at the end, sends Adam mad, thus "saving him
from the senseless agony of his logical fate" (*Bend* 352). Often mar-
shalled in support of the Godlike claims that Nabokov seems to invoke
for himself, the author's designing hand in this sequence suggests the
existence of "an omniscient consciousness existing outside time which
has 'already' prepared a design to unfold within it" (Norman, *History*
11). And, it cannot be denied, Nabokov has lent multiple supports to
this reading. In a letter to his editor at Doubleday outlining the novel's
basic plot, Nabokov explains that the end of the novel accomplishes
something as yet unprecedented in literature:

> [Krug] realizes suddenly the presence of the Author of
> things, the Author of him and of his life and all the lives
> round him, – the Author is *myself,* the man who writes the
> book of his life. This singular apotheosis (a device never yet
> attempted in literature) is, if you like, a kind of symbol of the
> Divine power. (*Selected* 49-50)

Yet one must tread warily when it comes to Nabokov's self-explana-
tions, and all the more when they are aimed at dimwitted editors of the

literary profession.[59] A more convincing clue comes from the novel's original title (still referred to as such in the letter to Donald B. Elder): *The Person from Porlock,* so named after Coleridge's famous bill-collecting visitor who fatally interrupted the scene of one of poetry's greatest hymns to the transcendent and creative power of Art. Instead of confirming a 'first cause' in the form of an all-powerful Godlike Creator dictating the show behind the scenes, Nabokov's intra- and extra-diegetic interventions in this and his other novels are better read as similarly Porlocking interruptions, ones that bracket the idea of the artist as, precisely, artifice: a stage prop or figure that can be exhibited or discarded at will.

This different understanding would then fold the concept of art as authorial signing into the larger, hyper-marking system that Derrida calls the signature. Derrida points out in "Signature, Event, Context" that, even as it signals presence, the written nature of the signature always also puts into play something that resists the former organization of forces (Derrida, *Margins* 329). It seems that whatever "art" bonds the subject to its name – and the name to its established ordering in letters – additionally leaves an ignoble 'residue,' something that is resistant to erasure by the signature's official claims of authorization and authentication. In *Bend Sinister,* this residue that challenges the principle of authority becomes formalized in the inky stain that contaminates Krug from the novel's opening paragraph, and whose presence Nabokov helpfully points out to us, his equally dimwitted readers, in the Introduction. There we read how the novel's plot "starts to breed in the bright broth of a rain puddle," spawning a series of spinoff transformations as if through some strange process of calligraphic meiosis:

> The puddle is observed by Krug from a window of the hospital where his wife is dying. The oblong pool, shaped like a cell that is about to divide, reappears subthematically throughout the novel, as an ink blot in Chapter Four, an ink-stain in Chapter Five, spilled milk in Chapter Eleven, the infusoria-like image of ciliated thought in Chapter Twelve, the footprint of a phosphorescent islander in Chapter Eighteen, and the imprint a soul leaves in the intimate texture of space in the closing paragraph. (165-6)

Remarked for us in this way by Nabokov, the kidney-shaped blotch performs in *Bend Sinister* as the impression of another authoring system that tracks simultaneously with, but on a different level to, the official signifying regime. Its repeating image performs inconspicuously as the hidden frame for the novel's scenes, pretending to the

"subthematic" support of the novel's world of objects and relations while secretly directing them, "breeding" the plot according to the exigencies of its own infernal logic. This, then, would revise our understanding of the author-function towards some shape-shifting principle inhabiting language. In the Introduction, Nabokov calls this shape-shifting principle the "verbal plague" of paronomasia. It is, he says "a contagious sickness in the world of words" (166). The inhabitants of Padukgrad are particularly susceptible to this condition. Its manifestations in the novel include "puns crossed with anagrams," "suggestive neologisms," "parodies of narrative clichés," "spoonerisms" and "of course the hybridization of tongues" (166). Like the inky hypo-graphematic "pool" in which they germinated, these linguistic "abominations" infect the officially sanctioned regime with their own "consonantal residue," proposing a different rule for literary production to that of the "Divine power" of the Author.

Thus it seems that something in the signature's protocol of repeatability – the very thing was supposed to grant it its power as archetrope and first technology of identity – also becomes unleashed in the act of inscription. Opposing itself to the authorial hand, with its Michelangelic fantasies of an aesthetic contract between mankind and God (Krug's first name, recall, is *Adam*), this padding *foot*print charts a zigzagging path through Nabokov's oeuvre, not as the stabilizing "link" between author and creation that leads to "another world of tenderness, brightness and beauty" as Nabokov waxes lyrically, if ironically, in the Introduction.[60]

> The puddle thus kindled and rekindled in Krug's mind remains linked up with the image of his wife not only because he had contemplated the inset sunset from her deathbedside, but also because this little puddle vaguely evokes in him my link with him: a rent in his world leading to another world of tenderness, brightness and beauty. (166)

But rather it is as a sort of "reverse cameo," as Tom Cohen has named a similar phenomenon in Hitchcock (Cohen, *Secret* 117), that this 'other' Nabokov fatally short-circuits the link joining "the Divine Author" to his progeny. For with his "singular apotheosis" – a "device never yet attempted in literature" – it seems that Nabokov opens a black hole. The "rent" opened in Krug's world by this hypermarking system will be a Benjaminian one-way street. In breaking or, rather, *interrupting* the fundamental 'law' of narrative with his authorial signature, Nabokov pries open literature's *poorly-lock*ed gates. However the thoroughfare to the Outside it reveals will permit traffic in only one direction, preventing any return to the "inset sunset", the representational

world of objects and relations, which the hypermark-signature professed merely to frame.

Malallegories of Reading I: Bergson

An increased sense of the universal equality of things. This is how Benjamin describes the perceptual program that underpins the assumption of art's reproducibility. Yet this supposes that a work can be reproduced, that is to say, that it would be available to representation, that is, of the order of perception. The hypogram/signature emerges in Nabokov as a unit of signification that breaks with existing perceptual models through which representational systems are traditionally administered and authorized. Krug, whose name in Russian means "circle," implicitly points us to this other model. The author of a leading work of philosophy, *The Philosophy of Sin,* Krug had never, Nabokov tells us, "indulged in the search for the True Substance, the One, the Absolute, the Diamond suspended from the Christmas Tree of the Cosmos" (*Bend* 304). Yet, Nabokov continues "nobody could really define what special features his philosophy had, or what 'eminent' meant or what 'his time' exactly was":

> [Krug] knew that what people saw in him, without realizing it, perhaps, was not an admirable expansion of positive matter but a kind of inaudible frozen explosion (as if the reel had been stopped at the point where the bomb bursts) with some debris gracefully poised in mid-air. (*Bend* 305)

It is a cinematic operation that is in play, then, as a philosophical 'turn' whose gravitational vortex draws into itself all representational technologies founded on identification, resemblance and analogy only to detonate them, along with the underlying causal chains that thread them back to the "Divine power" of an extra-linguistic One. Literally undefinable, because unfixable and unbounded, this would be a cinaesthetic operation that, like some runaway nucleating process, traverses all points of the signifying system at once. It would entail a crystallization in Deleuze's sense, a perpetually self-seeding process of formation and expansion. Such a 'cinem-autograph' side-steps, deflects and returns time's arrow, driving a shock-wave into the surrounding spatio-temporal fields and their signifying systems. Training its focus upon "the vanishing limit between the immediate past which is already no longer and the immediate future which is not yet" as Deleuze recalling Bergson puts it (Deleuze, *Cinema 2* 79), the cinem-autograph would split the subatomic unit of time itself.

Cinematic figuration thus sets in motion an 'event' that would undo all events understood as occurrences in a causal chain. This event is cast as an image that, freezing motion, grants a perception of time in its pure form, insofar as time is the (unchanging) "form" of everything that changes. Deleuze explains, "the still life is time, for everything that changes is in time, but time does not itself change" (Deleuze, *Cinema 2* 17). What implications would this have for Krug's philosophical subject? If cinema permits a perception of time itself in a totalizing instantaneity reminiscent of Bergson's (only hypothetical) "pure perception," it also implies an internal rupture in the subject that divides itself between an "actual" existence as existing in time and its "virtual" double who "re-members" each moment *as it occurs*. On this point, Bergson is perfectly clear, as Deleuze notes. In *Mind-Energy*, Bergson writes,

> [o]ur actual experience, then, whilst it is unrolled in time, duplicates itself along with a virtual existence, a mirror-image. Every moment of our life presents the two aspects, it is actual and virtual, perception on the one side and recollection on the other. [...]. Whoever becomes conscious of the continual duplicating of his present into perception and recollection [...] will compare himself to an actor playing his part automatically, listening to himself and beholding himself playing (cited in Deleuze, *Cinema 2* 79).

Contrasting with the supposition of a unique and original personhood that underpins the "divine power" of the artist-author, there is a fundamental de-personalization at the heart of the Bergsonian/Krugian subject who is effectively reduced to playing catch-up with itself. There would be an automaton-like aspect to all our actions as we respond to the stimuli around us, as Bergson's use of teletechnic metaphors prompts us to see. In *Matter and Memory* he describes the brain as a kind of "central telephone switchboard" whose operator – whom he names "attention" – is in charge of communications, either putting it on hold or spelling it back again, "word for word, in order to check its accuracy" (Bergson, *Matter* 123). But if for Bergson it is "memory" that holds together the discrete succession of moments of perception, it is also memory that offers a revised understanding of our relation both to the past and to the objects of one's representations, including, one might add, to the relation between the Author and his/her "progeny."

One can uncover the thread of this alternative understanding by following Bergson's explanation of how memory acts upon our present perception. All perception, he maintains, is doubled between the temporally-bound, external perception and memory. The latter "directs

upon the perception received the memory-images which resemble it." By doubling perception, memory in effect creates the present perception "anew," adding to one's concrete perception memory-images of the "same kind." One digs deeper and further into "more distant regions of memory, until other details that are already known come to project themselves upon those details that remain unperceived," he writes. In an image that Nabokov would certainly have approved of, Bergson asserts that memory effectively widens perception, it makes one see *more*:

> the operation may go on indefinitely; – memory strengthening and enriching perception, which, in its turn becoming wider, draws into itself a growing number of complementary recollections. (Bergson, *Matter* 123)

"The deeper the memory layers we tap into" glosses Suzanne Guerlac, "the more we actually perceive of reality, and the more meaning we can give to the real. It is as if the real and its interpretation of the real, were almost the same thing" (Guerlac 136).

And this is, in fact, Bergson's conclusion at the end of *Matter and Memory*. He writes, "our perception [...] is originally in things rather than in the mind, without us rather than within," although he qualifies this by saying one's experience of this coincidence between our perception and its object remains only hypothetical:

> it could only happen if were shut up within the present moment. In concrete perception memory intervenes, and the subjectivity of sensible qualities is due precisely to the fact that our consciousness, which begins by being only memory, prolongs a plurality of moments into each other, contracting them into a single intuition. (Bergson, *Matter* 291-2)

However, once freed from the logic and necessity of temporal constraints, as one is in cinematic representation, things change radically. A cinematic "memory" – which seems to be what Deleuze is gesturing towards with his time-image – sheds the last constraining link with "concrete perception." One would no longer be subject to the unidirectional arrow of time which, for Bergson, is a consequence of our experience of space. Space imposes itself with concrete perception as soon as one *acts* in the world. It is *action* that "raise[s] homogenous space as a barrier between the intellect and things," which are in fact "not really divided, any more than immediate perception is in truth unextended" (307-9).

For Nabokov, the real value of this "extended continuum," as Bergson names it, lies in the upset it poses to our understanding of

necessity. If memory, in Bergson's sense, was found to *double* percep-
tion, adding to our concrete perceptions a certain density and com-
plexity of memory-images that always-already precede perception,
this implies that the past retains a mobility, an ability to act in the
present. Bergson writes, "our past [...] is that which acts no longer but
which might act, and will act by inserting itself into a present sensa-
tion of which it borrows the vitality" (Bergson, *Matter* 320). There
will no longer, he concludes, "be any more reason to say that the past
effaces itself as soon as perceived, than there is to suppose that mate-
rial objects cease to exist when we cease to perceive them" (182). The
present is, in a sense, the *ghost* of the past; it is the spectral puppet-like
entity through which the past continues to speak and act.

Clearly, the past also remains alive for Krug. Among Nabokov's
novels, *Bend Sinister* is unusual for the constant interruption of the
narrative with images and memories from the past that jostle for pri-
ority with the present. In particular, images of Olga, Krug's recently
deceased wife, infuse the present as, for example, when Krug is driven
back from the Institute for Abnormal Children and Olga mysteriously
appears at the wheel. Is this just another of the many dream sequences
that have been weaving their way through the description of events
in *Bend Sinister*? Or is it perhaps Nabokov's hat-tip to the temporal
distortions effected on the subject's experience by trauma: Krug has,
after all, just been forced to watch a gruesome comedy leading to his
son's death, and traumatic experiences are well known for causing all
sorts of peculiar effects on the subject's experience of time. But to take
this path would be to miss Nabokov's delicate little cameo of Henri
Bergson himself who sits, in this vision, sleeping peacefully in the
back seat beside Krug's friend Ember as the "gaunt hollow-cheeked,
white-haired man who had come all the way from his remote country
to discuss with Krug the illusion of substance" (346).[61] By way of this
cameo, Nabokov implicitly declares his intentions for something else
that a "philosophy of Sin(ema)" must be capable of performing.

It is in chapter seven that one finds the fullest exposition of these
'cinestar' intentions, as well as the critical point where Nabokov
diverges from the Franco-Polish philosopher whose reflections we
have been following. In this scene, Krug visits Ember whom he finds
in bed with a cold. In his unhappy position of "Literary Adviser"
to Paduk's new State Theater, Ember – whose name hints both at
Bergson's memory and a more Nabokovian *embering* – tells Krug he
is overseeing a production of *Hamlet*, but this is a strangely "muddled"
version of Shakespeare's famous play. To make it fit for the revolution-
ary masses, the play's focus has had to shift from the melancholic
Dane to the "fine Nordic youth" Fortinbras, "a blooming young knight,

beautiful and sound to the core" (254). In this, the adapted play is only bringing into realization what a certain late "Professor Hamm" excavated – in Goodmanlike fashion – as "The Real Plot of *Hamlet.*" In a twist, the adapted play proposes that Shakespeare's famous ghost on the battlements – whose secret unleashes the drama of one of the greatest reflections in all of Western literature on, precisely, the impossibility of deciding between action and acting – is himself an impersonator, an *actor.*

> The real plot of the play will be readily grasped if the following is realized: the Ghost on the battlements of Elsinore is not the ghost of King Hamlet. It is that of Fortinbras the Elder whom King Hamlet has slain. The ghost of the victim posing as the ghost of the murderer – what a wonderful bit of farseeing strategy. (255)

Bergson initially proposed the figure of the actor to account for the effect of perception's doubling between concrete perception and past recollection. The subject would merely be playing a part dictated by the scene's real Director, the past. And yet if we imagine this has simply replaced one "first cause" (the Author) with another (the irrevocable past) to which the world of representation is linked by some form of causal necessity, we are quickly disabused by Nabokov. For here, in a double-crossing ploy, the ghost playacts not the walking talking "real" of the past but, precisely, another *ghost.* The present would not be the ventriloquzing of the past à la Bergson, but a redoubling with *another scene of acting.* It is not so much a question of depersonalization then. If Nabokov remains faithful to Bergson up to a point, here he proposes that 'behind' the past is an arche-scene of *impersonation.* With the click of a mouse-trap, Nabokov brackets any action whatsoever as a spectral likeness of what is *already* imitation.

In so doing, Nabokov also dissolves the final link with "concrete perception" and its spatio-temporal order. For recall how for Bergson, it is only because of the requirements of action that space is deployed as homogenous. Action requires the imposition of space, but this is only a schema, an "abstraction" or "symbol," Bergson claims. While the real, or the "extended continuum," he writes, "is something intermediate between divided extension and pure inextension,"

> it is as a result of the very necessities of action that extension should divided itself up for us into absolutely independent objects (whence an encouragement to go on subdividing extension); and that we should pass by insensible degrees from affection to perception (whence a tendency to

suppose perception more and more inextensive). (Bergson, *Matter* 326-7)

It is only because one must act in the spatial world that this division into external objects and internal perception becomes necessary for Bergson. But for Nabokov, by contrast, an ur-principle of impersonation slides out the checkered tiles of Cartesian space from beneath one's feet. If all "action" is always already "acting," this implies there is no stabilizing link connecting the present to the past, whose further implication is that the "schema" of a homogenous space becomes defunct – exposed as the artificial construct it is. The traditional oppositions of "mind" and "matter" constitute "something representing a brand-new class," as Krug muses:

> Now let us have this quite clear. What is more important to solve: the "outer" problem (space, time, matter, the unknown without) or the "inner" one (life, thought, love, the unknown within) or again their point of contact (death)? [...]. Or is "outer" and "inner" an illusion too, so that a great mountain may be said to stand a thousand dreams high and hope and terror can be as easily charted as the capes and bays they helped to name? (306)

Cherche la 'la'

If all perception, in Nabokov/Bergson/Krugian "philosophy" is thus already 'cinematic,' what would film itself imply for consciousness? What effect, in other words, would a redoubling of cinema back upon itself unleash? Following Ember's description of the revolutionaries' grotesque *Hamlet* adaptation, Krug tries to comfort his friend who has dissolved into tears after hearing about the disappearances of Krug's friends, the Maximovs, by the Paduk regime. In an attempt to cheer him up, Krug tells Ember about a "curious character" whom he met on a train in the United States. This man wanted to make a film adaptation of *Hamlet*. Krug rehearses the plan, elaborating in blank verse the film's opening shot:

> *"We'd begin," he had said, "with*
> *Ghostly apes swathed in sheets*
> *haunting the shuddering Roman streets,*
> *And the mobled moon..."* (257)

The screenplay continues with a sequence of images: "the ramparts and towers of Elsinore"; "Hamlet's first soliloquy is delivered in an unweeded garden that has gone to seed" (257); "The moonlight

following on tiptoe the Ghost in complete steel, a gleam now settling on a rounded pauldron, now stealing along the taces" (257); "Hamlet dragging the dead Ratman from under the arras and along the floor and up the winding stairs" (257); "Hamlet's sea-gowned figure, unhampered by the heavy seas, heedless of the spray, clambering over bales and barrels of Danish butter and creeping into the cabin where Rosenstern and Guildenkranz, those gentle interchangeable twins 'who came to heal and went away to die,' are snoring in their common bunk" (258).

As the screenplay's "pictorial possibilities" develop, we also start to hear a bit more about Krug's former interlocutor. He is "a hawkfaced shabby man whose academic career had been suddenly brought to a close by an awkwardly timed love affair" (258). His scene sketching an image of "lusty old King Hamlet" is suddenly broken with an unexpected outburst: after inviting Krug to a draught from his hip flask, the man turns from the Shakespearean drama to his own: "He added he had thought she was eighteen at least, judging by her bust, but, in fact, she was hardly fifteen, the little bitch" (258).

When Krug is rescued from his fate, his past is magically withdrawn by the Author's act of pity. In Krug's madness, Nabokov erases the memory of his "hideous misfortune" and breaks the causative logic of narrative fate. But here, and with a "pang" not so much of Authorial "pity," perhaps, as of some immortal passion, something unmistakeable from the future "slides" along its own moonbeam as a replay or repetition with a difference of the authorial gesture. For in the bird-like figure of the disgraced academic, Nabokov suggests a post-*Lolita*, alcoholic, Humbert Humbert who did not die but, released from his "tomblike seclusion," cruises the "men's lounge" of America's Amtrak trains and accosts anyone, ancient Mariner-like, who will listen to his rambling self-defense in the wake of Lolita's death in childbirth. That is to say, we have a vision of the afterlife of a possible Humbert *following* the close of the novel *Lolita*, yet appearing in *Bend Sinister, before* the later novel has been written.

Ember and Krug then begin to elaborate on the possibilities put forth for the cinematic *Hamlet* that have been sparked by this "curious character":

> Ember stops sniffling. He listens. Presently he smiles. Finally, he enters into the spirit of the game. Yes, [Ophelia] was found by a shepherd. In fact her name can be derived from that of an amorous shepherd in Arcadia. Or quite possibly it is an anagram of Alpheios, with the "S" lost in the damp grass – Alpheus the rivergod, who pursued a long-legged

nymph until Artemis changed her into a stream, which of course suited his liquidity to a tee [...]. Or again we can base it on the Greek rendering of an old Danske serpent name. Lithe, lithping, thin-lipped Ophelia, Amleth's wet dream, a mermaid of Lethe, a rare water serpent, *Russalka letheana* of science [...]. (*Bend* 259)

"Ophelia," "help-mate"[62] of something as yet unnamed "dies in passive service," Ember muses. In service to what? To a principle of going *under*. Flooding the representational space, Ophelia puts another model of representation into play, one that will suck down the very principles of romance poetry, along with all the regimes of identification including those of memory and of action, into the whirlpool with her:

> we see her [continues Krug], on her back in the brook (which table-forks further on to form eventually the Rhine, the Dnepr and the Cottonwood Canyon or Nova Avon) in a dim ectoplastic cloud of soaked, bulging bombast-quilted garments and dreamily droning hey nonny nonny or any other old laud. This is transformed into a tinkling of bells, and now we are shown a liberal shepherd on marshy ground where *Orchis mascula* grows [...]. (258-9)

Orpheus, the "amorous" "liberal shepherd," the "father of songs," could sing so beautifully he could divert the course of rivers, but even he could not bring his beloved Eurydice back from the dead. Ophelia, however, figure of a fatal miscarriage of sexual justice, avenges what turn out to be the murderous effects of her namesake's song as well as those of his "forty thousand brothers," all unwitting "pupils of La*mord*" (260). She does so not with the erotic seductions of the siren's song but with a droning that penetrates even the most carefully beeswax-stopped ears. Where Orpheus diverts the rivers of song, passive Ophelia "on her back in the brook" drowns out, pulls down, and sucks back into herself the very principle of poetry itself. A lethal nymph who mimes the tropes of romance – (a quick internet search reveals that the *Orchis mascula* has no nectar but attracts pollinating insects by *mimicking* flowers of other species) – Ophelia slips from the unwanted embraces of poetry's rivergods by transforming into the *non*sensical stream of letters itself. We thus recognize her affinity with another of Nabokov's "slim slimy ophidian" nymphs, "both hotly hysterical and hopelessly frigid": if a traumatized Humbert Humbert cruises through *Bend Sinister* as a sort of advance "memory" of a book that has yet to be written, Lolita herself now makes a ghostly

pre-appearance in the form of Ophelia's "quick gray-blue eyes, the sudden laugh, the small even teeth" (260) – although Lo, of the great, gray, grave eyes (*Lolita* 265; 268) is presumably less concerned as to whether she is being "made fun of."

Ophelia, Olethia, Lolethia, Lolita. A *lethal* logic sees a dead Lolita re-turn in *Bend Sinister* as a sort of advance cinematic trailor of herself, heralding her future existence as the chimeric mother of "Lithe, lithping, thin-lipped Ophelia" (259). In *The Real Life of Sebastian Knight*, Nabokov invokes the paradox of "twins" born at different times. Here, Ophelia and Lolita engage in an "awkwardly timed" *philiation* process that cancels causal logics, a "mother" arriving *after* a "daughter" who effectively "killed" her in childbirth. In such a case, the full battery of poetic models of identification, reproduction and action would find themselves gagged by a "blank" verse so 'pure' it erases the very concept of beginning, advancing in its place a "mobled moon": two intertwining Möbial "mothers" who envelop or "muffle" the other's chance at life; a chimeric or vanishing progenitor.

In *Bend Sinister*, Nabokov compels us to rethink the way the name hangs together. His analytic of ordering is irrevocably severed from the model of a first cause that cements the letters of one's name in place. For with lisping Lo-Lethia (and with a watery wave to the future twin mothers, Aqua and Marina, of *Ada*), Nabokov invokes not one but *two* causes, each cancelling the other out. Crucially, like telltale ripples on a pond, this *going down* of identificatory systems exposes some kind of internal attraction in language that operates as a sort of vortex. Exerting a "pull" on the letters of one's name as they cycle acrobatically through the combinatory of their anagrams, some self-cancelling principle of letteral attraction serves not so much as the antidote to the "verbal plague" of Padukian paronomasia but as the auto-immune disease of the hypermarking system itself. The signature system turns against itself. Like an over-zealous antibody, letteration turns the protocols of linguistic Ekwilism upon themselves to devastating effect.

One would need another model of authorship, this time as an internal operation that resists the "totalitarian" rule of Ekilism – and its hitmen, Alpheus and his army of forty-thousand Alpha-male rivergods. This other model presents as a force that draws back the letteral tide that otherwise rushes metonymically outwards, pulling language back like a lunar gravitational field. What name could we give to this Lo-Lethian *under*-pinning of the linguistic fabric whose slow bleed soaks through and engorges language's "bulging bombast-quilted garments" (*Bend* 259)? We must look to another figure of a going under, one so profound it will become impossible to say whether or not it

ever took place. What would go down – if indeed it does go down – is precisely a "Master."

Malallegories of Reading II: Mallarmé

In his Introduction to *Bend Sinister,* Nabokov draws our attention to the coded presence of Mallarmé in this novel, alerting us that the French symbolist poet "has left three or four immortal bagatelles." In particular, he focuses on the following little phrase from "The Afternoon of a Faun" which, like Proust's Vinteuil melody, surfaces at certain moments in the text: *"sans pitié du sanglot dont j'étais encore ivre,"* which Nabokov translates as "spurning the spasm with which I was still drunk." He points out for us its fragmentary reappearance in the form of "Dr. Azureus' wail of rue" (*"malarma ne donje"*), and in Krug's apologetic expression, *"donje te zankoriv,"* when he interrupts a couple kissing (168). However, this cross-lingual evocation of the earlier Coleridgean theme of the interruption of poetry's erotic enjoyment now gives way to a different Mallarméan theme, one which exerts a still more powerful hold over Nabokov's novel. This is the Mallarmé of the disappearing event, the Mallarmé of the "solar drama," of the "sunset" of poetry and its inset battery of seductive ruses. The fact that it should be the post-crisis Mallarmé, rather than of the earlier "Afternoon of a Faun" we are to focus on has been suggested already by another Coleridgean motif we have touched on, namely, the ancient Mariner sketched in the birdlike figure of a post-*Lolita* Humbert Humbert. He invokes the image of a shipwreck and, with it, one of poetry's most famous images, Mallarmé's figure of a drowning Master in "Un coup de dès."

As Thomas Karshan has noted, what Nabokov will take from this later Mallarmé is, precisely, what the poet calls "this region of vagueness in which all reality dissolves" (*"dans ces parages du vague, en quoi toute réalité se dissout"*). For Karshan, the Klein bottle-like structure of *Bend Sinister,* which reduplicates Krug's image of a stocking being turned inside out, seems to point at a fundamental Mallarméan nothingness at its heart, leading the critic to propose that Nabokov's novel raises the question whether it is merely a nightmare "conjured up out of the trivial surroundings of a person sitting in his room" (Karshan 17). In support of this, Karshan draws our attention to a sequence of books in the novel, which he sees functioning like Mallarméan "art-objects": voided structures whose forms are produced by their contents such as the Mallarméan poet's cup that is composed purely of the foaming words of poetry. However, rather than being "empty," as the critic describes them, the real interest of these books is their explicit

design as decoys, enlisted for some secret operation that will employ the great French poet as its façade.[63] Thus in chapter five, when Krug dreams about sitting an examination on the topic of "an afternoon with Mallarmé, an uncle of his mother," he relates how,

> [s]omebody on his left asked him to pass a book to the family of his right-hand neighbour, and this he did. The book, he noticed, was in reality a rosewood box shaped and painted to look like a volume of verse and Krug understood that it contained some secret commentaries that would assist an unprepared student's panic-stricken mind. (232)

Mallarmé's poetry is enlisted for a cheating operation. What will it enable us to swindle? *Chance* of course.

Mallarmé's famous poem centers on a shipwrecked sailor – a "Master" – whose upraised hand clasps two dice. Here is how Alain Badiou sketches Mallarmé's diarama:

> Within the scenic frame, you have nothing apart from the Abyss, the sea and sky being indistinguishable. Yet from the 'flat incline' of the sky and the 'yawning deep' of the waves, the image of a ship is composed, sails and hull, annulled as soon as invoked, such that the desert of the site 'quite inwardly sketches [...] a vessel' which, itself does not exist, being the figurative interiority of which the empty scene indicates, using its resources alone, the probable absence. (Badiou *Being* 192).

Out of this abyss, an image of a feather gradually emerges, which potentially "adjusts" to form the headpiece of Shakespeare's Hamlet:

> The feather at the possible limit of its wandering, adjusts itself to its marine pedestal as if to a velvet hat and under this headgear – in which a fixed hesitation ("this rigid white-ness") and the "sombre guffaw" of the massivity of the place are joined – we see, in a miracle of the text none other than Hamlet emerge, "sour Prince of pitfalls"; which is to say, in an exemplary manner, the very subject of theatre who cannot find acceptable reasons to decide whether or not it is appropriate, and when, to kill the murderer of his father. (Badiou, *Being* 194)

It is a question once more of the Aristotelian problematics of identity and action. Previously, through his trick filched from Hamlet's mouse-trap, Nabokov succeeded in subtracting the Bergsonian necessities of space with an internal bracketing that redefined all action as *acting*.

But here the Mallarméan Hamlet rescinds the very concept of Being itself. In Mallarmé's poem, a fundamental uncertainty about the status of experience takes hold. Conjured from the barest outlines of a feather, Hamlet's "lucid and lordly crest of vertigo" metamorphoses into another image: the "delicate dark form" of a Siren standing aloft whose tail slaps a rock, "false manor immediately evaporated into mist, which imposed a limit on infinity." Then, restating the previous image, the feather is buried in "the original spray," its peak having become "withered by the identical neutrality of the abyss." Mallarmé's famous phrase follows: "Nothing, of the memorable crisis or might the event have been accomplished in view of all results null human, will have taken place (an ordinary elevation pours out absence), but the place." A fundamental undecidability of representation is raised in Mallarmé's poem: did we see an image of a shipwreck or was it merely an illusion formed by a play of light over the Abyss of nothingness? Did the bitter prince of the reef emerge from the outlines of a feather? Or was it merely a spray of foam?

When Badiou comments on Mallarmé's famous poem, what he takes from it is the idea of an event that, although strictly undecidable, nevertheless emerges as something that is outside of calculation. For the poem concludes:

> Except, on high, perhaps, as far as place can fuse with the beyond (aside from the interest marked out to it in general by a certain obliquity through a certain declivity of fires), toward what must be the Septentrion as well as North, a constellation, cold from forgetfulness and desuetude not so much, that it doesn't number, on some vacant and superior surface, the successive shock in the way of stars of a total account in the making.

Badiou maintains that this fundamental undecidability requires us to make a choice. Mallarmé's gnomic phrasing, "a throw of the dice will never abolish chance"/"All thought emits a throw of the dice" is understood by Badiou as the injunction, "decide from the point of the undecidable." This further means that one must "legislate without law as to its [the event's] existence," which perhaps unsurprisingly also turns out to be the task of poetry:

> If poetry is an essential use of language, this is not because it is devoted to Presence, to the proximity of being; on the contrary, it is because it submits language to the maintenance of that which, being radically singular, pure action, would without have fallen back into the nullity of the place. Poetry

is the assumption of an undecidable: that of acting itself, the
action of the act, of which we can only know has taken place
by wagering on hits truth. (Badiou, "Exact" 71)

In Nabokov's revision of the Mallarméan wager, the stakes are even
more far-reaching. They concern language's ability to overcome fini-
tude and to outsmart death. In this, Nabokov would merely be follow-
ing Mallarmé's own lead, together with the French poet's own two
"masters," Edgar Allan Poe and Villiers de l'Isle-Adam, two writers
whose lifelong obsession, as Christophe Wall-Romana reminds us,
was devoted to dissolving the material divide separating life and death
(Wall-Romana 129).

In *Bend Sinister*, chance appears as the hand-maiden of Paduk's
regime. It is by chance that Adam's colleague, the former Vice-
President of the Academy of Medicine, is also named Krug; it is an
unfortunate accident that David is mistaken for another child whose
name is almost the same. Here chance equates with death, with the
absolute contingency that haunts the aesthetic-ideological regime.
Chance was also the name for a certain radical imperviousness of
language itself, its failure to discriminate among subjects, which we
earlier encountered as the 'equalizing' tendency of language in the
face of a subject's singularity. Finally, chance also designates what
Saussure thought he had discovered in the echoes of the dead's names
in the poetic tribute of Saturnine poetry. "Is it by chance?," he queried
the Italian poet Pascoli.

If chance and death are proposed as interchangeable in *Bend Sinister*,
this delivers a tautological meaning to Mallarmé's "throw of the dice":
"death will never abolish death"/"All thought emits death." The mes-
sage seems indisputable: despite the grandiose claims of aesthetic ide-
ology and the fulsome poetic tradition, death would be the absolute
"Master" from whom one can never escape.

And yet it is clear that Nabokov refutes this, which is why he
chooses a figure, precisely, of a *drowning* "Master" as the instru-
ment of his intervention. If Mallarmé affords Nabokov with a means
for cheating the chance-that-is-death, it will lie in the French poet's
own meditations on the crisis of poetry. If poetry – at least Romantic
poetry – cannot 'save' us from death, a certain prose, that is, the prose
of a crib-sheet secreted within the Book of poetry, perhaps can.

In his acclaimed article, "Crise de vers," based on a lecture he deliv-
ered at Oxford and Cambridge, Mallarmé muses upon the chance that
obtains in the sound of a word and its relation to what the word signi-
fies. He writes, "beside the opaque *ombre* [shade], *ténèbres* [shadows]
is not very dark; what a disappointment, before the perversity that

makes the timbres of *jour* [day] and *nuit* [night], contradictorily dark in the first case, bright in the latter" (cited in Milner, 87). Leaving aside the suspiciously Nabokovian dark-motif of shadow and shade, what interests here is Mallarmé's concern with how sound and sense might be interrelated. The French linguist, Jean-Claude Milner, comments how, for Mallarmé, even if one's expectation is disappointed (as it is in the case of night and day), there is nevertheless an assumption "that the sonority of the term retains some property of the thing" (Milner 88). Clearly, this marks a significant departure from the Saussurian position of the arbitrariness of the sign. But although everyday language defeats this expectation, Milner goes on to explain, poetry's task would be to fulfil it: "working with the sonorities of words, combining them and opposing them, poetry can make it so that in a line, *nuit* becomes dark and *jour* bright, *ténèbres* darker than *ombre*" (Milner 90).

What is the context for Mallarmé's claim? If literature, in Mallarmé's eyes finds itself in an "exquisite crisis," the reason can be traced back to Victor Hugo in whose gargantuan shadow poetry has been forced to become an "imperial" discourse. In Hugo's hands, all of discourse has been colonized by poetry. In a manner akin to the paronomastic totalization of Paduk's regime, anything and everything has become fair game for the poetic license. Milner cites Mallarmé: "Hugo, in his mysterious task, drove [*rabbatit*] all of prose – philosophy, oratory, history – into the realm of verse, and, seeing as he was verse personified, nearly confiscated, from anyone who thought, discussed or narrated, the right to speak" (Milner 90-91). Thus it falls to Mallarmé – and by extension to Nabokov – to recover language from poetry's despotic grasp: to "redeem" language means extricating prose from the tyranny of the Hugolian poetic rule. How Mallarmé accomplishes this is explained by Milner: it will be a question of sonorities. For while poetry is always implicated in a "supplementary component comprised of calculations, symmetries, plays of sonority and, running under it all, a design to create, by means of verse, this single word that language lacks," prose will be a matter of sonorous style. Style is prose "versified." And, with this, Mallarmé wrests verse from the Hugolian embrace in the form of a prose that is saturated, bled through, with sound.

Now, according to Mallarmé's above-mentioned logic, one ought to be "disappointed" that one's name does not reflect one's personality, just as the word *jour* fails to sound "bright." For nothing is more prosaic than a name. A name 'names' nothing so much as the sheer contingency through which one enters language – one generally has no advance 'say' over what one is called. Saussure's rule concerning the

arbitrary nature of the sign would seem to have its most perfect exemplar in the case of one's name. And yet Nabokov, by way of Mallarmé, counter-intuitively will insist that a name can in fact "abolish chance." A name that is versified – which is to say, *styled* – breaks with the necessity that a throw of the dice will never abolish chance.

In another essay, also cited by Milner, Mallarmé lays out his aesthetic program: "When chance aligned [...], having been conquered, word by word, unfailingly the blank returns." Milner glosses the poet as follows: Mallarmé "defines the poetic line (*vers*) as a line (*ligne*) bound by blanks [...]. The blank is that of the printed page; the victory is obtained by means of sonorities and sonorities alone" (95). However, in case this seems to double-down on Karshan's suggestion that Nabokov, following Mallarmé, is engaged in a play of undecidable ambiguity, let us recall that for Mallarmé the consummate figure of the blank page is Ophelia. "Ophelie, vierge enfance," as the poet calls her in the essay on *Hamlet*, would be "the very symbol of Mallarmé's *'page blanche,'* the page in its stage of 'virginity' before the poet violates it through the act of writing," as Richard Weisberg comments (Weisberg 790). Ophelia would represent the 'victory' of a pure sound that is 'like' the thing it names. It is she who establishes a necessary relation between word and thing, she who pulls the contingent, "arbitrary" letters of her symbolic designation back around to an image of her virginal blank whiteness – O.

A name 'versified,' which is to say, "sounded" in this way by-passes the normal channels through which meaning arises. Ophelia's sonority opens a rupture in time, intervening in the temporality of language whose rules dictate that meaning unfolds sequentially in time, compelling one to wait until the end of the sentence before assigning meaning. However, a name that is 'styled' short-circuits the time of thinking, inserting cognitive blanks into the sequence of syllables, *béances* that, like Ophelia, flow the course of the sentence back upon itself. A wormhole in language, the prosaic name therefore succeeds where poetry fails. For if Nabokov agrees with Mallarmé that "all thought emits a throw of the dice" – "all thought emits the chance that is death" – to the extent that the name *does not think*, it is victorious over the absolute Master, Death, who drowns in its nonsensical "soundings."

Philosophy in the Bergsonian/Krugian system was still subject to the limit presented by death. And yet the name's sonorous "verse" inserts blanks in meaning, finally destroying the absolute *necessity* of contingency. Another model of chance would be in play in the name, the "chance" through which a person's cognomen resists the rule of the arbitrariness of the signifier. Mallarmé called this other chance, "the

mere chance that persists in terms, despite the artifice of dipping them alternately into sense of sonority" (Milner 87).

Olga: a glo

Well, it is time at last to address the novel's aching trauma, the accidental death of little David at the hands of the Institute for Abnormal Children. As I mentioned, this is presented to Krug in the form of a silent film:

> The lights went out and square shimmer of light jumped onto the screen. But the whirr of the machine was again broken off (the engineer being affected by the general nervousness). [...]. The whirring noise was resumed, an inscription appeared upside down, again the engine stopped.
> A nurse giggled.
> "Science, please!" said the doctor. [...].
> A trembling legend appeared on the screen: Test 656. This melted into a subtle subtitle: "A Night Lawn Party." Armed nurses were shown unlocking doors. Blinking, the inmates trooped out. "Frau Doktor von Wytwyl, Leader of the Experiment (No Whistling, Please!) said the next inscription. (*Bend* 344)

Next we are shown the image of a rubber-gloved hand and a blackboard pointing out the "climactic points and other points of interest in the yarovization of the ego." A subtitle reads, "The Patients Are Grouped at the Rosebush Entrance of the Enclosure. They are Searched for Concealed Weapons," with the shot yielding the discovery of a lumberman's saw from inside the sleeve of the fattest boy with the caption, "Bad Luck, Fatso!" A collection of weapons laid out on a tray comprises the next shot: "the aforeseen saw, a piece of lead pipe, a mouth organ, a bit of rope, one of those penknives with twenty-four blades and things, a peashooter, six-shooter, awls, augers, gramophone needles, an old-fashioned battle-ax." The next inscriptions read "Lying in Wait" and "The Little Person Appears." At this point, David appears in the film:

> Down the floodlit marble steps leading into the garden he came. A nurse in white accompanied him, then stopped and bade him descend alone. David had his warmest overcoat on, but his legs were bare and he wore his bedroom slippers. The whole thing lasted a moment: he turned his face up to the nurse, his eyelashes beat, his hair caught a gleam of lambent light; then he looked around, met Krug's eyes, showed no

sign of recognition and uncertainly went down the few steps
that remained. His face became larger, dimmer, and vanished
as it met mine. The nurse remained on the steps, a faint not
untender smile playing on her dark lips. "What a Treat," said
the legend, "For a Little Person to be Out Walking in the
Middle of the Night," and then "Uh-Uh. Who's that?"

 Loudly Dr. Hammecke coughed and the whirr of the
machine stopped. The light went on again. (344)

What strikes one immediately in this depiction of film viewing is the
collision it stages between text and image. Writing, in the shape of the
silent film's intertitles, performs a trepanning of the image comparable
to the one evidently suffered by David, as we learn from the scene
that unfolds:

 The murdered child had a crimson and gold turban around its
 head; its face was skilfully painted and powdered: a mauve
 blanket, exquisitely smooth, came up to its chin. (345)

Writing's crude (de-)captions counter-sign the apparent inevitabil-
ity of the death of life's fragile body. But curious here is the way the
intertitular death-dealing inscriptions are allied not just with the grue-
some psychoanalytic "tools" for "yarovizing" (to fertilize, vernalize)
the ego, but also with the workshop of the author into which David
has seemingly descended: "His face became larger, dimmer, and van-
ished as it met mine." The question is whether we can understand the
violence of this textual event – one of the most harrowing in all of
Nabokov – as a projection in a double sense, that is, not only literally
as a literary simulation of an experience of silent film viewing, but,
more pointedly, of literature as an ur-cinematic scene projected inside
another head? If so, the true target of Nabokov's decapitating hand
would ultimately be *himself* – or, more properly, his fertile "ego" as it
is fed like a film strip through the self's canned battery of tropes. As
such, this scene would represent an axing of literature's entire figural
system, the verdant rhetorical "springtime" that yarovizes the former's
structures of personification, identification, authorization, action, each
dropping like ripe apples with the stroke of Nabokov's pen:

 Krug was caught by a friendly soldier.
 "*Yablochko, kuda-zh ty tak kotisha* [little apple, whither are
 you rolling]?" asked the soldier and added:
 "*A po zhabram, milaĭ, khochesh* [want me to hit you,
 friend]?" (345)

The paragons of the aesthetic state are knocked out by Nabokov's pen-
hand, which devolves now into unreadability:

> *Tut pocherk zhizni stanovitsa kraĭne nerazborchivym* [here the
> long hand of life becomes extremely illegible]. *Ochevidtzy,
> sredi kotorykh byl i evo vnutrenniĭ sogliadataĭ* [witness among
> whom was his own something or other ("inner spy"? "private
> detective"? The sense is not at all clear)]. (345)

Bend Sinister sinks beneath the weight of its made-up language. A
Babeling brook of vowels storm the Institute for Abnormal Children
and the operatives of Paduk's regime. And with this collapse, Krug's
dead wife Olga suddenly returns, driving the modest car that carries
Krug, Ember and the little cameo of Bergson across the "wild moun-
tains" at dusk. In her wake, the Institute burns down, ignited by some
kind of "son-glow" of sound that carries across the limits of time and
space. A "solar catastrophe" documents the sunset of a certain history
and tropology of the "I" in the name of a more radical impersonality
that continually works against that history as its "inner spy." Even as it
summons the great French poet, this impersonality sheds the last ref-
uge of the aesthetic, exchanging Mallarméan undecidability for sheer
unreadability.

Hypersensitivity

Perception, rather than being the property of a finite "I," is revised in
Bend Sinister as a cinematic "eye" belonging neither to an actor nor a
creator but to something that traverses the divide between the two. For
too-close readers of Nabokov's *oeuvre* will have perhaps perceived a
memory pressing into the present from the past in the Russian word
sogliadataĭ that concludes Nabokov's "longhand" scrawl in the citation
above. It is a reference to the Russian title of one of Nabokov's earli-
est novels. Translated into English as *The Eye*, *Sogliadataĭ* relates the
story of Smurov, a man who believes he is dead but who really lives
on in the world, thus giving us a hint to what is in play: a form of per-
ception that sees through the bar normally separating life from death.
What patterns of reading might be advanced by this other, 'cinematic'
eye/spy? In chapter two, Krug is caught on a bridge, barred on one
side by illiterate soldiers who cannot decipher his permit, and on the
other by a group who, although literate, insist the document must be
signed by the first. Shuttling back and forth between the two barred
sentries, Krug,

> walked fast and held his pass in his fist. What would hap-
> pen if I threw it into the Kur? Doomed to walk back and
> forth on a bridge which has ceased to be one since neither
> bank is really attainable. Not a bridge but an hourglass which

somebody keeps reversing, with me, the fluent fine sand, inside. (*Bend* 182)

Reading Nabokov requires a constant double movement, a darting eye flitting back and forth between the twin poles of legibility and illegibility. From this perspective, reading entails an extra-legal shunting operation along the transit routes of the official significatory regime in an exteriorized interval between the signifying mark and its counter-signature. But this is a task without end, for in Nabokov every signature is always-already a counterfeit: "I sign his, he signs mine, and we both cross," advises the little pale grocer who is similarly caught with Krug in the double-bind of Paduk's Symbolic law. The reigning forces that should seal the message are ultimately AWOL: "'This is the end of the bridge. And lo – there is no one to greet us.' Krug was perfectly right. The south side guards had deserted their post and only the shadow of Neptune's twin brother, a compact shadow that looked like a sentinel but was not one, remained as a reminder of those that had gone" (187).

Reading Nabokov means making an emergency run to the points in a text where there is a glitch or suspension in the smooth functioning of the signifying system – not to rewire and repair its faulty operation but to stretch, to elongate the distance between its two points. In this distention of the signifier, reading must be, as Saussure intuited, a matter of *hearing things*. What things? The muted thlock-thlock of the signifier as it bats its way back and forth across the bridge of metaphor. The almost soundless click that betrays the mechanical process through which meaning attaches to the word. The quiet tapping of the padograph tacking the letters of our identity together. As it was in the case of Nabokov's downstairs neighbor during the composition of *Bend Sinister*, it is a matter of hypersensitive hearing.

By means of the agency of the "family plot," Hollywood films of the 1940s and 1950s register a danger to the state in the form of an internal threat. In classics such as Orson Welles's *The Stranger* (1946), Alfred Hitchcock's second *The Man who Knew Too Much* (1956), and lesser-known films such as *Mystery of the 13th Guest* (1943) and *Murder by Invitation* (1941), the peril comes not from the outside world but from within the home itself. A common feature of this genre is the conceit of the extra, uncounted "guest" in a family drama of succession. In the latter two films, death stalks in the form of a mysterious killer who invites seeming strangers to an isolated house. Not strangers after all, it turns out, they are members of one family. By knocking them all off, the killer stands to inherit the family fortune. The villain thus interrupts the rightful transmission of the estate, but the pretext of inheritance masks what is really being passed down, for this is not so much items of monetary value, it turns out, as the 'wealth' of a certain representational and conceptual order supported by the right relation to a first cause. Inheritance, in the final analysis, implies the legitimate relation of descendants to an original that is the source of their riches.

But concealed in secret compartments hidden in the walls, the killer in these films short-circuits the 'natural' train of succession. Secretly he interferes in how events unfold in time. He removes and then replaces objects from his position off-stage. He kills off family members and leaves their corpses in cupboards only to cause them to disappear again in a darkly comic game of *Fort/Da*. Joan Copjec has suggested that the key to the detective genre is the paradox of an excess in a representational system (Copjec 170). In whodunits of the "thirteenth guest" variety, this excess registers in the figure of the family member who is also a foreign body, a trespasser in his own family.

Nabokov's work is filled with such guest figures, carriers of the "aurelian sickness" that in his real life threatened more than once to derail his literary career as he recounts in *Speak, Memory*. A love of butterflies appears in his autobiography as the expression of a masculine gene, typically passed down asexually through a line of tutors.[64] In his fiction, Nabokov expands this idea of an alternative, non-biological parentage to encompass a medley of what one might term 'lepi-adoptive' tutelary figures whose influence steers his heroes towards different fates.[65] Garbling their literary history like Nabokov's young tutor from Volga who "informed me that Dickens had written *Uncle Tom's*

Cabin" (*Speak* 504), what links them is the 'cinematic' threat they pose to literature's established representational order, whose tropes they imitate only to deflect from their usual course. Accordingly, the legacy these tutelary figures bequeath to Nabokov is counterfeit from the outset, riddled with impersonations, ventriloquism and repetitions. Collectively, they represent an inheritance in *letters* where, like the "Muscovite muskrats" of the tutor Lenksi's tongue-twisting dictation (506), meaning "scrambles out" laterally from Nabokov's writing instead of waiting its turn to unfold through time in an orderly manner.

To the extent it has been critically remarked, this contest of competing claims by cinema and literature has largely been read through its refraction by a familiar narrative topos: Nabokov's dual or multiple worlds theme.[66] But this spatial thematization lends itself all too easily to recapture by theotropic paradigms, which have saturated Nabokov criticism with resounding discoveries of a ghostly "otherworld" – of the sort that Nabokov himself was always so quick in his novels to satirize, incidentally, as a wrong turn. From this perspective, the question of whether the spirits are malevolent or benign is largely irrelevant for behind their shadow-play lies that most supervising figure of all, the overweening specter of Nabokov criticism: Nabokov the Godlike Creator. However, if we divest our interest in Nabokov from the question of the author's authority, with its outworn programs of self-hood, what would we find? One's reading would trip, precisely, over the jutting outlines of a family plot concerning two related but separate representational strains, both devolving from the same 'paternity.' In *The Real Life of Sebastian Knight*, Nabokov allegorically figures the intertwined heritage of literature and cinema as half-brothers, variants of a single generative power, which silently reaches into and upends the ancestral models of identity and identification regulating Nabokov's authorial conceit.

Published in 1941, *The Real Life of Sebastian Knight* is conspicuous as the first of Nabokov's novels written in English. When the story opens, Sebastian Knight, the narrator's half-brother and famous novelist, has newly died, leaving open a number of unexpected questions about his life. In an attempt to solve these mysteries, V. embarks upon a literary biography of his relative. V.'s text, *The Real Life of Sebastian Knight* would be the putatively true life and account of Sebastian Knight – *real* opposed to the comically inaccurate version written by Knight's former secretary, the ironically named Mr Goodman. Parodying the genre of detective quest, *The Real Life of Sebastian Knight* is a recount of the events leading up to the death of the young novelist. What we learn is that Knight, the author of six well-received novels, was unhappily involved with a mysterious Russian femme

fatale for whom he left his long-time companion, the long-suffering English woman, Clare Bishop.

As critics have noted, Sebastian's life history demonstrably reflects Nabokov's own youthful biography as elaborated in *Speak, Memory,* although one also notes this latter work studiously avoids any mention of the disastrous affair with Irina Yurievna Guadanini for whom Nabokov nearly left his wife, Véra. The 'plot' of *The Real Life of Sebastian Knight* revolves around this absence in both the "real" and "fictional" Nabokov histories. It draws V. into a cat-and-mouse game of impersonation played by the mysterious Nina Rechnoy.

However the real object of V.'s quest, it turns out, is another Black Queen, Death, who outwits V. in the novel's final scene. In a parody of the reader's desire for narrative resolution, at the close of the novel V. sits at the bedside of one whom he believes is the dying Sebastian, but in this instance, too, it turns out to be a case of mistaken identity. The endgame resolves nothing, Death's stealth operation remains intact – V.'s death-bed vigil is at the side of a stranger, not Sebastian Knight but a certain Mr Kegan whose name has been bungled in a comic scene of linguistic *méconnaissance:*

> "No," he growled, "the English Monsieur is not dead. K, K, K..."
> "K, n, i, g..." I began once again.
> "C'est bon, c'est bon, he interrupted. "K, n, K, g ...n...
> I'm not an idiot you know. Number thirty six." (*Real* 156)

If the soporific satisfactions of narrative endings prove off-limits for Nabokov, this is not because of any error in perception whose implication is that it could be righted. It is because the fundamental premise of identity as being the exclusive *property* of one individual turns out to be faulty. "The soul is but a manner of being," V. realizes from his vigil at the misshuffled bedside, "not a constant state" (159). For this is the mystery the story of Sebastian's "real life" finally reveals to his half-brother: "I am Sebastian Knight," V. announces at the novel's end:

> I feel as if I were impersonating him on a lighted stage, with the people he knew coming and going – the dim figures of the few friends he had [...].They move round Sebastian – round me who am acting Sebastian. [...]. Sebastian's mask clings to my face, the likeness will not be washed off. I am Sebastian, or Sebastian is I, or perhaps we both are someone whom neither of us knows. (159-60)

The individual, it transpires, is merely a disguise, masking a more far-reaching exchangeability among selves:

any soul may be yours, if you find and follow its undulations.
The hereafter may be the full ability of consciously living in
any chosen soul, in any number of souls, all of them uncon-
scious of their interchangeable burden. (159)

Reel Life

V. begins his account of Sebastian's "real life" with the biographer's
traditional conceit, regaling us with certain incontrovertible "facts."
In the first sentence we learn that Sebastian was born on the 31st of
December, 1899. And thanks to the chance finding of an old lady's
diary, we even know the meteorological conditions on that day: "fine
and windless" (3), 12 degrees below zero as it happens. However,
such realist details quickly dissolve into a lyrical rhapsody about the
"delights of a winter day" in St. Petersburg. Here V. mocks the pro-
saic details of the biographical real, offering in its place the superior
virtues of memory: "Her dry account," he sniffs, "cannot convey to
the untravelled reader the implied delights of a winter day such as she
describes in St. Petersburg":

> the pure luxury of a cloudless sky designed not to warm the
> flesh, but solely to please the eye; the sheen of sledge-cuts on
> the hard-beaten snow of spacious streets with a tawny tinge
> about the middle tracks due to a rich mixture of horse-dung:
> the brightly coloured bunch of toy-balloons hawked by an
> aproned pedlar; the soft curve of a cupola, its gold dimmed
> by the bloom of powdery frost; the birch trees in the public
> gardens, every tiniest twig outlined in white; the rasp and
> tinkle of winter traffic... (3)

V.'s passage is a virtuosic flight of poetic description, a tribute to the
literary power of words to transport us to an unknown or forgotten
place. Critically, however, this reanimated St. Petersburg has not been
brought back by the agency of literary memory but by an *image*, spe-
cifically, by an old picture postcard snapped by an anonymous photog-
rapher in the previous century, which now lies on the narrator's desk.
To complete the earlier quote:

> every tiniest twig outlined in white; the rasp and tinkle of
> winter traffic ... and by the way how queer it is when you look
> at an old picture postcard (like the one I have placed on my
> desk to keep the child of memory amused for a moment). (3)

From the outset, it is a cinematic memory that directs V.'s biographical
project, as indeed we ought to have suspected from the very beginning

of this passage. For this photographic projection of the old Russian capital floats before us as if conjured by the circular repeating reels of the old female diarist's name whose "egglike alliteration," the narrator confesses, would have "been a pity to withhold." "Her name was and is Olga Olegovna Orlova." And in fact, when we look (or listen) more closely to the descriptive passage, V's language similarly bristles with repeating vowels and consonants:

> the *sheen* of *sledge*-cuts on the hard-beaten *snow* of *spacious streets* with a *tawny tinge* about the middle tracks due to a *rich mixture* of horse-dung: the brightly coloured bunch of toy-balloons hawked by an aproned pedlar; the soft *curve* of a *cupola,* its gold *dimmed* by the *bloom* of powdery frost; the birch trees in the public gardens, every *tiniest twig* outlined in white; the rasp and *tinkle* of winter *traffic* ... and by the way how queer it is when you look at an old *picture postcard* (like the one I have placed on my desk to keep the child of memory amused for a moment). (3, my emphasis)

If, in this opening gambit, the real of biography is set in opposition with an apparently more 'real' memory, memory, too, suddenly finds itself divided between two forms: a lived memory versus a cinematic one. There would be a hidden forking at play at every turn in the dialectic of life and its representation, intimating the presence another power of artistic generation that is secretly at work in the attempt to represent the "real life" of Sebastian Knight. What is this other power?

One could describe it in shorthand as a tendency towards self-replication in the representational impulse that escapes or exceeds the conscious intention of the representing subject. For from the outset, V.'s account of Sebastian's "real life" documents a narrative "fate" driven not by fidelity to biographical facts but to the shapes and sounds of linguistic patterns. Another protocol of representation is simultaneously set loose by the literary biographer's impulse to portray the real, founded on different representational necessities than those of fact, event and information. These other necessities – the exigencies of sound and letter – secretly direct V.'s sentences away from their documentary goal. In accordance with this discovery, Sebastian's birth date now registers with its full cinematic import: born at the very *turn* of the 20th century, that is, the cinematic century, it is through its double zeros that Sebastian's short life will be thrown as if through the rotating reels of a film projector.

Even from this short account, one quickly sees how Nabokov sabotages the mimetic model that governs the art/life opposition, inserting into its dialectic a third, 'cinematic' actor that fatally interferes

with the mirror reflection. In this respect, Nabokov is classically Platonic. In *The Republic*, Plato claims that art is not twice but "thrice removed" from the real. As Socrates explains in his famous allegory of the cave in Book 7, what we perceive are merely shadows cast by firelight upon the wall to which our eyes are forcibly turned. Art, as mimesis, would be the imitation not of the real but of another *appearance*, which is itself only a poor reflection of a truth that lies elsewhere beyond the cave, in the realm of ideal forms. When Badiou rewrites Plato's *The Republic*, it will be precisely this 'cinematic' dimension of the cave allegory that becomes the centerpiece of his philosophical intervention.[67]

In *The Real Life of Sebastian Knight*, Nabokov similarly cautions us to beware the trap of dualistic paradigms. "Remember," V. forewarns, "that what you are told is really threefold: shaped by the teller, reshaped by the listener, concealed from both by the dead man of the tale" (40). In V.'s formulation, both the biographer and his reader appear cut off from the real of Sebastian's truth which, in the form of death, escapes the representational grasp. But a little later, death *itself* reveals something about Sebastian's life. Projecting the figure of a reflecting pool, V. marvels at,

> an occult resemblance between a man and the date of his death. Sebastian Knight d. 1936... This date to me seems the reflection of that name in a pool of rippling water. There is something about the curves of the last three numerals that recalls the sinuous outlines of Sebastian's personality. (143)

Let us pause here for a minute to take in the import of this strange statement. If V. remains circumspect about representation's ability to convey the truth about Sebastian's life, it seems this is not due to something 'ineffable' about the real. A neo-Platonic ruse smuggled into Plato's cave by Plotinus, the concept of the Ineffable shuts down Plato's nascent arche-cinema with the fiction of an inexpressible One located beyond all language. The Ineffable wraps itself around the poetic impulse as a stalling tactic of last resort intended to secure a strict chain of relations between an original and its imitation, strategically promoting a final link in the representational chain to the status of non-link which proves, paradoxically, the most powerful link of all.

When V. proposes a similarity between Sebastian's name, date of death and personality, on the other hand, he posits a relation between the real and its representation that is structurally different from that proposed by other representational forms such as the novel, theater or even the visual arts, different that is, from the dual captivations of fiction and representation offered respectively by *diegesis* and *mimesis*.

As V. halts before the collusion between Sebastian's life and his death, he fixes on the relation between Sebastian's name and his date of demise. He finds Sebastian's "personality" aligning along the expressive coils of the numbers 9, 6 and 3. Making a mockery of Saussure's dictates regarding the arbitrariness of the sign, V. proposes a nominal determination for Sebastian that would see name, self and date coalesce, the name transforming to number and spreading stainlike to absorb all the technologies of 'fate' and 'character,' the customary preserve of the 'literary.'

Has V. lost himself in a Cratylic fantasy? In Plato's *Cratylus*, Socrates elicits Hermogenes's assent that names have "by nature a truth" (Plato, n.p.).[68] "As his name, so also is his nature," they agree. Their discussion, however, quickly converges on farce for by this logic each letter of the name should similarly be expected to share a prior relation of likeness to what it represents, and so on, down to each mark or inscription. The specter of this *mise en abyme* is quickly put to rest by Cratylus. How do we know, Socrates asks, whether the name really is like the thing it describes? "How can we suppose that the givers of names had knowledge, or were legislators before there were names at all, and therefore before they could have known them?" Cratylus's answer is that names originate from a power "more than human": true names come from a divine source.

The *Cratylus* dialogue proves the wrong reference point for the form of likeness V. is getting at which, on closer inspection, has more in common with Walter Benjamin's concept of non-sensuous similarity. In his 1933 essay, "The Doctrine of the Similar," Benjamin broaches a similar question to Plato's regarding the relation of words to things. Like Plato, Benjamin traces what he calls the "mimetic faculty" to an onomatopoeic quality present in all language. And yet, if there appears a similarity between the word and what it names, this likeness must necessarily also traverse the differences of languages. To account for linguistic differences, Benjamin suggests that whatever "similarity" obtains between the thing and its linguistic sign must inhere as a relation among languages. Non-sensuous similarity emerges as a cross-linguistic relation of all languages to each other. Its privileged location is the written sign. Here is Benjamin:

> Language is the highest application of the mimetic faculty: a
> medium into which the earlier perceptive capabilities for rec-
> ognizing the similar had entered without residue, so that it is
> now language which represents the medium in which objects
> meet and enter into relationship with each other, no longer
> directly, as once in the mind of the augur or priest, but in

their essences, in their most volatile and delicate substances, even in their aromata. In other words: it is to writing and language that clairvoyance has, over the course of history, yielded its old powers. (Benjamin, "Doctrine" 68)

Interestingly, then, Benjamin will also turn to a cinematic figure to render more concretely his concept of a non-sensuous similarity. Where V. discerns Sebastian's "personality" secreted in the coils of his death date, Benjamin likewise sees writing disclose a "picture puzzle" of its writer, which silently runs parallel to what he calls the "semiotic or communicative element of language." Writing, Benjamin claims, records and preserves an "archive" of such non-sensuous similarities and correspondences, each deriving not from a one-to-one mapping of word to thing held together by a divine hand but by way of a third route, a detour through an indirect relation *among* languages as they circle around the real.[69]

If, from the different languages, one were to arrange words meaning the same thing around what they mean as their center, then it would be necessary to examine how these words, which often have not the slightest similarity to each other, are similar to that meaning in their center. [...]. It is therefore non-sensuous similarity which not only creates the connection between the spoken word and what is meant; but also the connection between what is written and what is meant, as well as that between the spoken and the written word. And each time in a completely new, original and underivable way. (Benjamin, "Doctrine" 67)

In Benjamin, the resemblance in play in language is thus radically different from Plato's hierarchies of appearances summitting at the Real of truth, beauty, and the Good. Re-semblance in fact is a misnomer for a likeness that has no memory or 'recollection' of a first cause. We would be dealing with a similarity or semblance without original, a sort of ductile, floating similitude or '-esqueness' (SK-ness) capable of straddling multiple different formal systems at once: writing, speech, letter, number, diverging from their usual task of representing the "semiotic and communicative" elements of language to form motile images. What name could we give to this representational force? Here the legacy of Nabokov's "aurelian sickness" gives us a hint in the shapes of one of the natural world's more mysterious adaptations – mimicry.

Mimicry is normally thought of in terms of the self-preservatory functions of disguise, camouflage and intimidation in the natural

world. However, as the French sociologist Roger Caillois has noted, there are cases (particularly among butterflies no less) when certain adaptations seem inexplicable in such purely functional terms. This leads Caillois to posit the idea of mimicry as an aesthetic principle. Writing in 1958, he comments that "reluctant as one may be to accept this hypothesis [...], the inexplicable mimeticism of insects immediately affords an extraordinary parallel to man's penchant for disguising himself, wearing a mask, or playing a part" (Caillois, *Man* 20).[70] Twenty years earlier, in the 1935 essay, "Mimicry and Legendary Psychasthenia," he writes, "Mimicry would [...] be accurately defined as an incantation fixed at its culminating point and having caught the sorcerer in his own trap" (Caillois, "Mimicry" n.p.). Releasing itself into the world as pure semblance, mimicry suggests a mode of representation that has shed the responsibility of representing a real. Possessing the fundamental characteristic of the lure, mimicry marks the point where representation emerges as something other than what it seemed, constituting, as Dolar has suggested, a sort of anamorphosis in the natural world (Dolar, "Anamorphosis" 131).

Mimicry thus offers Nabokov another model of 'biography' than the tropes of literary realism, this time as *bio-graphein*, literally, a living writing. And in fact, this is precisely how V. describes the effects of Sebastian's last novel, *The Doubtful Asphodel.* It was as if, in reading it,

> [t]he answer to all questions of life and death, "the absolute solution" was written all over the world he had known: it was like a traveller realising that the wild country he surveys is not an accidental assembly of natural phenomena, but the page in a book where these mountains and forests, and fields, and rivers are disposed in such a way as to form a coherent sentence; the vowel of a lake fusing with the consonant of a sibilant slope; the windings of a road writing its message in a round hand, as clear as that of one's father; trees conversing in a dumb-show, making sense to one who has learnt the gestures of their languages... Thus the traveller spells the landscape and its sense is disclosed, and likewise, the intricate pattern of human life turns out to be monogrammatic, now quite clear to the inner eye disentangling the interwoven letters. (139-40)

In the earlier passage, Sebastian's "personality" undulated in the curves of number. Here the world itself coils around the linguistic sign. Mimesis's famous divide stretching back to the Greeks is a MacGuffin, Nabokov implies. In an anamorphotic twist, 'life' and

'art' are not the mirror reflections envisaged by the mimetic model, but different "personalities" – half-brothers – sprung from the same wellspring of inscription. Both art and life are equally *images* for Nabokov, twin illusions forged in the flickerings of a mercurial pan-graphematic line.[71]

On Edge in the Lumber-room

If, in *The Real Life of Sebastian Knight*, being is disclosed as fundamentally anamorphotic, this implies that neither 'art' nor 'life' hold the rights and privileges of a first cause or origin. In Dolar's phrasing, to say that subjectivity is anamorphotic means "we never have an initial zero situation where subject would confront being out there, where subject would be established in a subject-object relation, a correlation" (Dolar 125). Yet if the core distinction lies not in the representation/real diremption but in a shared inscriptive ancestry always preceding that divide, what causes the split that sees representation run along two parallel paths, which a certain metaphysical tradition has misread as ontological? If, in Nabokov's novel, V.'s and Sebastian's mutual identities only become visible to us when cast through the twists of the detective plot – a surrogate for the 'turns' of literary figuration per se, – it is because, while inhabiting the same space, 'art' and 'life' co-exist in different temporalities. Time produces a ripple in the representational manifold that travels out into spacetime in different directions and at different velocities. It is time that produces the illusion of a difference between self and other, initiating Being's partition into the standard categories of the appearance and the "real" beyond.

When one encounters this difference in temporalities in Nabokov's novel, it is troped in terms of V.'s perpetual belatedness with respect to Sebastian's life, culminating in his comically missed appointment at Sebastian's death-bed. For not only does he mistake the two Mr K.'s, he is also, apparently, too late anyway: "'Oh-la-la!' the nurse exclaimed getting very red in the face. 'Mon Dieu! The Russian gentleman died yesterday, and you've been visiting Monsieur Kegan...'" (159).[72]

Certainly, Sebastian's own experience of time is deeply idiosyncratic. As V. tells us, for Sebastian, time,

> was never 1914 or 1920 or 1936 – it was always year 1. He could perfectly well understand sensitive and intelligent thinkers not being able to sleep because of an earthquake in China; but, being what he was, he could not understand why these same people did not feel exactly the same spasm of rebellious grief when thinking of some similar calamity that had happened as many years ago as there were miles to

China. Time and space were to him measures of the same
eternity [...]. (50)

Statements such as these have lent support to the earlier-discussed fig-
ure of Nabokov the arch-Designer who transcends time to reveal the
underlying pattern of all things. We hear Samuel Schuman, for exam-
ple, suggesting that "Nabokov's ideal reader is the mirror of the author,
and the author stands as an all-knowing, all-seeing God in relation to
his work" (Schuman 127). This common theme of Nabokov criticism –
David Potter refreshingly describes it as among the "worst habits" of
Nabokov scholarship – is buttressed by Nabokov's own self-projec-
tions in essays and interviews as a despotic figure, a "haughty aristo-
crat" bent on controlling every aspect of his art.[73] However, it is also
evident that such readings imply a mimetic representational model: an
originating "Vladimir Nabokov" who, as all-powerful aucteur, stamps
his name anagrammatically across his work like Hitchcockian cam-
eos, thus securing for himself the stabilities of authorship as the "self-
conscious artificer of his created world" in Robert R. Patteson's words
(Patteson 241).

But as is becoming increasingly clear, such presumed fantasies of
authorial control are neutralized, made redundant in advance by a
Nabokovian cinematic power of replication that registers as a broader
refusal of any metaphor of self or personhood that could supply the
final halting link in the representational chain. As we have seen, V.'s
investment in the literary "real" of biography is undercut in advance
by an uncanny cinematic mimicry, which destabilizes and absorbs
all concept of self as something separate or autonomous, sloughing
it off as a false face or detachable tail, mask for a writing system that
always precedes the "fall" of representation into its consolidated cat-
egories of alphabet, number, figure and trope even as it anticipates and
deforms them.

If the mimetic paradigm therefore fails to account for what is
involved in Nabokov's signature "effects," what other ways are there
for understanding what is in play? How else, in other words, might one
read Sebastian's strange atemporal vision if not as the expression of a
totalizing authorial vision? Interestingly, in Sebastian's own novels,
Nabokov offers us a surrogate for how one might think time outside of
mimetic models and their implacably teleological apparatuses.

The Prismatic Bezel is Sebastian's first novel. If this title seems ini-
tially opaque ("bezel," meaning "edge"), things become clearer once
we learn that Sebastian's working title for the novel was "Cock Robin
Hits Back," giving us our clue: Sebastian's book is a counterpunch
to death, a refusal to lie back and allow literature to pacify with its

mourning dirges from the nursery.[74] Unsurprisingly, Sebastian's book
treats an already familiar cinematic theme, a detective mystery cen-
tered on a group of strangers at a boarding-house, one of whom has
been murdered. And sure enough, all of the twelve guests turn out to
be related and, as their individual stories start to blossom, the tale, says
V. "takes on a strange beauty":

> The idea of time, which was made to look comic (detec-
> tive losing his way... stranded somewhere in the night)
> now seems to curl up and fall asleep. Now the lives of the
> characters shine forth with a real and human significance
> and G. Abeson's sealed door is but that of a forgotten lum-
> ber-room. (72)

The illusion, however, is brought to an abrupt halt by a "grotesque
knocking" which admits the detective, a "shifty fellow" who "drops
his h's." But the dead body has disappeared and the joke is on us: old
"Nosebag," the seemingly most harmless of the lodgers, removes his
disguise, disclosing the face of G. Abeson. "'You see,' says Mr. Abeson
with a self-deprecating smile, 'one dislikes being murdered'" (72-3).

We should look past the tired plot in which Sebastian parodies the
clichés of the "decaying" modern novel, V. tells us. The novel's real
interest lies in how it brings to the fore what he calls "methods of liter-
ary composition":

> It is as if a painter said: look, here I'm going to show you
> not the painting of a landscape, but the painting of different
> ways of painting a certain landscape, and I trust their har-
> monious fusion will disclose the landscape as I intend you
> to see it. (73)

In his next book, *Success*, Sebastian continues with his experiment,
focusing this time on exposing the "methods of human fate":

> The author's task is to find out how this formula [the meet-
> ing of his two heroes] has been arrived at; and all the magic
> and force of his art are summoned in order to discover the
> exact way in which two lines of life were made to come into
> contact. [...]. But fate is much too persevering to be put off
> by failure. And when finally success is achieved it is reached
> by such delicate machinations that not the merest click is
> audible when at last the two are brought together. (74-5)

What Sebastian performs in these and his later books (whose titles
ring strangely and suspiciously as close cousins of Nabokov's own)
is what one would now call a meta-representational gesture. He takes

his reader behind the scenes, as it were, to demonstrate the 'mechanical' engineering behind the seemingly 'natural' trajectories of *diegesis* and *mimesis*. Yet as the narrative circles back each time around to the novel's opening reality, Sebastian (and by extension in layered fashion by Nabokov in *The Real Life of Sebastian Knight*) performs a topologization of form and content. The gesture is not so much that of an all-powerful Creator who, winking slyly at us, reveals the workings of his puppetry from a position outside the representational universe. Rather it offers the paradox of an "edge" in a representational system that, offering the illusion of leading into a dimension beyond its coordinates, surreptitiously returns one, Escher-like, to the opening framework from which one began.

This is surely what V. means when he describes *The Prismatic Bezel* as "somewhat allied to the cinema practice" (71) for this is the "cinematic" gesture par excellence, according to Deleuze. In *Cinema 2*, Deleuze quotes Jean-Louis Schefer as saying cinema "is the sole experience where time is given to me as a perception" (Deleuze, *Cinema 2* 37). The temporal equivalent of an anamorphotic effect, cinema's "time-image" gives access to an incommensurability in the coordinates of space and time, and it does so by seeming to achieve not "a real as it would exist independently of the image" but "a before and an after as they coexist with the image, as they are inseparable from the image" (Deleuze, *Cinema 2* 38). Such a "temporalization of the image" is accomplished in different ways by the different directors Deleuze refers to, including the characteristic tracking shots of Resnais and Visconti, and Welles' use of depth of field. Most relevant to the discussion here however is what Deleuze identifies as the "crushing" of the image's depth in the films of Carl Theodor Dreyer. Dreyer's "planitude" of the image "directly open[s] the image on to time as fourth dimension" (39). In flattening the image, by shearing it of the illusion of depth, Dreyer would take apart the mechanics of the movement-image to give us nothing but the interval 'between' each moment itself. In the time-image, "the interval is set free," Deleuze puts it later on, "the interstice becomes irreducible and stands on its own" (277).

The cinematic time-image would thus present a means of going 'backstage' in representation much in the way performed by Sebastian's – and Nabokov's – novels. Presenting the interval *between* the succession of instants, the time-image exhibits the necessarily repressed gap that secretly sustains the cinematic illusion of movement. In this sense, it is similar to Sebastian's vision of space and time as "measures of the same eternity" – not in the sense of seeing from a position outside representation but by showing us, anamorphotically,

the "eternal" but necessarily occluded moment of time's beginning and end *from within time itself.*

Consequently, if something comparable to cinema's flattened time-image is possible in writing, its closest counterpart may be the elongated, slow-motion stretching of sentences found in Sebastian's first drafts. V. describes,

> the queer way Sebastian had – in the process of writing – of not striking out the words which he had replaced by others, so that, for instance, the phrase I encountered ran thus: "A he a heavy A heavy sleeper, Roger Rogerson, old Rogerson bought old Rogers bought, so afraid Being a heavy sleeper, old Rogers was so afraid of missing to-morrows. He was a heavy sleeper. He was mortally afraid of missing to-morrow's event glory early train glory so what he did was to buy and bring home in a to buy that evening and bring home not one but eight alarm clocks of different sizes and vigour of ticking which alarm clocks nine alarm clocks as a cat has nine which he placed which made his bed-room look rather like a." (30)

In these repetitions, it is hard not to think of the stutterings of a string of letters threading through a mental projector that has not quite caught. What Nabokov draws attention to here are the secret workings of the representational sleight-of-hand that is normally unseen or repressed in ordinary discourse. All representation, Nabokov reminds us, is subject to time and space, but lurking within its categories is something that proves more archaic than both, something which as Stiegler has said, "remains unthought": speed (Stiegler 15). It is speed that quietly stitches together the images that Nabokov suggests are the raw materials of both art and life, giving the illusion of movement to each.[75]

The Thirteenth Guest

In *The Prismatic Bezel*, a living old Nosebag revivified the dead G. Abeson through an anagrammatic rematerialization. Something in the apparatus of language seeks to redefine life and death, proving them as pregnable to one another as representation is to the real. This redefinition is repeated in *The Real Life of Sebastian Knight*. Despite her opening victory in the novel, Death fails to adequately secure her territories, which in the course of the novel become infiltrated by a "real life," a reproductive power that sidesteps and emerges unscathed from the necessities of any natural process.[76] Whatever name we give

to this power, it is proof that something lives on beyond the individual and his or her particular death, suspending the category of the self in favor of something that undoes identity protocols, along with the accompanying logics of time that support them. In this, Nabokov finds an unlikely ally in Freud. In *The Ego and the Id*, Freud claims that the id harbors the "residues" of countless egos. The id alone is capable of being "inherited" (Freud, *Ego* 38).

Freud's comment comes at the close of his discussion of the emergence of "morality" in man. The preserve of the superego, morality emerges in Freud's discussion as something that has its origins in totemism. Freud says that what we usually think of as "the highest in the human mind" has its source in what belonged "to the lowest part of mental life," the id. What intrigues about Freud's discussion is his description of how the id came by the experiences that in the murky origins of the human's phylogenetic development led to the formation of the super-ego. "Reflection at once shows us," he comments,

> that no external vicissitudes can be experienced or undergone by the id, except by way of the ego, which is the representative of the external world to the id. Nevertheless it is not possible to speak of direct inheritance in the ego. (Freud, *Ego* 38)

Freud goes on to explain that although nothing in the ego can be directly passed down to successive generations, if experiences are repeated "often enough and with sufficient strength in many individuals in successive generations, they transform themselves, so to say, into experiences of the id, the impressions of which are preserved by heredity" (38).

According to Freud, then, we carry within ourselves the traces of multiple egos whose "memories" pulse through us as the drive: "when the ego forms its super-ego out of the id, it may perhaps only be reviving shapes of former egos and be bringing them to resurrection" (Freud, *Ego* 38). It is an astounding claim, but one which Sebastian and – surprisingly, given his well-known antipathy to all things Freudian – Nabokov seems to endorse in *The Real Life of Sebastian Knight*. The id threads its way through each individual as a super-sleuth, carrying the 'riches' of an inheritance that can never be diluted, squandered or otherwise lost. Spanning multiple generations, it gathers up the memories it will pass on *in toto* through a transmission process Lacan calls a "direct line" in contradistinction to the signifier's normally circuitous operation (Lacan, *Seminar* 14, lesson of 7.12.66). It comes as no surprise to readers of Nabokov, then, that the figures Lacan reaches for to illustrate how the signifier "short-circuits" the pathways of thought to arrive at the subject's "truth" should appear as a flexing V-shape, in

which we also recognize the characteristic initials of one's of litera-
ture's most consummate of cryptocrats. Lacan writes,

> [y]ou have only to remind yourselves of the figure of the
> Roman five, for example, in so far as it is involved and reap-
> pears everywhere in the outspread legs of a woman, or the
> beating of the wings of a butterfly, to know, to comprehend
> that what is involved is the handling of the signifier. (Lacan,
> *Seminar* 14, lesson of 7.12.66)

Smuggled into the literary drawing-room along with the after-din-
ner mints and crossword puzzles as a harmless game of anagrams,
or sheathed in the 'childish' clothing of what Cohen, speaking of
Hitchcock, names "cinememes,"[77] (Cohen, *Secret* 221), the VN signa-
ture effect zigzags through Nabokov's works as an extra, "thirteenth"
guest at literature's *table d'hôte*. It comes into view now in *The Real
Life of Sebastian Knight* as Sebastian's initials, which have meanwhile
sharpened into focus. The curves of Sebastian's S taper into points
and, with the K, perform a quarter turn to line up beside their siblings:
NVNVNVN.[78] Is this the final calling card of Nabokov the Creator, or
something more singular? An immortal wandering "guest," perhaps,
at the heart of the human family romance that secretly draws back in
all exigencies of 'thought' – including, and especially, the twists and
turns of the pleasure principle's desiring quest – heading toward what
is neither living nor dead but older than both? You decide.

8 History's Hard Sign: 'The Visit to the Museum'

> The real has for its characteristic the fact that it sticks to the
> soles of one's shoes.
> —*Lacan, Seminar 4*

In Nabokov's short story, "The Visit to the Museum," all of the con-
structs of museology – identification, possession, inheritance, dis-
play – breed the perfect conditions for the dissolution of the idea of his-
tory as the record of past experience. Originally composed in Russian,
this "disconcertingly resistant text," as Norman aptly describes it,
reveals the archive as an aporetic structure (Norman, "Nabokov and
Benjamin" 96). The Nabokovian Museum fails to record anything, it
no longer attempts to preserve memory, or to offer instruction as befits
its definition as a place of learning but instead ushers in a sort of a
cinematic parallax view of history. Parallax, as Žižek in *The Parallax
View* reminds us, is defined as the seeming change in an object's loca-
tion, brought about by a shift in observational perspective (Žižek,
Parallax 17). This change, moreover, effects not only the subjective
view of the object but, as he puts it, "always reflects an 'ontological'
shift in the object itself" (17). To expose the object of history to a par-
allax view, as Nabokov does in this tale, is to re-set the perceptual and
cognitive programs giving rise to a certain understanding of Being.
What Nabokov uncovers is an unexpectedly Lacanian point, which is
that our sense of ourselves as wholes is itself the effect of a parallax.
Rather than being the 'natural' viewpoint, it is a parallax that coheres
the infant's disparate parts into the appearance of a One, giving us the
illusion of a totality. Parallax would seal, as it were, the representa-
tional contract that permits the flowers, in Henri Bouasse's famous
optical trick that Lacan refers to several times, to be perceived as sit-
ting upright in the reflected vase, which is in fact upside down (Lacan,
Ecrits 565). The lesson Lacan draws from this is that our apprehension
of our body is in a strong sense virtual, our sensorial unity no more
'real' than the sun that appears to emerge, crowning the streetlamp in
the reflected pond in Figure 1.

In "The Visit to the Museum" – to visit, from *videre*, "to see, notice,
observe" – ordinary perception is progressively distorted until the
entire premise of experience, as what happens to a body occupying
a particular location in space and possessing a continuity over time,

Figure 1. "The sun is visible above the top of the streetlight. In the reflection on the water, the sun appears in line with the streetlight because the virtual image is formed from a different viewing point." (Wikipedia; *The Sun Streetlight and Parallax*, by Brocken Inaglory, CC BY-SA 4.0).

is rescinded. The story, whose twist turns on a banned letter of the Russian alphabet, mysteriously transports the narrator from a Museum in an unspecified, sun-dappled moment in the south of France to a stark present-day of Soviet Russia. But the tale's seeming premise, namely, of history's ostensible separation from the linguistic material that composes it, becomes increasingly questionable following the cinaesthetic distortion of vision that Nabokov's Museum inflicts.

We take our start from the story's narrator who, we learn, has been asked to help in the recovery of his friend's inheritance. This inheritance takes the form of a portrait of his friend's grandfather painted by the famous painter Leroy, which ended up in the museum of Leroy's birth place, the French town of Montisert. Right from the outset, then, "The Visit to the Museum" puts into play the idea of representation and of its proxies, even as it queries the status of possession and inheritance, identification and appearance. Once he locates the painting – to his great surprise, given his friend's frequent failure "to remain this side of fantasy" (*Stories* 277) – the narrator tries to buy it from the museum's director, M. Godard, but he finds himself strangely rebuffed. The director tells him that the only Leroy painting they have in the collection is not a portrait but, rather, a cattle-flecked landscape titled "The Return of the Herd." To an increasingly mystified narrator, M. Godard insists,

> I have been curator of our museum for almost twenty years now and know this catalogue as well as I know the Lord's Prayer. It says here *Return of the Herd* and that means the herd is returning, and, unless perhaps your friend's grandfather is depicted as a shepherd, I cannot conceive of his portrait's existence in our museum. (*Stories* 280)

Counter to its promise of completion and accuracy, the Montisert Museum's catalogue is an unstable record in which one encounters the past as an errant, textual impasse that goes on to saturate the rest of the tale. Letters go unanswered – "When I asked why he did not get in

touch with the museum, he replied that he had written several times, but had never received an answer" (277); paper and pen supplies are scarce – "while wandering about Montisert's empty streets in search of a stationery store..." (277). With fatal errors in its record leading to spotty gaps in the precincts of history and memory, the Montisert Museum seems plagued with the literary analogue of silver lice, a well-known "bathroom pest on the Riviera" (*Look* 591). Nabokov's archive disarticulates history's linear assumptions, which are over-written with the silvery traces of other technologies for constructing time. Tunnelling orthogonally through the leaves of the archive, these other technologies take different forms but their association with cine-matics is a constant as we soon discover.

Let us shadow the narrator with our own "felted steps" to survey the Montisert Museum's collection. First up, and presided over by two stuffed owls – stealth predators whose acute nocturnal vision implicitly cites a certain *noir* aesthetic – is a case of old coins, the vestiges of ancient economies harboring different orders or models of representational exchange. Swimming next into view is a display of "venerable minerals" (278). Formed through a process of "twinning," the diffracted, mirror-image pattern of a crystal's growth registers a potential rupturing of Euclidean space, posing a cinematic challenge to organic models, which Deleuze elaborates in the suggestive terms of a "virtual" regime (Deleuze, *Cinema 2* 70). As they lie like dormant cinematic projectiles awaiting their moment of firing in "open graves of dusty papier mache" (278) (the favoured material not only for masks and theatrical backdrops but also for sabots, the small disks or rings in a firearm that guide a bullet through the driving band of a gun), the crystals hint at the Museum's stealth assassination of linear temporal models that the idea of history would institute.

As it roves further over the Museum's attractions, the narrator's eye pauses at a display of "black lumps of various sizes," which he likens to "frass," the fine powdery material that cellulose-digesting insects extrude as their waste. The custodian explains that this black *Stoff* was the discovery of a certain "Louis Pradier, Municipal Councillor and Knight of the Legion of Honour" (278), whose surname recalls that of a 19th-century Swiss copyist, giving us a first clue (indeed, it is always advisable to pay attention to names in Nabokov). In antici-pation of our encounter with the Leroy portrait, mimetic representa-tion is already put into question here at multiple levels. For a quick search reveals that Charles-Simon, the 'real' Pradier of the "Knight of the Legion of Honor," received his citation for his engraving of "Virgil Reading the Aeneid to Augustus," which was first painted in 1812 by the history painter Ingres. Charles-Simon's etching of "Virgil

Figure 2. Virgil Reading the Aeneid to Augustus by Charles-Simon Pradier, Public domain, via Wikimedia Commons.

Reading" would thus be a copy of a painting that preceded it. But there's a Nabokovian twist – readily apparent if one is on the lookout for it given the painting's implicit references to both a double and a ghost,[79] not to mention the drama of the scene itself, which depicts an interrupted scene of reading. Pradier's *imitation*, it seems, served as the 'original' for Ingres' subsequent recreation of his painting in 1864. Ingres evidently reworked his painting by tracing over Pradier's engraving, whose lines are partially left visible in the finished canvas.

In these inversions of the expected order of succession, Virgil's hypostasized scene of instruction ricochets the viewer into a mysterious site where the mimetic premise of original and copy, of the real and its representation are suspended – as if literally blocked by Augustus's upraised hand that halts Virgil's recitation of his text (see Figure 2). Out of the swoon that replaces or perhaps now becomes the act of reading floats an alternate, 'cinematic' history of representation, which is set forth in the Museum's ensuing exhibits: "a Chinese vase," like the omphalous of some other reproductive process "probably brought back by a naval officer" (279), highlights ideographic and phonosemantic rather than alphabetic writing systems, shrugging off what Saussure calls the "linear nature of the signifier" (Saussure 70) in favour of a more visual simultaneity. Proceeding next to a display of "porous fossils," we encounter moulded images cast directly through the Earth's own, material, printing techniques – inscriptions formed by a representational 'agent' that is utterly removed from human hands and human time. "A pale worm in clouded alcohol" is similarly suggestive, not only of aborted branches of other evolutionary life-forms but also of other, perhaps only temporarily suspended poetic traditions for, as Nabokov in another text reminds us, the French *vers* (verse) is aurally identical to *ver* (worm) (*Look* 620).[80] Next, and conjuring up the idea of secret messages inscribed in invisible ink in Poe's short story, "The Gold Bug,"[81] a seventeenth-century map of Montisert printed in "red-and-green ink" might offer directions to these other, pre-Enlightenment traditions. The "trio of rusted tools" immediately following seems to support this Poe connection, as does the Museum's name itself: Montisert echoes Poe's Montresor

in "The Cast of Amontillado," impos-
ing the idea of some kind of literary
"Fortunato" being unsuccessfully
contained.[82] Thus the tools – rusty
with disuse – could be for digging into
textual riddles. Each of these visual
and aural cryptonymic figures point
back to the counter-anachronization
of the Pradier image that appeared
to spawn them: purporting merely to
imitate, a copyist etches inscriptions
which the official historical record
paints over but whose off-cuts and
shavings remain discernible as the
detritus of another representational
agency that chews through the Book
of History, leaving its waste in "black
lumps of various sizes" – *letters*.

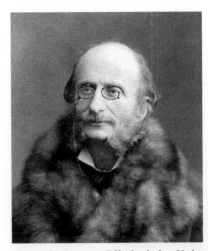

Figure 3. Jacques Offenbach by Nadar
circa 1860s (a.k.a. Gaspard-Félix Tourna-
chon, 1820–1910). Public domain, via Wi-
kimedia Commons.

It is in the dim glow of this coun-
ter-historical light, in a room dominated by a "large sarcophagus"
(perhaps one of the very Saturnine tombs from whose hypogram-
matic inscriptions Saussure fled in horror[83]) that the narrator chances
upon "the very object whose existence had hitherto seemed to me but
the figment of an unstable mind" (279). The Leroy painting hanging
between "two abominable landscapes (with cattle and 'atmosphere')"
is described thus:

> The man, depicted in wretched oils, wore a frock coat, whis-
> kers, and a large pince-nez on a cord; he bore a likeness to
> Offenbach, but, in spite of the work's vile conventionality, I
> had the feeling one could make out in his features the hori-
> zon of a resemblance, as it were, to my friend. In one corner,
> meticulously traced in carmine against a black background,
> was the signature *Leroy* in a hand as commonplace as the
> work itself. (*Stories* 279)

As it emerges from the status of fantasy into the apparent field of ref-
erence, the grandfather's portrait takes shape as a cinematic figure
par excellence. The "likeness," which the narrator casually observes
it possesses with the Parisian composer of comic operettas, initially
seems to connect it with the famous 1860's photograph of Jacques
Offenbach by Nadar (see Figure 3).[84] One of numerous photographs
of well-known artists made by the Nadar brothers, in this studio por-
trait, Offenbach peers through oval lenses at something out of frame

Figure 4. Jacques Offenbach by Edouard Riou and Nadar. 1858 Public domain, via Wikimedia Commons.

to his right, his enormous fur collar seeming to blend with his dappled "whiskers" like an extension of his body. The fur's viscous textures initially seem to recall the brushstrokes of oil paints, but another complication of representation's technological history enters into play once one recalls that painting's "wretched oils" have also long harbored the chemicals also used in film processing: silver halide's iodine.

If the Leroy painting, like the previous Museum objects, is therefore already allied with a cinaesthetic challenge to the mimetic order, what is also striking is the way cinema itself seems split here between an initial allegiance to photography's 'punctum,' its expression of a 'real,' and to something that appears to lead back to older representational instruments such as the hand – albeit only *after* its initial dispossession by the non-human agency of the camera. For the narrator's mention of a "horizon of a resemblance" calls forth the idea of a line and, with this reference, a different 'likeness' to Offenbach emerges, leading this time back to the hand-drawn sketch of him, also made by Nadar in collaboration with Edouard Riou (Figure 4). In this cartoon, a caricatured version of the photograph, Offenbach again peers out through his circular glasses. However his fur collar has since been replaced with his cello, which wraps his neck and upper body almost as effectively as the ruff in the photograph. The photograph's textured riches alluding to oil paint's depth and interiority have been replaced with a musical instrument's two-dimensional *strings*.

Photography's 'likeness,' a mimetic concept tied to the idea of a pre-existing real, finds itself over-written with quivering, proto-animated lines drawn, perhaps, by the ghost hand secreted in the custodian's pocket, presenting as some sort of manual dexterity which seems to have become separated from its seat in any body. This severed hand, another cinematic figure, introduces the idea of the cut as something that breaks with every logic of inheritance as a process of continuity and succession. Hence to speak of "resemblance" in this context means beginning from a different starting point than that of the reflection implied by photography. Called up by figures of plucking, scratching and stippling, facsimile – from *facere*, to make – suggests the

furrowing of the representational manifold with sharpened tools such as the "spade, a mattock, and a pick" that the narrator absent-mindedly passed over in his tour of the Museum's first room (*Stories* 279).

The upshot is that even as the narrator and the Museum director tussle over the epistemological status of the object of perception, as authorized either by Imaginary apprehension or by the Symbolic's written record, both remain equally inattentive to the existence of an order that has already turned against both registers. Hence, if a ghost of the comic French composer presides over this story of a failed commission, it would be the Offenbach of *Les deux aveugles* (*Two Blind Men*) rather than the composer of *Orphée aux enfers*.[85] What is this other order? At this point writing re-enters as a doubled topos: it is simultaneously the instrument of law, authority and memory, that is, of what would be transmitted by the blue end of the pencil Godard offers the narrator to seal their agreement in writing, and a carnivalesque, "festive" overturning of all such constructs, which becomes incarnated in the colour red. "'All right,' he said. 'Here, take this red-and-blue pencil and using the red – the red, please – put it in writing for me'" (*Stories* 281).

Red has already made an advance appearance in the "carmine" lettering of Leroy's signature (perhaps also silently citing the flamboyant Nadar's own signature flashing letters lighting up the outside of his studio in illuminated red gas lamps). This color now begins a flooding of the Museum's visual field. A red bus "packed with singing youths" nearly runs the narrator over before disgorging its boisterous load at the museum. Wearing "some kind of festive emblems in their lapels" and "very purple-faced, and full of pep," the youths cause a commotion with their "rowdy cries" (281). Like throwbacks to some counter-Athenian tradition (recall the Spartans' own famous red cloaks), these members of "some rural athletic organization" fire shots at history's Minerva – "another was taking aim at an owl with his fist and forefinger" (281) – in a comic spectral war. These would be avatars of a counter-historical tradition, a Benjaminian "materialist historiography" that vests the Museum's trademark silence with Homeric mirth: a "lewd laughter" mocks the Museum's iconography of death – "some at the worm in alcohol, others at the skull."[86]

Like in the glow of a darkroom light, red redounds with the realization that, never 'natural,' the 'real' has always been a hothouse for experiment, a "deserted laboratory with dusty alembics on its tables" (283) *sans* maker or designer. And in the wake of this discovery, a full-scale cinematic derealization of the world begins, as if started by the phantom flame that a youth pretends to ignite with a borrowed light from the portrait's "glowing cigar" (282). Causal logic collapses: above

the "din," and with increasingly Carrollian reasoning, the museum
director shouts, "I must first discuss the matter with the mayor, who
has just died and has not yet been elected" (282). Teleological histories
slide into reverse: "'Who's the old ape?' asked an individual," gestur-
ing to the Leroy painting. Nothing can be decided, because decisive-
ness "is a good thing only when supported by law" and the law of the
archive, as authorized by the signature, "fell like snowflakes into a
massive spittoon," having been torn into pieces by "fingers, moving as
it were on their own" (281).

The immediate consequence is a refragmentation of the body. The
body is sliced back up, limbs amputated, the head disassociated from
the trunk. We enter into cinematic zones of magnification:

> I lost my way for a moment among some enormous marble
> legs, and twice ran around a giant knee before I again caught
> sight of M. Godard, who was looking for me behind the white
> ankle of a neighboring giantess. (282)

"Ancient Sculpture" elicits another experience of the body, prior to its
integration by mirror logics. Cholodenko observes of cinema that "it
violently opened a wound – a wound in a sense never closed, a posthu-
mous wound – in 'reality,' as well as in the 'self,' the 'subject,' a wound
no amount of suturing (and its system) could close" (Cholodenko,
"Crypt" 108). Nabokov, too, renders the cinematic encounter as an
uncontrollable opening. For once the body has been cut up by the cam-
era, its Imaginary sack is no longer containing. As the body's form
expands, the Museum amplifies in tandem.

The angle of vision then takes another turn. We pass through a suc-
cession of *entr'actes*, each presiding over a diminishing human per-
spective. A whale skeleton recalls Melville's description of Leviathan
as the "unspeakable foundations, ribs and very pelvis of the world,"
(Melville n.p.), obtruding as a figure of exteriority, a series of curved
bars encasing the void. Moving into "still other halls, with the oblique
sheen of large paintings, full of storm clouds, among which floated
the delicate idols of religious art in blue and pink vestments" (283), an
aterrestrial viewpoint unfolds. When our gaze returns earthwards, it
is to a deserted *Oikos*. An "abrupt turbulence of misty draperies," ush-
ered in from a fallen 'house' vacated of the human viewpoint, trans-
ports us to a scene where the lines of rectilinear perspective bulge
into hemispheric globes of fish-eye lenses: "chandeliers came aglitter
and fish with translucent frills meandered through illuminated aquar-
iums" (283). Prismatic, iridescent with reflections, this is the "per-
spective of the inside" to recall Jean Epstein's suggestive phrase, "a
multiple perspective, shimmering, sinuous, variable and contractile"

perspective through which the world "becomes its own image, and not an image which becomes world" in Deleuze's phrasing (Deleuze, *Cinema 1* 23, 57).

These ocular displacements introduce another order of dimensionality: "Racing up a staircase, we saw, from the gallery above, a crowd of gray-haired people with umbrellas examining a gigantic mock-up of the universe" (283). An entire model of the world, which the Museum synecdochically fronted for, has always been a "mock-up," suggests Nabokov, as another one – now self-consciously cinematic – overruns it. When the narrator is found lingering among "models of railroad stations" (283), one is reminded that such 'mere' toys are nevertheless what engineer the catastrophic derailings of models of knowledge that the cinema exults in. Yet if film is revealed to be fakery at its core, its circular loopings on comically shaky, miniature trestles end up being unexpectedly operational. In a quarter turn, the doors of the arriving train swing open to become the cascading drawers of filing systems: "in front of me stretched an infinitely long passage, containing numerous office cabinets and elusive, scurrying people" (283). A strange loop, whose content upends into becoming its own formal principle, the self-citational, cinematic 'train' auto-archives itself.

It is at this juncture that the museological transposes aurally back to its "ancient" source in *music*. Like hands criss-crossing one another on piano keys, music takes us to a scene of reflective models engaged in a mise-en-abyme of self-cancellation:

> Taking a sharp turn, I found myself amid a thousand musical instruments; the walls, all mirror, reflected an enfilade of grand pianos, while in the center there was a pool with a bronze Orpheus atop a green rock. (283)

Resonating from a khoratic pool, music should be understood not just as the Apollonian allusion, Orpheus's worship of the sun-god, but as the Greek name for something that auto-theorizes itself. For as Penelope Murray and Peter Wilson observe, *mousikē* in fact names the totality of instrumental sound, poetic word and movement embraced by the Muses. The first of the so-called *tekhnai* nouns, *mousikē* is thus intimately connected with *theory*, representing, as they surmise "the first area of Greek cultural practice that produced more or less systematic descriptive and explanatory accounts of itself" (Murray and Wilson 2). What chiefly interests is the way such self-theorization entails a different – performative – relation to the past than that proposed by memory. As Murray and Wilson describe it, *mousikē* "betokens a total and privileged access to the past." As such, *mousikē* would

entail the originary fashioning of the structures of spatial and temporal difference itself.

And with this recomposing of spacetime, a whole other program of knowledge and understanding – *exposition: "the act of expounding, setting forth, or explaining"* – seems in the process of being constructed, Metropolis-like, in the catacombs honeycombing the Museum's foundations as the narrator threads precariously down staircases of stone steps resounding with "whistles, the rattle of dishes, the clatter of typewriters, the ring of hammers, and many other sounds," coming from "exposition halls of some kind or other, already closing or not yet completed" (*Stories* 283). Here, consciousness, perhaps even 'Being' itself harks back to its primordial structuring by technics: "whistles," "rattles," "clatter" "hammers." What these sounds call up are the alternations of rhythmic beats and patterned serial repetitions. They sequence what Stiegler has theorized as the body's originary grammatization.[87]

Suddenly sightless from cinema's winding back of existing perceptual and cognitive paradigms, the narrator gropes about the "unknown furniture" of a different epistemological regime. But at this point the direction of the narrative changes and the tale embarks on its final fantastic turn. Like a butterfly emerging from its cocoon, a qualitative shift seems to take place and the narrator finds himself "with a joyous and unmistakable sensation" metamorphically egressing from the museum's cinematic vortex and back out into "reality" (284). He marvels at the new solidity of the ground: "The stone beneath my feet was real sidewalk, powdered with wonderfully fragrant, newly fallen snow, in which the infrequent pedestrians had already left fresh black tracks." Contrasting with his previous chaotic "feverish wanderings" comes a "pleasant feeling" of peace. The quiet of a snowy streetscape "replaced all the unreal trash amid which I had just been dashing to and fro" (284).

As he "trustfully" starts to "conjecture" what has occurred – "why the snow, and what were those lights exaggeratedly but indistinctly beaming here and there in the brown darkness" (284) – the narrator is suddenly struck by a missing letter, the absent Russian "hard sign" on an advertisement. Unspoken, manifesting only in written form to the mark a separation between certain consonants and vowels (non-palatized and iotated), the Russian "hard sign" – "ъ" – was abolished in the orthographic reform following the 1917 Bolshevik revolution, as Nabokov informs us in a footnote (*Stories* 673). It is the omission of this "hard sign" on the cobbler's placard "'...INKA SAPOG' ('... OE REPAIR')" that clues the narrator in to what has happened. A wormhole, the Montisert Museum has tossed him out into "the factual

Russia of today, forbidden to me, hopelessly slavish, and hopelessly my own native land" (285). And with this realization, we also appear to have exited from this confusing, whirling vortex into a more readily comprehended narrative space. As if materializing from the frescoes of the Museum's pediment, the golden figure of allegory swoops down to provide the solution to the tale's riddle, prompting the "Orphic" interpretation of the story that various critics have proposed: as a satire of the USSR, "The Visit to the Museum" testifies to the sovereign power of the literary imagination to resurrect the past. It is literary memory that protects the narrators's "fragile, illegal life" from the unspeakable ordeals of history (Masing-Delic 95).

And yet. It also seems that whatever is elicited by the idea of the "real" here has already been undercut by the hypostasized scenes of shredded writing and arrested reading that precede it. If the 'nightmare' of history would be the sole dream from which one cannot awake – if History is "what hurts," as Fredric Jameson famously put it (Jameson 102) – what is curious is how a strange symmetry, a certain visual echo, suffuses this putative "real."

> Oh, how many times in my sleep I had experienced a similar sensation! Now, though, it was reality. Everything was real – the air that seemed to mingle with scattered snowflakes, the still unfrozen canal, the floating fish house, and that peculiar squareness of the darkened and the yellow windows. (285)

The scattered snowflakes, re-materializations of the "snowflakes" of M. Godard's torn-up contract, suggest metonymic fragments of the reader's and author's contractual "agreement" to abide by a certain representational order of origin and copy, the firm boundaries separating text from interpretation dissolving in the "unfrozen canal." As one pauses at the "peculiar squareness of the darkened and the yellow windows," why should the panels of a comic strip suddenly spring to mind? Looking back, the description of the Museum's mottled façade of "many colored stones" abruptly becomes recognizable as the marbled sides of a leather-bound book whose ornate columns and "gilt inscription" recall the gold-leaf ornamentation of early book covers. The Museum's "bronze door" doubles as a clasp, blocking our exit. Is allegory's "real" merely one more cover, a final flailing gesture of the order of the Book as it goes under in a cinematic parallax of all of its tropes and figures? If so, with them too must go the humanist armature and model of reading through which a certain figure of Nabokov the Auteur, redeemer of the past, has been cast.

For training the eye back over the text in a more "leisurely" way this time, something else also leaps out:

> Continuing my leisurely examination, I looked up at the
> house beside which I was standing and was immediately
> struck by the sight of iron steps and railings that descended
> into the snow on their way to the cellar. There was a twinge
> in my heart, and it was with a new, alarmed curiosity that
> I glanced at the pavement, at its white cover along which
> stretched black lines, at the brown sky across which there
> kept sweeping a mysterious light, and at the massive parapet
> some distance away. (284)

Iron steps, railings, a chiaroscuro sketch of light and dark bands... An
expanding series of lines leads away from every promise of a return
to substantial reality. It is into a cartoon world, animation land that
we have been summarily disgorged. The "factual" world, it transpires,
is no less insubstantial that the Museum's cinematic one. Both tend
towards a "drop," a black pit into which language as sense or mean-
ing descends.

> I sensed that there was a drop beyond it; something was creak-
> ing and gurgling down there. Further on, beyond the murky
> cavity, stretched a chain of fuzzy lights. Scuffling along the
> snow in my soaked shoes, I walked a few paces. (284)

What creaks, gurgles, fuzzes and scuffles is *The Return of the Heard*:
language unleashed by its internal phonics.

Au Repère[88]

First published in Russian in 1939, "The Visit to the Museum" was
written just before the outbreak of the Second World War, yet it reads
strangely presciently as we emerge from our Covid-19 cocoon into a
world whose anchor in a certain "reality" has shifted. One may think
of Trump's cartoon-like suspension of the Symbolic law in favour of a
gravity-defying market for *jouissance* as the symptom of our exit from
the world formerly known as History. Like in Nabokov's St Petersburg
("No place for children"), in our new "factual" reality of the 'hard
sign' of climate chaos, with its concomitant prospect of human extinc-
tion, it is quite simply the facts themselves that are becoming elusive
as the reigning new catastrophic illogic oversees the wiping or writing
over of the historical record.

Accordingly, if climate change inaugurates a decisive rupture with
humanity's past, it is emerging just as much as a rift in older models
of the social relation. Where, in a previous era, the neurotic's access to
enjoyment was mediated by the Name-of-the-Father whose instituting
cut placed a prohibition on jouissance, thereby opening the subject onto

the exigencies of desire, in the contemporary "post-truth" world, the paternal prohibition seems largely absent, giving rise to the increased anxiety, depression and the new epistemic category that Jacques-Alain Miller labels "ordinary psychosis" (Miller, "Ordinary" 139). It is as if, taking advantage of the opening in time that cinema inaugurated, what Lacan once called the "ghost" of Reason, has in the meantime assumed control of the knobs and levers of perception and, with it, the instruments of identity and memory that previously contained it. Unknotting itself, Houdini-like, from its containing structures of the fantasy – the Enlightenment's "old cases" and "displays" that, by parenthesizing it, maintained the object (a) at the correct ('safe') distance from the subject, – a certain hyper-enjoyment or *jouissance* has swarmed into every gap.

Clinical practitioners like Miller have observed that the 21st century is increasingly defined by the retreat of desire. Yet I suspect few would argue in favour of a return to the paternal signifier – even if this were possible: the strutting Symbolic Father is precisely the comic figure most keenly performed by today's new Masters of jouissance. These fake or Make-Believe Names-of-the-Father would be the symptoms of a "hole" in a Symbolic system gone psychotically awry. Lacan, speaking of psychosis, remarks how at "the point at which the Name-of-the-Father is summoned a pure and simple hole may thus answer in the Other; due to the lack of metaphoric effect, this hole will give rise to a corresponding hole in the place of phallic signification" (Lacan, *Ecrits* 465-6). How, then, can one repair the Symbolic's hole in the ravaged days of the late Anthropocene? Here Nabokov re-enters – comedically, of course, given his legendary antipathy towards psychoanalysis – as a writer uniquely equipped for this moment (out) of Time.

Recall how in the story the narrator is only able to orientate himself in "reality" because he remarks the absence of the Russian hard sign on the shoe shop's insignia:

> And by the light of a streetlamp whose shape had long been shouting to me its impossible message, I made out the ending of a sign – "…INKA SAPOG" ("…OE REPAIR") but no, it was not the snow that had obliterated the "hard sign" at the end. "No, no, in a minute I shall wake up," I said aloud, and, trembling, my heart pounding, I turned, walked on, stopped again. From somewhere came the receding sound of hooves, the snow sat like a skullcap on a slightly leaning spur stone and indistinctly showed white on the woodpile on the other side of the fence, and already I knew, irrevocably, where I was. (284)

Figure 7. English Embankment, St Petersburg, (cropped) CC-BY-SA 3.0 2009 YKatrina.

Abolished by the Bolsheviks, the hard sign was officially erased from the Russian alphabet. Yet as one can see in Figure 7, the hard sign merely went underground or, rather, overground.

With a breath-taking insouciance for Enlightenment models of phenomenality, an oil lamp re-pockets the missing hard sign consigned to the Real's inky bog. A reversed-out letter ъ, the shape of the St Petersburg streetlamp (on the Angliyskaya Embankment no less) "has long been shouting its impossible message" to all in plain sight, in stark defiance of the representational regime that sought to eliminate it.[89] The corrected sign reads починка сапог. "POCHINKA SAPOG" (SHOE REPAIR).

Poche, French for pocket. Poch, poche, poach, pocket, – seanced by this bubbling open stream of phonemes, *Offenbach* returns. He comes into focus now not as the Orphic avatar of the lyrical tradition – always a sweltering costume for the composer of *opéra bouffon* whose own Orphée, incidentally, is only too delighted to lose Eurydice[90] – but in his cameo appearance as one of the numerous cinaesthetic O-shapes that have been cycling, like the woman "in besplattered stockings […] spinning along on a silver-shining bicycle," unnoticed until now throughout the tale: the October night, the Owls, the Oriental vase, Orpheus of course, the Obvodny, the narrator's exclamation "Oh!" and, finally, the truncated sign: "OE REPAIR." If the soles of language's metrical 'feet,' the connecting legs of the Symbolic's transport system, can be patched, Nabokov suggests, it will be by way of another operation of seeing and hearing secreted within History's rectilinear perceptual order. Ever-attentive to the letter, Nabokov's cinesthesia forces this operation into the open.

Notes

1　See for example Appel, Wyllie, Petit, Connolly, de Vries and Barton Johnson. For broader considerations of Nabokov's interest in optical technologies, see especially Grishakova. For a related study of Nabokov's "theatrical imagination," see Frank.

2　As Blackwell notes, contemporary theories of subatomic structure and quantum mechanics were "alluring" to Nabokov precisely insofar as they offered "possible ammunition against a purely mechanistic philosophy." (Blackwell 144).

3　Connolly comments, "In its manipulation of cinematic motifs, *Laughter in the Dark* affirms a basic truth in Nabokov's fiction: those who live their lives through the derivative patterns of conventional art display both a poverty of the imagination and a sterility of the soul." (Connolly 216).

4　See Lacan, *Seminar* 23, *The Sinthome*.

5　Rabaté 7.

6　In the short story, "The Return of Chorb," the titular figure tries to undo the events leading up to his wife's death by repeating them. The quest ends in Chorb's "meaningless smile" and the story ends with the lackey's stunned whisper, they "don't speak." (*Stories* 153-4).

7　Merriam-Webster Dictionary, https://www.merriam-webster.com/dictionary/tralatitious

8　*Бок* is Russian for "side."

9　In *Seminar* 18, Lacan tells an amusing story about the "birth" of the signifier as it materializes from the fragmented body: one's arm which, trespassing on a neighbor's enjoyment, gets repeatedly thrown back. Out of the chance patterns derived from the accumulations of this projection a schema arises from which the signifier as semblant materializes. (Lacan 1971, lesson of 13.1.71).

10　See, for example, Louria and Mattison.

11　See Stiegler 33.

12　For an account of the American and British publications of the memoirs, see Boyd, *American*, 192.

13　Two hypotheses regarding the neurological basis of synaesthesia have been put forward: Cross-Modal Transfer (CMT) and Neonatal Synaesthesia (NS). Briefly, the first proposes synaesthesia as a

genetic mutation (thought to be carried by the X chromosome) whereby synapses linking contiguous brain areas fail to be removed during ordinary neural development. The second (NS) builds on the CMT theory but suggests a functional explanation for synaesthesia. For (NS), all human brains begin with cross-sensory modalities, but these become inhibited in 'normal' development. Synaesthesia is accordingly thought to be caused by an "inhibition failure" of the synapses between adjacent brain regions. See Lawrence Marks, see also Maurer and Mondloch.

14 See Laura Marks 213.

15 See Deleuze, *Cinema* 2.

16 Paul Leni's short animated Rebus-Films were shown in German theaters from 1925 and 1927.

17 Lanyi, cited in Grishakova 197.

18 Frances Guerin notes how by the end of the 1920s, Germany had 4000 cinemas with up to 2 million visitors a day. (Guerin 7).

19 Given their artistic inclinations and connections in the émigré community and Berlin art-world, it is tempting to speculate that Véra and Vladimir might also have been in attendance at the historic matinee, "Der absolute Film" at the Ufa-Theater Kurfürstendamm for one of its two showings, on the 3rd or 10th of May 1925. Organized by the Novembergruppe, an arts organization named after the 1918 German revolution, the program presented experimental art films and abstract animations by Ludwig Hirschfeld-Mack, Hans Richter, Walter Ruttmann, Fernand Leger and Dudley Murphy, Francis Picabia and Rene Claire, as well as by the Swedish filmmaker and artist Viking Eggeling. (Elder 163).

20 Other film adaptations include the film by Tony Richardson of the 1932 novel, *Kamera Obskura/Laughter in the Dark* (1938) which appeared in 1969. In 1972, a version of *King, Queen, Knave* came out, directed by Jerzy Skolimowski. And following Nabokov's death in 1977, many more film adaptations of his works have been made, including Rainer Werner Fassbinder's *Despair* (1978), Jerome Foulon's *Mademoiselle O* (1994), Francois Rossier's *A Fairy Tale* (1997), Valentin Kuik's *An Affair of Honor* (1999), Marleen Gorris' *The Luzhin Defence* (2000), and Eric Rohmer's *The Triple Agent* (2004).

21 For a characteristic statement on Einstein's theories of spacetime, see *Strong Opinions*: "While not having much physics, I reject Einstein's slick formulae; but then one need not know theology to be an atheist." (114)

22 The other two words are âllo and pa-pa. (*Look*, 574).

23 Fronting as simple reversibility, Otto's multi-dimensional palindrome inscribes a wormhole, a rupture or tear in the representational fabric of the literary plane. In this respect, "Otto" stages what may be the earliest of the world-transgressing shifts that have been hailed as the hallmarks of Nabokov's writing.

24 "Chitinous" simply means hardened exoskeleton but as a polysaccaride it also connotes the raw material of cinema's precursor: magic lantern's cellophane.

25 See the many competing readings in Leving.

26 De la Durantaye cites an index card marked "Freud" in the New York Public Library's Berg collection which reads: "Ever since I read him in the Twenties he seemed wrong, absurd, and vulgar." (De la Durantaye, "Nabokov and Freud" 62).

27 "Signs and Symbols" was restored to its original three parts when it was republished in *Nabokov's Dozen* after its butchering by *The New Yorker*'s editorial team, who also inverted the title to "Symbols and Signs."

28 Nabokov's first choice for this image, the even more Freudian "broken blossoms," was highlighted by *The New Yorker*'s copy-editing team as the same as the title of a 1919 movie directed by D.W. Griffith. Nabokov gladly conceded the phrase. (Leving 58).

29 White had written, "Do you mean it to be straight fiction, or do you mean it to be a parody or satire on the gloomy new school of psychiatric fiction? I believe that it is the latter," letter of July 10, 1947 (Leving 49).

30 Žižek explains, "The link between immediate 'dream-components' and the latent 'dream-thought' exists only on the level of wordplay, i.e., of nonsensical signifying material. (Žižek, *Looking* 51).

31 Freud claims, "Dreams are completely egoistical. Whenever my own ego does not appear in the content of the dream, but only some extraneous person, I may safely assume that my own ego lies concealed, by identification, behind the other person." (Freud, *Interpretation* 358).

32 A repeating critical theme is to caution against our own "referential mania" when assigning an identity to the third caller. In this respect, Vicks offers the most intriguing and exemplary suggestion, namely, that it is the son's telepathic reception of our own reading thoughts that are causing his delusions. (Vicks 103).

33 Joyce wrote, "I've put in so many enigmas and puzzles that it keep the professor busy for centuries arguing over what I meant,

and that's the only way of insuring one's immortality" (Gifford and Seidman v).

34 27774268, 47273 and 23324 7586 respectively.

35 "These holes and the letters that remain at each halt are elaborated replications of the original encoding of presence and absence that was generated by flipping the coin – a coin whose two-sidedness is recast in each letter by the four numeric pathways defining it, two of which include a loop (the two collapsing into a single self-loop in the letter code) and two of which do not. [...]. The separate pathways that the letters take, however, could just as well be viewed as differ-ent kinds of 'knots' (stitches or weaves) tying the letters together." (Brahnam, "Computational" 265).

36 Wilson accused Nabokov of "flattening Pushkin out and denying to his own powers the scope for their full play." (Wilson, "Strange").

37 This does not even take into account *Speak, Memory*'s own pecu-liarly doubled history, hints of which are given in the subtitle, "An Autobiography Revisited."

38 Tellingly, much of Kinbote's story appears to have been plagiarized from the account of Charles the Second of England's escape fol-lowing his defeat at the Battle of Worcester. See William Harrison Ainsworth's novel *Boscobel, or, The Royal Oak*, 1871.

39 See Derrida's comment in "White Mythology": "The very opposi-tion between appearing and disappearing, the whole vocabulary of phainesthai, of aletheia, and so forth, of day and night, visible and invisible, present and absent, all this is possible only under the sun" (Derrida, "White" 52).

40 An interesting case might be made for Rilke's *Duino Elegies* as an intertext of Shade's "Pale Fire." The resonances between the poems are particularly strong in the Tenth Elegy, which contains explicit references to both fountain and mountain: Rilke writes of the moun-tains of "Grief-Land" "where the fountain of joy/glistens in moon-light." The typographical element at the heart of Shade's poem implicitly cites Rilke's figure of the southern sky "pure as on the palm of a sacred hand, the clearly shining M." Finally, Hazel's name is suggested by Rilke's "bare hazels": "But if the endlessly dead woke a symbol in us, see, they would point perhaps to the catkins, hanging from bare hazels, or they would intend the rain, falling on dark soil in Spring-time."

41 Nonetheless Nabokov's much-trumpeted claim that he spoke practi-cally no German, despite having lived in Berlin for over a decade during the 1920s and '30s, is considered questionable by Nabokov scholars such as Michael Maar (2009). It is thus possible he did read

the Benjamin text, either in its original or in its French translation by Maurice de Gandillac, but this latter appears in print in 1971, i.e. even later than the Zohn English version. See the Preface to the English translation of his 1928 novel *King, Queen, Knave,* "I spoke no German, had no German friends, had not read a single German novel either in the original, or in translation." (*King* vi).

42 Nabokov's English and Russian works are rife with internecine borrowings. For example, a thinly-disguised Kinbote appears in Nabokov's last and unfinished Russian language novel, *Solus Rex* as the king K, and in the short story, "Ultima Thule" as the "strange Swede or Dane – or Icelander," the "lanky, orange-tanned blond fellow with the eyelashes of an old horse" (*Stories* 510). 'Sirin,' a traditional figure of a maiden-bird in Old Russian folklore with mythological origins in the Sunbird, was Nabokov's Russian pseudonym.

43 Recall Kinbote's comment on the Mrs Z's "grotesque pronunciation" of, naturally, Mont Blanc as "Mon Blon." (*Pale* 625).

44 "To posit the existence of a primal object, or even of a Thing, which is to be conveyed through and beyond a completed mourning – isn't that the fantasy of a melancholy theoretician." (Kristeva 66).

45 Nabokov's satirical name for Freud, whom he also at times refers to as "Sigismond Lejoyeux" (*Speak, Memory*), "Dr. Sig Heiler," "Herr Doktor Sig," "Dr. Froit of Signy-Mondieu-Mondieu (*Ada*), "Dr Bonomini" ("Ultima Thule"), "the Viennese medicine man" (*Lolita*). (Rancour-Laferrie 15). Freud's beyond-the-grave revenge takes the form of not one but *two* Nabokov scholars who bear his name, both of us women and sharing a keen interest in performance issues (see this book and Frank).

46 Hillis Miller comments, "From Montaigne to Descartes and Locke, on down through associationism, idealism, and romanticism to the phenomenology and existentialism of today, the assumption has been that man must start with the inner experience of the isolated self. Whether this experience is thought of as consciousness (the Cogito of Descartes), or as feelings and sense impressions (the sensation of Locke), or as a living center (the punctum saliens of Jean Paul), or as the paradoxical freedom of Sartre, in all the stages of modem thought the interior states of the self are a beginning which in some sense can never be transcended." (Miller, "Theme" 210).

47 Possibly from the "serious wound" inflicted by Van during their duel, whose details Van hints at before dissolving its memory into "the mist." Was there really a duel? Did Van kill Andrey? We simply don't know, since "actually it was all much duller" we're told. (*Ada* 426).

48 The quote continues, " – rather like those false cigarettes – menthol
 sticks with the end made to look "embery" – that people who try to
 give up smoking are said to use." Wilson, in reply, urges Nabokov to
 try *The Princess Casamassima* and *A Small Boy and Others* before
 "giving up" Henry James. (Nabokov and Wilson 211).

49 Nabokov's delight in the comedy of sex is treated by Eric Naiman in
 his wonderful *Nabokov, Perversely.*

50 Recall that Densher is persuaded by Kate to pretend to make love to
 the dying Milly so that, with luck, she will leave her fortune to him
 and thus enable him and Kate to marry. (James, *Wings*).

51 Guillaume's original example concerns the derailing of a train but
 Lacan's substitution of a bomb indicates what is at stake for Lacan,
 namely, the 'explosion' of jouissance which can only occur in a tem-
 porality outside that of the subject's time. For more on the French
 imperfect and Lacan's use of it, see Alain Merlet, "Imparfait" http://
 wapol.org/ornicar/articles/219mer.htm

52 This logic models the Lacanian "vel" of alienation that asks a sub-
 ject-to-be to relinquish its being (jouissance) in favor of a Symbolic
 existence in language. Alienation would be atemporal since it takes
 place in a 'time' before the subject's existence; the subject that
 'chooses' language over being is said to make a "forced choice" –
 forced in the sense that it is only after the choice has been made to
 submit to a Symbolic identity that one can consider it to take place,
 since any other decision "forecloses," as Bruce Fink explains, "the
 possibility of one's advent as a subject." (Fink 50).

53 Menard's conceit is to write Don Quixote, not as a 20th-century
 'remake' but by "continuing to be Pierre Menard and coming to the
 Quixote *through the experiences of Pierre Menard.*" Not in essence
 a difficult undertaking, confesses Menard to the narrator. "If I could
 just be immortal, I could do it." (Borges 91-92).

54 Cervantes himself plays with this idea when, in Part 2, he has Don
 Quixote encounter a second version of himself who has been roam-
 ing the Manchegan plains before him.

55 Nabokov qualifies his attitude towards James in *Strong Opinions*:
 "My feelings towards James are rather complicated. I really dislike
 him intensely but now and then the figure in the phrase, the turn of
 the epithet, the screw of an absurd adverb, cause me a kind of tingle,
 as if some current of his was also passing through my own blood."
 (cited in Gregory 55).

56 The letteral equivalent of "neutrino," the most tiny quantity of real-
 ity ever imagined by a human being according to F. Reines.

57 Robertson adds that this assumption was increasingly chal-
 lenged as the forensic science of handwriting analysis took hold.
 (Robertson 56).

58 The other main camp of Nabokov critics take the opposite view,
 accusing him of what Norman condenses as the charge of "gratu-
 itous formalism." For more on these competing readings of Nabokov,
 see Norman 111, 131.

59 One recalls Nabokov's need to explain to Katharine White, his edi-
 tor at *The New Yorker*, the hidden message contained in the final
 paragraph of "Signs and Symbols."

60 Nabokov notoriously leaves little cluster bombs for inattentive read-
 ers in his Introductions, which often contain falsehoods or at best
 variations of the events in the novel that is to come. In this case,
 Nabokov follows his comment concerning "his" link with Krug with
 a "companion image" of Krug's wife Olga removing her jewelry in
 front of a mirror which he claims "appears six times in the course
 of a dream." When Olga herself appears in *Bend Sinister* in front of
 a mirror, it is not to see herself "divesting herself of herself, of her
 jewels, of the necklace and tiara of earthly life" in Krug's dream of
 her, but with a quizzical, questioning look as if to ask the reader if
 we really have been taken in. In chapter fifteen, we read, "In a casual
 flash, for no reason at all, he recollected a way Olga had of lifting her
 left eyebrow when she looked at herself in the mirror." (*Bend* 309).

61 See for example Bergson in his Nobel prize photograph https://
 en.wikipedia.org/wiki/File:Bergson-Nobel-photo.jpg

62 In Greek, "ópheleia" translates as assistance, profit, benefit.

63 The other book Karshan attends to similarly contains a trick: "Orlik,
 the old zoologist, opened a little book lying next to him and discov-
 ered that it was an empty box with a lone pink peppermint at the
 bottom." (*Bend* 208).

64 Although not exclusively as Nabokov "inherited" it from his bio-
 logical father who caught the "bug" from his German tutor. (Boyd,
 Russian 69).

65 A quick rundown of such figures would include Valentinov, Luzhin's
 "chess father" in *The Defense*, Ivan Black in *Look at the Harlequins*,
 Kinbote in *Pale Fire*, Van in *Ada or Ada*, and many others.

66 See for example Johnson, *Worlds*.

67 In Badiou's version, an astute Glaucon discerns that the impression
 the audience perceives in the theater which masquerades as the real
 is in fact a projected 'digital' copy of the analogue copies who parade

down the moving walkway that doubles for 'life' in representation's darkened auditorium. (Badiou, *Plato* 212).

68 Plato, *Cratylus*.

69 Note, too, that for Benjamin the perception of similarities must always travel through this *third* path which he likens to the figure of the astrologer who is able to read off in the conjunction of two stars a similarity to a human being. (Benjamin, "Doctrine" 66).

70 Caillois' comments are in fact echoed by Nabokov in *Speak, Memory*, where he talks about "nonutilitarian delights" of mimicry, observing Nature's "points of mimetic subtlety, exuberance, and luxury far in excess of a predator's power of appreciation." (*Speak* 465).

71 Recall how for Bergson, the proper dividing line is not between appearances and the real but between images and memory. As he writes in *Matter and Memory*, "Here I am in the presence of images, in the vaguest possible sense of the term, images that are perceived when I open my senses and not perceived when I close them." (Bergson, *Matter* 1).

72 Sebastian and V. will thus only infrequently intersect with each other in the narrative. Nonetheless, although they are 'traveling' at different speeds, V. does have a vague presentiment of the "common rhythm" that inheres between himself and Sebastian, which he likens to the two fraternal tennis champions who, despite the difference in their strokes, followed the same essential pattern "so that had it been possible to draught both systems two identical designs would have appeared." (*Real* 25).

73 See Nabokov's comments in *Strong Opinions*. See also his foreword to *Lolita: A Screenplay*: "If I had given as much of myself to the stage or screen as I have to the kind of writing which serves a triumphant life sentence between the covers of a book, I would have advocated and applied a system of total tyranny, directing the play or the picture myself, choosing settings and costumes, terrorizing the actors, mingling with them in the bit part of guest, or ghost, prompting them, and, in a word, pervading the entire show with the will and art of one individual – for there is nothing in the world that I loathe more than group activity." (*Lolita* 673).

74 The "well-known nursery-rhyme" ends "All the birds of the air/ fell a-sighing and a-sobbing,/when they heard the bell toll/for poor Cock Robin."

75 Benjamin similarly comments, "speed, that swiftness in reading or writing which can scarcely be separated from this process, would then become, as it were, the effort or gift of letting the mind participate in that measure of time in which similarities flash up fleetingly

out of the stream of things only in order to become immediately engulfed again." (Benjamin, "Doctrine" 68). In Sebastian's novel, *Lost Property*, Nabokov obliquely references the chess opening called the Mortimer trap. Named after the 19th century chess player, James Mortimer, it entails Black making a false move in the hope of drawing White in to making a mistake. This is just one of many chess references in *The Real Life of Sebastian Knight* including, of course, the names of key characters.

76 Specifically Nabokovian cinememes include the petting zoo of small dachshunds, rabbits, mice, tortoises, monkeys, squirrels, parrots, wax dummies and mechanical dolls, furred moths and spiders, small items of "lost property" such as the matches, stray chess pieces, letters, tennis balls, buttons, marbles, broken china shards that are littered throughout his works, which one consumes without really noticing, along with the chocolate, colored jujubes and other *boules de gomme* Nabokov sells us from his refreshment stand during brief intermissions.

77 In case we missed it the first time, the letters S and K are also each just *three* steps away from V and N in the alphabet.

78 The painting depicts Octavia fainting at the hearing the name of her dead son Marcellus whom Aeneas meets as a ghost in Book 6 of *The Aeneid*. There were, moreover, two historical figures named Marcus Claudius Marcellus.

79 "I let my index finger stray at random over a map of northern France; the point of its nail stopped at the town of Petiver or Petit Ver, a small worm or verse, which sounded idyllic." (*Look* 620).

80 In Poe's "The Gold Bug," a hieroglyphic signature appears "rudely traced, in a red tint." (Poe, "The Gold Bug").

81 For a brilliant reading of Poe's "The Cask of Amontillado," see Cohen, "Poe's *Foot d'Or.*" (Cohen, *Anti-Mimesis* 105-126).

82 See de Man, "Hypogram" 24.

83 See https://en.wikipedia.org/wiki/Jacques_Offenbach.

84 Performed in a former magician's theater, Salle Lacaze, "a little theater of magic," in 1865, *Two Blind Men* was Offenbach's first foray into comic opera. It was made into a film in 1900 by George Méliès.

85 Recall Benjamin's description of messianic universal history as a "festively enacted history." (Benjamin, "Paralipomena" 405).

86 John Tinnell explains grammatization as the process "by which a material, sensory, or symbolic flux becomes a gramme, which – broadly conceived – can include all manners of technical gestures

that maintain their iterability and citationality apart from an origin or any one particular context." (Tinnell 135).

87 The technology dictionary, TechDico, offers the following translations of "repère" – mark, cue, indicia, frame of reference, guideline, frame, benchmark (a "mobile" *repère* is given in English as *snaking*). https://www.techdico.com/translation/french-english/rep%C3%A8re.html

88 My profound thanks to David Ottina for this discovery.

89 This operetta is also famous for its "Duo de la mouche" where Jupiter's part in the love song consists of a fly's buzzing sound.

Works Cited

Ainsworth, William Harrison. *Boscobel, or, The Royal Oak*. Tinsley Brothers, 1871.

Appel, Alfred. *Nabokov's Dark Cinema*. Oxford University Press, 1974.

Badiou, Alain. *Being and* Event. Translated by Oliver Feltham. Bloomsbury 2013.

Badiou, Alain. "Is it exact that all thought emits a throw of the dice?" Translated by Robert Boncardo and Christian R. Gelder. *Hyperion*, vol. 9, no. 3, 2015, pp. 64-86.

Badiou, Alain. *Plato's Republic: A Dialogue in 16 Chapters*. Translated by Susan Spitzer, introduction by Kenneth Reinhard. Columbia University Press, 2012.

Barthes, Roland. *Camera Lucida: Reflections on Photography*. Translated by Richard Howard, foreword Geoff Dyer. Hill and Wang, 1981.

Baxter, Charles. "Nabokov, Idolatry, and the Police State." *boundary 2*, vol. 5. no. 3, 1977, pp. 813-828.

Benjamin, Walter. "La tâche du traducteur." Translated by Maurice de Gandillac. *Oeuvres*, Editions Denoël, 1971.

Benjamin, Walter. "Doctrine of the Similar." Translated by Knut Tarnowski. *New German Critique*, vol. 17, Special Walter Benjamin Issue, Spring, 1979, pp. 65-69.

Benjamin, Walter. "On Some Motifs in Baudelaire." *Walter Benjamin: Selected Writings, vol. 4, 1938-1940*. Edited by Marcus Bullock and Michael W. Jennings. Belknap, 2003, pp. 313-355.

Benjamin, Walter. "Paralipomena to 'On the Concept of History.'" *Walter Benjamin: Selected Writings, 4: 1938-1940*. Edited by Howard Eiland and Michael W. Jennings. Harvard University Press, 2006.

Benjamin, Walter. *The Origin of German Tragic Drama*. NLB, 1977.

Benjamin, Walter. "The Task of the Translator." *Walter Benjamin: Selected Writings, vol. 1, 1913-1926*. Edited by Marcus Bullock and Michael W. Jennings. Belknap, 1996, 1969, pp. 253-263.

Benjamin, Walter. "The Translator's Task." Translated by Steven Rendall. *TTR: traduction, terminologie, rédaction*, vol. 10, no. 2, 1997, pp. 151-165.

Bergson, Henri. *Matter and Memory*. Translated by Nancy Margaret Paul and W. Scott Palmer. Dover, 2004.

Bergson, Henri. *Mind-Energy*. Translated by H. Wildon Carr. Macmillan, 1920.

Blackwell, Stephen H. *The Quill and the Scalpel: Nabokov's Art and the Worlds of Science*. Ohio State University Press, 2009.

Borges, Jorge, Luis. "Pierre Menard, Author of the Quixote." *Collected Fictions*. Translated by Andrew Hurley. Penguin, 2019.

Boyd, Brian. Ada Online. http://www.ada.auckland.ac.nz/, n.d.

Boyd, Brian, *Vladimir Nabokov: The American Years*. Princeton University Press, 1991.

Boyd, Brian. *Vladimir Nabokov: The Russian Years*. Princeton University Press, 1993.

Boyd, Brian. *Stalking Nabokov*. Columbia University Press, 2013.

Bouasse, Henri. *Optique géométrique élémentaire: focométrie, optométrie*. Delagrave, 1917.

Brahnam, S Berlin. "On Lacan's Neglected Computational Model and the Oedipal Structure: An Expanded Introduction." *S: Journal of the Circle for Ideology Critique*, vols. 10/11, 2017-18, pp. 261-274.

Brahnam, S Berlin. "Primordia of Après-Coup, Fractal Memory, and Hidden Letters: Working the Exercises in Lacan's Seminar on 'The Purloined Letter.'" *S: Journal of the Circle for Ideology Critique*, vols. 10/11, 2017-18, pp. 202-244.

Bullock, Marcus. "Bad Company: On the Theory of Literary Modernity and Melancholy in Walter Benjamin and Julia Kristeva." *boundary 2*, vol. 22, no. 3, 1995, pp. 57-79.

Burton, Robert. *Anatomy of Melancholy*, 1638. <https://archive.org/details/theanatomyofmela10800gut> [Accessed May 11, 2015].

Caillois, Roger. *Man, Play and Games*. Translated by Meyer Barash. Simon and Schuster, 2001.

Caillois, Roger. "Mimetisme et Psychasthenie Legendaire." *Minotaure*, vol. 2, no. 7, 1935, pp. 4-10.

Cervantes, Saavedra, Miguel de. *Don Quixote*. Project Gutenberg.

Cholodenko, Alan. "Speculations on the Animatic Automaton." *The Illusion of Life 2: More Essays on Animation*. Edited by Alan Cholodenko. Power Publications, 2007, pp. 486-528.

Cholodenko, Alan. "(The) Death (of) the Animator, or: the Felicity of Felix, Part I." *Animation Studies*, vol. 3, 2009.

Cholodenko, Alan. "The Crypt, the Haunted House, of Cinema." *Cultural Studies Review*, vol. 10, no. 2, 2004, pp. 99-103.

Clancy, Laurie. *The Novels of Vladimir Nabokov*. St Martin's Press, 1984.

Cohen, Tom. *Anti-Mimesis from Plato to Hitchcock*. University of Cambridge Press, 1994.

Cohen, Tom. "'J'; or, Hillis le Mal." *Provocations to Reading: J. Hillis Miller and the Democracy to Come*. Edited by Barbara Cohen and Dragan Kujundzic. Fordham University Press, 2005, pp. 83-94.

Cohen, Tom. *Hitchcock's Cryptonymies, Vol. 1: Secret Agents*. University of Minnesota Press, 2005.

Cohen, Tom. *Hitchcock's Cryptonymies, Vol. 2: War Machines*. University of Minnesota Press, 2005.

Cohen, Tom, Claire Colebrook, and J. Hillis Miller. *Twilight of the Anthropocene Idols*. Open Humanities Press, 2016.

Connolly, Julian. "Laughter in the Dark." *The Garland Companion to Vladimir Nabokov*. Edited by V. E. Alexandrov. Garland, 1995, pp. 214-225.

Copjec, Joan. "Locked Room/Lonely Room: Private Space in Film Noir." *Read My Desire: Lacan Against the Historicists*. MIT Press, 1994, pp. 163-200.

De la Durantaye, Leland. "The Pattern of Cruelty and the Cruelty of Pattern in Vladimir Nabokov." *The Cambridge Quarterly*, vol. 35, no. 4, 2006, pp. 301-326.

De la Durantaye, Leland. "Vladimir Nabokov and Sigmund Freud, or a Particular Problem." *American Imago*, vol. 62, no. 1, Walks on the Wild Side, Spring, 2005, pp. 59-73.

Deleuze, Gilles. *Cinema 1: The Movement-Image*. Translated by Hugh Tomlinson and Barbara Habberjam. University of Minnesota Press, 1997.

Deleuze, Gilles. *Cinema 2: the Time-Image*. Translated by Hugh Tomlinson and Robert Galeta. University of Minnesota Press, 1989.

De Man, Paul. "Conclusions: Walter Benjamin's 'The Task of the Translator.'" Messenger Lecture, Cornell University, March 4, 1983, *Yale French Studies*, 69, The Lesson of Paul de Man, 1985, pp. 25-46.

De Man, Paul. "Hypogram and Inscription: Michael Riffaterre's Poetics of Reading." *Diacritics*, vol. 11, no. 4, Winter, 1981, pp. 17-35.

De Man, Paul. "Kant and Schiller." *Aesthetic Ideology*. Edited by Andrzej Warminski. University of Minnesota Press, 1996.

Derrida, Jacques. "For the Love of Lacan." *JEP: European Journal of Psychoanalysis*, vol. 2, 1995-96, pp. 63-90.

Derrida, Jacques. *Of Grammatology*. Corrected edition. Translated by Gayatri Chakravorty Spivak. Johns Hopkins University Press, 1997.

Derrida, Jacques. "Signature, Event, Context." *Margins of Philosophy*. Translated with notes by Alan Bass. University of Chicago Press, 1984, pp. 309-330.

Derrida, Jacques. "Ulysses Gramophone: Hear Say Yes in Joyce." Translated by François Raffoul. *Derrida and Joyce: Texts and Contexts*. Edited by Andrew J. Mitchell and Sam Slote. SUNY Press, 2014, pp. 41-86.

Derrida, Jacques. "White Mythology: Metaphor in the Text of Philosophy." Translated by F. C. T. Moore. *New Literary History*, vol. 6, no. 1, On Metaphor, 1974, pp. 5-74.

DeRewal, Tiffany, and Roth, Matthew. "John Shade's Duplicate Selves: An Alternative Shadean Theory Of Pale Fire." *Nabokov Online Journal*, vol. 3, 2009. <http://www.nabokovonline.com/volume-3.html> [Accessed May 7, 2015].

De Saussure, Ferdinand. *Course in General Linguistics*. Edited by Charles Bally and Albert Sechehaye in collaboration with Albert Riedlinger. Translated with an introduction and notes by Wade Baskin. McGraw Hill, 1998.

Detienne, Marcel. *The Masters of Truth in Archaic Greece*. Foreword by Pierre Vidal-Naquet. Zone Books, 1996.

De Vries, Gerard, and D. Barton Johnson. *Nabokov and the Art of Painting*. Amsterdam University Press, 2005.

Dolar, Mladen. "Anamorphosis." *S: Journal of the Circle for Lacanian Ideology Critique*, vol. 8, 2015, pp. 124-140.

Dolar, Mladen. "Nothing Has Changed." *Filozofski vestnik*, vol. 26, no. 2, 2005, pp. 147-160.

Dolinin, Alexander. "The Signs and Symbols in Nabokov's 'Signs and Symbols.'" *Zembla*. https://www.libraries.psu.edu/nabokov/dolinin.htm

Eisenstein, Sergei. "Dickens, Griffith, and the Film Today." *Film Form: Essays in Film Theory*. Translated by Jay Leyda. Harcourt Brace, 1949.

Elder, R. Bruce. *Harmony and Dissent: Film and the Avant-garde Art Movements in the Early Twentieth Century*. Wilfried Laurier University Press, 2008.

Ermath, Elizabeth Deeds. *Sequel to History: Postmodernism and the Crisis of Representatioal Time*. Princeton University Press, 1992.

Fink, Bruce. *The Lacanian Subject: Between Language and Jouissance*. Princeton University Press, 2017.

Foucault, Michel. *The Order of Things: An Archaeology of the Human Sciences*. Vintage, 1994.

Frank, Siggy. *Nabokov's Theatrical Imagination*. Cambridge University Press, 2012.

Freud, Sigmund. "Creative Writers and Day-Dreaming" (1908). *The Standard Edition of the Complete Psychological Works of Sigmund Freud*, vol. 9, (1906-1908). Translated and edited by James Strachey. Hogarth, 1959, pp. 143-153.

Freud, Sigmund. "The Ego and the Id" (1923). *The Standard Edition of the Complete Psychological Works of Sigmund Freud*, vol. 19, (1923-1925). Translated by James Strachey. Hogarth, 1961, pp. 3-59.

Freud, Sigmund. "Mourning and Melancholia" (1917). *The Standard Edition of the Complete Psychological Works of Sigmund Freud*, vol. 14, (1914-1916). Translated by James Strachey. Hogarth, 1959, pp. 237-258.

Freud, Sigmund. *A General Introduction to Psychoanalysis*. Translated by G. Stanley Hall. Pantianos Classics, 2016.

Freud, Sigmund. *The Interpretation of Dreams*. Translated by James Strachey. Avon Books, 1965.

Gifford, Don, and Robert J. Seidman. *Ulysses Annotated*. University of California Press, 1989.

Green, Geoffrey. *Freud and Nabokov*. University of Nebraska Press, 1988.

Gregory, Robert. "Porpoise-iveness Without Porpoise: Why Nabokov called James a Fish." *The Henry James Review*, vol. 6, no.1. Fall, 1984, pp. 52-59.

Grishakova, Marina. *The Models of Space, Time and Vision in V. Nabokov's Fiction: Narrative Strategies and Cultural Frames*. Tartu University Press, 2012.

Guerin, Frances. *A Culture of Light: Cinema and Technology in 1920s Germany*. University of Minnesota Press, 2005.

Guerlac, Suzanne. *Thinking in Time: An Introduction to Henri Bergson*. Cornell University Press, 2006.

Hitchcock, Alfred. *Hitchcock on Hitchcock*, vol. 1. Edited by Sidney Gottlieb. University of California Press, 2015.

Huygens, Ils. "Deleuze and Cinema: Moving Images and Movements of Thought." *Image and Narrative*, vol. 18, September, 2007.

Jacobs, Carol. "The Monstrosity of Translation." *Modern Language Notes*, vol. 9, 1975, pp. 755-766.

Jakobson, Roman. *The Sound Shape of Language*. Translated by Linda R. Waugh. De Gruyter, 2002.

James, Henry. *Complete Stories, 1898-1910*. The Library of America, 1996.

James, Henry. *The Wings of the Dove*. Edited by J. Donald Crowley and Richard A. Horrocks. Norton, 2002.

Jameson, Fredric. *The Political Unconscious: Narrative as a Socially Symbolic Act.* Cornell University Press, 1981.

Johnson, D. Barton. "Nabokov as a Man of Letters: The Alphabetic Motif in his Work." *Modern Fiction Studies,* vol. 25. no. 3, 1979, pp. 397-412.

Johnson, D. Barton. *Worlds in Regression: Some Novels of Vladimir Nabokov.* Ardis, 1985.

Joseph, John E. *Saussure.* Oxford University Press, 2012.

Karshan, Thomas. "Nabokov's 'Homework in Paris': Stéphane Mallarmé, *Bend Sinister,* and the Death of the Author." *Nabokov Studies,* vol. 12, 2009/2011, pp. 1-30.

Kobel, Peter. "Nabokov Won't Be Nailed Down." *The New York Times,* April 22, 2001 http://www.nytimes.com/2001/04/22/movies/film-nabokov-won-t-be-nailed-down.html?pagewanted=all

Kristeva, Julia. *Black Sun: Depression and Melancholia.* Columbia University Press, 1992.

Lacan, Jacques. *Écrits.* Translated by Bruce Fink with Heloise Fink and Russell Grigg. Norton, 1999.

Lacan, Jacques. "The Mirror Stage as Formative of the *I* Function. *Écrits: The First Complete Edition in English.* Translated by Bruce Fink with Heloïse Fink and Russell Grigg. Norton, 2006.

Lacan, Jacques. *The Seminar of Jacques Lacan, Book 2: The Ego in Freud's Theory and in the Technique of Psychoanalysis, 1954-1955.* Edited by Jacques-Alain Miller, translated by Sylvana Tomaselli. Cambridge University Press, 1988.

Lacan, Jacques. *Séminaire 4: La Relation d'objet.* Text established by Jacques-Alain Miller. Seuil, 1998. Translated by Cormac Gallagher. Unpublished.

Lacan, Jacques. *The Seminar of Jacques Lacan, Book 11, The Four Fundamental Concepts of Psychoanalysis, 1963-1964.* Edited by Jacques-Alain Miller, translated by Alan Sheridan. Norton, 1998.

Jacques Lacan, *The Seminar of Jacques Lacan, Book 14, The Logic of Fantasy, 1966-1967.* Translated by Cormac Gallagher. Unpublished.

Lacan, Jacques. *The Seminar of Jacques Lacan, Book 17, Psychoanalysis Upside Down/The Reverse Side of Psychoanalysis, 1970.* Translated by Cormac Gallagher. Unpublished.

Lacan, Jacques. *The Seminar of Jacques Lacan, Book 18, On a Discourse That Might Not Be A Semblance, 1971.* Translated by Cormac Gallagher. Unpublished.

Lacan, Jacques. *The Seminar of Jacques Lacan, Book 20, On Feminine Sexuality, the Limits of Love and Knowledge (Encore), 1972-1973.* Edited by Jacques-Alain Miller, translated by Bruce Fink. Norton, 1999.

Lacan, Jacques. *The Seminar of Jacques Lacan, Book 23, The Sinthome, 1975-1976.* Polity, 2016.

Lacan, Jacques. "Sign, Symbol, Imaginary." Translated by Stuart Schneiderman. *On Signs.* Edited by Marshall Blonsky. Johns Hopkins, 1985, pp. 203-209.

Lanyi, Gabriel. "On Narrative Transitions in Nabokov's prose." *A Journal for Descriptive Poetics and Theory of Literature,* vol. 2, 1977, pp. 73-78.

Leader, Darian. *Why Do Women Write More Letters Than They Post?* Faber and Faber, 1997.

Leving, Yuri, editor. *Anatomy of a Short Story: Nabokov's Puzzles, Codes, Signs and Symbols.* Bloomsbury, 2014.

Louria, Yvette. "Nabokov and Proust: The Challenge of Time." *Books Abroad,* vol. 48, no. 3, 1 July, 1974, pp. 469-476.

McQuire, Scott. *Visions of Modernity: Representation, Memory, Time and Space in the Age of the Cinema.* Sage, 1998.

Maar, Michael. *Speak, Nabokov.* Verso, 2009.

Marks, Laura U. *The Skin of the Film: Intercultural Cinema, Embodiment, and the Senses.* Duke University Press, 2000.

Marks, Lawrence E. "On Colored-hearing Synesthesia: Cross-modal Translations of Sensory Dimensions." *Psychological Bulletin,* vol 82, no. 3, 1975, pp. 303-331.

Masing-Delic, Irene. "Replication of Recreation? The Eurydice Motif in Nabokov's Russian Oeuvre." *Russian Literature,* vol. 70, 2011, pp. 391-414.

Mattison, Laci. "Nabokov's Aesthetic Bergsonism: An Intuitive, Reperceptualized Time." *Mosaic: a Journal for the Interdisciplinary Study of Literature,* vol. 46, no. 1, 2013, pp. 37-52.

Maurer, D. and C. Mondloch. "Neonatal Synesthesia: A Reevaluation." *Synesthesia: Perspectives From Cognitive Neuroscience.* Edited by C. L. Robertson & N. Sagiv. Oxford University Press, 2005.

Melville, Herman. *Moby-Dick, or the Whale.* Project Gutenberg 2008.

Metz, Christian. "The Imaginary Signifier." *Screen,* vol. 16 no. 2, 1972, pp. 14-76.

Meyer, Priscilla. "Pale Fire as Cultural Astrolabe: the Sagas of the North." *The Russian Review,* vol. 47, 1988, pp. 61-74.

Miller, J. Hillis. "The Theme of the Disappearance of God in Victorian Poetry." *Victorian Studies,* vol. 6. no. 3, Symposium on Victorian Affairs, 1963, pp. 207-227.

Miller, Jacques-Alain. "Ordinary psychosis revisited." *Psychoanalytical Notebooks,* vol. 26, 2008, pp. 139-167.

Miller, Jacques-Alain. "Interpretation in Reverse." *The Later Lacan: An Introduction.* Edited by Véronique Voruz and Bogdan Wolf. SUNY Press, 2007.

Miller, Jacques-Alain. "Orientation." *A Real for the 21th Century.* Scilicet, 2014.

Miller, Jacques-Alain. "The Unconscious and the Speaking Body." Translated by A. R. Price, text established by Anne-Charlotte Gauthier, Ève Miller-Rose and Guy Briole. Presentation at the Xth Congress of the WAP in Rio de Janeiro in 2016.

Milner, Jean-Claude. "Mallarmé Perchance." Translated by Liesl Yamaguchi. *Hyperion,* 2016, pp. 87-109.

Moraru, Christian. "Time, Writing, and Ecstasy in *Speak, Memory*: Dramatizing the Proustian Project." *Nabokov Studies,* vol. 2, 1995, pp. 173-90.

Munsterberg, Hugh. *The Photoplay: A Psychological* Study. Appleton, 1916.

Murray, Penelope, and Peter Wilson. *Music and the Muses: The Culture of Mousikē in the Classical Athenian City.* Oxford University Press, 2010.

Nabokov, Vladimir. "Anna Karenin." *Lectures on Russian Literature.* Edited by Fredson Bowers. Harcourt Brace, 1981.

Nabokov, Vladimir. "Foreword." *Aleksandr Pushkin, Eugene Onegin: A Novel in Verse.* Translated by V. Nabokov. Princeton University Press, 1964, pp. vii-viii.

Nabokov's Interview by James Mossman. Review, BBC-2 (October 4) 1969. <http://lib.ru/NABOKOW/Inter13.txt_with-big-pictures.html> [Accessed 11 February, 2014].

Nabokov, Vladimir. *Novels and Memoirs, 1941-1951: The Real Life of Sebastian Knight, Bend Sinister, Speak, Memory.* The Library of America, 1996.

Nabokov, Vladimir. *Novels, 1955-1962: Lolita, Pnin, Pale Fire.* The Library of America, 1996.

Nabokov, Vladimir. *Novels 1969-1974: Ada or Ardor: A Family Chronicle, Transparent Things, Look at the Harlequins!* The Library of America, 1996.

Nabokov, Vladimir. *Selected Letters, 1940-1977.* Edited by Dmitri Nabokov and Matthew J. Bruccoli. Harcourt Brace, 1989.

Nabokov, Vladimir. *The Stories of Vladimir Nabokov.* Vintage, 2008.

Nabokov, Vladimir. *Strong Opinions.* Vintage, 1990.

Nabokov, Vladimir Vladimirovich, and Edmund Wilson. *Dear Bunny, Dear Volodya: The Nabokov-Wilson Letters, 1940-1971.* Revised and expanded edition, edited, annotated and introduction by Simon Karlinsky. University of California Press, 2001.

Naiman, Eric. *Nabokov, Perversely.* Cornell University Press, 2010.

Norman, Will. "Nabokov and Benjamin: A Late Modernist Response to History." *Ulbandus Review,* vol. 10, My Nabokov, 2007, pp. 79-100.

Norman, Will. *Nabokov, History and the Texture of Time.* Routledge, 2012.

Patteson, Richard R. "Nabokov's 'Bend Sinister': The Narrator as God." *Studies in American Fiction,* vol. 5, no. 2, Fall, 1977, pp. 241-253.

Petit, Laurence. "Speak, Photographs? Visual Transparency and Verbal Opacity in Nabokov's *Speak Memory.*" *Nabokov Online Journal,* vol. 3, 2009.

Pifer, Ellen. "Shades of Love: Nabokov's Intimations of Immortality." *The Kenyon Review,* New Series, vol. 11, no. 2, 1989, pp. 75-86.

Plato. *Cratylus*. Translated by Benjamin Jowett. Project Gutenberg.

Poe, Edgar Allan. *The Works of Edgar Allan Poe, Vol. 1*, Project Gutenberg, 2008.

Potter, David. *Ardor or Ada? Authority, Artifice, and Ambivalence in Nabokov's Ada, or Ardor*. Masters Thesis, The University of Sydney, 2019.

Rabaté, Jean-Michel. *James Joyce and the Politics of Egoism*. Cambridge University Press, 2009.

Rancière, Jacques. *The Lost Thread: The Democracy of Modern Fiction*. Translated by Steven Corcoran. Bloomsbury, 2016.

Rancour-Laferrie, Daniel, editor. *Russian Literature and Psychoanalysis*. John Benjamins, 1989.

Robertson, C. L. & N. Sagiv, editors. *Synesthesia: Perspectives From Cognitive Neuroscience*. Oxford University Press, 2005.

Robertson, Craig. *The Passport in America: The History of a Document*. Oxford University Press, 2021.

Rowe, W. W. *Nabokov's Spectral Dimension*. Ardis, 1981.

Saunders, Thomas. *Hollywood in Berlin: American Cinema and Weimar, Germany*. University of California Press, 1994.

Schuman, Samuel. "Hyperlinks, Chiasmus, Vermeer and St. Augustine: Models of Reading *Ada*." *Nabokov Studies*, vol. 6, 2000/2001, pp. 125-127.

Sobchack, Vivian. "What My Fingers Knew: The Cinesthetic Subject, or Vision in the Flesh." *Senses of Cinema*, vol. 5, 2000.

Stiegler, Bernard. *Technics and Time 1: the Fault of Epimetheus*. Translated by Richard Beardsworth and George Collins. Stanford University Press, 1998.

Sussman, Henry. *Franz Kafka: Geometrician of Metaphor*. Coda Press, 1979.

Tinnell, John. "Grammatization: Bernard Stiegler's Theory of Writing and Technology." *Computers and Composition*, vol. 37, 2015, pp. 132–146.

Vicks, Meghan. *Narratives of Nothing in 20th-Century Literature*. Bloomsbury, 2015.

Wall-Romana, Christophe. "Mallarmé's Cinepoetics: The Poem Uncoiled by the Cinématographe, 1893-98." *PMLA*, vol. 120, no. 1, Special Topic: On Poetry, Jan, 2005, pp. 128-147.

Weisberg, Richard. *"Hamlet* and *Un Coup de Dès*: Mallarmé's Emerging Constellation." *Modern Language Notes*, vol. 92, no. 4, 1977, pp. 779-796.

Wilson, Edmund. "The Ambiguity of Henry James." *The Triple Thinkers: Twelve Essays on Literary Subjects*. Penguin, 1962.

Wilson, Edmund. "The Strange Case of Pushkin and Nabokov." *The New York Review of Books*, July 15, 1965.

Wiśniewski, Mikołaj. "Nabokov's 'Screen Memory." *Nabokov Studies*, vol. 5, 2017.

Wyllie, Barbara. *Nabokov at the Movies: Film Perspectives in Fiction*. McFarland, 2003.

Žižek, Slavoj. *Looking Awry: An Introduction to Jacques Lacan through Popular Culture*. MIT Press, 1991.

Žižek, Slavoj. *The Parallax View*. MIT Press, 2009.